The Practice Run

The Practice Run

How a Failed Art Heist Provided a Blueprint for the World's Largest Art Robbery

Frederick J. Fisher

ROWMAN & LITTLEFIELD
Lanham • Boulder • New York • London

Rowman & Littlefield
Bloomsbury Publishing Inc, 1385 Broadway, New York, NY 10018, USA
Bloomsbury Publishing Plc, 50 Bedford Square, London, WC1B 3DP, UK
Bloomsbury Publishing Ireland, 29 Earlsfort Terrace, Dublin 2, D02 AY28, Ireland
www.rowman.com

Copyright © 2025 by Frederick J. Fisher

All rights reserved. No part of this book may be reproduced in any form or by any electronic or mechanical means, including information storage and retrieval systems, without written permission from the publisher, except by a reviewer who may quote passages in a review.

British Library Cataloguing in Publication Information Available

Library of Congress Cataloging-in-Publication Data Available

ISBN 979-8-8818-0595-1 (cloth : alk. paper)
ISBN 979-8-8818-0596-8 (electronic)

For product safety related questions contact productsafety@bloomsbury.com.

∞™ The paper used in this publication meets the minimum requirements of American National Standard for Information Sciences—Permanence of Paper for Printed Library Materials, ANSI/NISO Z39.48-1992.

For Becky

Contents

Acknowledgments ix

1	Affirmation	1
2	The Hydes and Mrs. Gardner	5
3	Acquiring Art on a Budget	15
4	The Transition	29
5	A Career Move	37
6	Young Mr. Vanderbilt	47
7	Saved by the Dog	83
8	Brian Michael McDevitt	95
9	Planning the Heist	103
10	Facing the Law	125
11	Revitalizing The Hyde	131
12	McDevitt Again	143
13	Déjà Vu	155
14	"To Catch a Thief"	167
15	Hollywood Reinvention	171
16	Circumstantial, Or . . .	181

17	Dead or Alive?	193
18	Where Do We Go from Here?	199
Epilogue		205
Sources		207
Index		211
About the Author		217

Acknowledgments

While writing this book was a solitary process, it was not without the generous support and contributions of so many wonderful individuals. The person who inspired me to pursue this project was Ronald S. Kermani, retired investigative reporter at the *Times-Union* newspaper in Albany, New York. His thorough scrutiny of the attempted heist of The Hyde Collection, particularly his in-depth investigation of its plotter, Brian Michael McDevitt, was a master class of reportage. I am particularly beholden to Ron for providing me with the police interrogation transcripts of the three individuals involved with this incident. I also greatly appreciate those individuals who granted me interviews for this book, notably Stephanie Rabinowitz, Michael Morey, Doug McIntyre, and Jim Arnold. I am also indebted to all those who reviewed the manuscript of this book through its various stages of development. To my wife, Becky, who kept me focused when I was drifting off subject, and to the following individuals, who gave me helpful advice: Elaine Reichl, Joyce Barrett, Joseph and Sara Cutshall-King, and Thomas McShane. And after I nearly abandoned my manuscript as inconsequential, I sought the professional advice from Fred LeeBrun, short story writer and novelist, who helped me reassess and improve my prose. I am indeed grateful to him for his sage guidance. And for technical assistance, I want to sincerely thank Caroline Kinne and Ayleen Gontz. Further, I am beholden to my literary agent, Tracy Crow, for her belief that my story had publishing potential. And I owe a debt of gratitude to my publisher, Rowman & Littlefield, notably to Charles Harmon and Lauren Moynihan. Finally, I want to apologize if I have forgotten anyone who might have aided me during this lengthy process. Just know how much I appreciate all of you who have helped to make this book possible.

Chapter 1

Affirmation

About five thirty that bitterly frigid morning, the telephone rang, waking me from a deep sleep. I stumbled from bed after several rings, staggered to our adjoining little TV room, and fumbled for the phone. The brusque male voice on the other end said, "Is this Fred Fisher, the director of The Hyde Collection?"

"Yes, what's going on?"

He identified himself as an Albany, New York, police officer. "There was an attempted robbery on your museum last night, and we think the person whom you alerted us about a few months ago might have been the guy who tried to rob your place."

My heart started racing. "Did he steal anything?"

"No, they couldn't get in the place. The museum was closed, and they didn't try to break in."

"What do you mean, *they*? Was there more than one guy?"

"Yeah, a couple of guys, and we're trying to locate them now."

Unable to draw out additional information, I thanked him and hung up. But my thoughts were running wild as I walked back to the bedroom. My wife, Becky, with her nose barely out of the heavy covers, stammered, "What's that all about?"

"I just can't believe it. That bastard Vanderbilt tried to rob the museum last night. I'm sure it was him. I knew he was up to no good." After explaining the sparse details to her, I dressed and went downstairs to the kitchen to undertake my customary morning ritual of coffee-making. My loyal companion, our mutt dog, Nutmeg (an odd mix of German Shepherd and Airedale terrier), had followed me downstairs and into the kitchen and was looking longingly at me with her bewhiskered face pleading for an early morning walk. "Not now, Meggy. I've got too much on my mind."

It was still dark, and according to the round plastic thermometer outside our kitchen window, 15 degrees below zero. Thankfully, no new crop of fresh white stuff had fallen during the night, adding to the already-accumulated foot

of snow I'd had to shovel from our long, narrow driveway the previous morning. This was not unusual weather for upstate New York, near the foothills of the Adirondacks, particularly in late December.

Here we were, just three days before Christmas, and my museum had nearly been robbed. I wondered how many of the museum's Old Masters they would have taken—the Rembrandt, the two Rubens, the Picasso, the marvelous little Botticelli? No matter what, this news was going to cause a shitstorm of speculation. What would my board say? How would the community react to this news? And even more concerning was, what in the hell would be printed about this debacle in the regional newspapers? All I needed was sensational press to make the museum look bad. I could just hear the local gossips finding something nasty to say about this despicable episode, to fault me and my small staff. That immediately got me to wondering if this breaking story would be on the front page of the Glens Falls *Post-Star*. *God, I hope not*, I told myself. I would at least like an opportunity to be interviewed first so the story would be given a fair chance at accuracy.

By this time, a hint of sunrise was filtering into the windows of our little, brown-stained Sears and Roebuck kit-built house on Coolidge Avenue. I looked through the front hall window wondering if the paper had been delivered. Indeed, it was there. After all, it was almost quarter after six, and I could usually count on the paper arriving by six. However, this morning a small, red dented-up sedan was parked perpendicularly, blocking our driveway. The motor was running, but I couldn't discern if the driver was inside. My first thought was that the car belonged to the father of the paperboy, and being a good father, he was helping his son on this godforsaken cold morning. My paper on the icy driveway was only about five feet from the exhaust-spewing car, so I decided to wait a few minutes for the father to drive his son to the next street.

Ten minutes, fifteen minutes, twenty minutes—the car was still there. Why was it taking so long for the kid to deliver his papers? My patience was wearing thin; I was beside myself to see if this story had made the headlines. When I couldn't take it any longer, I walked through the kitchen to our back porch, put on my coat and boots, and headed for the door with a sad dog glaring at me as I gently pushed her aside, leaving her indoors.

For some reason, I had a queasy feeling about the strange car, its motor having been running for some time now. When I was about fifteen feet away, a craggy-faced male with a bushy mustache slowly sat up in the driver's seat, crammed a cigarette in his mouth, gave me a cold, hard stare, gunned the engine, and drove off in a screeching flash.

I retrieved my paper and ran back toward the house, unsure what was happening. Maybe that *wasn't* a thoughtful paperboy's dad; could something else be going on here? Could this be someone from the FBI—was I being considered a suspect in this wretched caper? Could Vanderbilt be a member of a

larger crime syndicate? Were they staking out our house for some malicious objective? Now my imagination was in overdrive.

During the next few days, this treacherous story would gradually come into focus as the two perpetrators were captured and the media launched into high gear. The museum and its staff, including yours truly, were extremely fortunate that this was a failed endeavor. But how could I have possibly guessed that ten years later, this incident, an attempted heist at The Hyde Collection in remote Glens Falls, New York, would raise suspicion about the perpetrator of yet another heist—regrettably, the successful burglary at the famed Isabella Stewart Gardner Museum in Boston, Massachusetts, in which two young thieves, dressed as policemen, stole eleven Old Master paintings and a couple of lesser objects worth more than a half-billion dollars. The mastermind of The Hyde's attempted heist, Brian Michael McDevitt, a Boston suburb resident, is considered by some a possible suspect in the Gardner's devastating crime. However, in their frenzy to pin the crime on an assortment of Boston's infamous thugs, it took nearly two years for the FBI to focus on McDevitt.

The astonishing resemblance between the Gardner Museum and The Hyde Collection, both art collectors' Italianate homes-transformed-into-museums, as well as the remarkable similarity of the two theft incidents, shrieks of a direct association. Yet, at this writing, the crime has yet to be solved, or the valuable stolen art retrieved, even though the FBI persuasively claim they know who the perpetrators are but are unwilling to divulge their names. Perhaps it is McDevitt, and they're hiding his identity in hopes he will pinpoint the mastermind of the heist.

This is the story of how I became acquainted with McDevitt, who was masquerading in the small town of Glens Falls as a young Vanderbilt heir and freelance writer intent on learning the details of my museum's security under the pretense of writing a story about stolen art. His naïve eagerness almost immediately raised my suspicion, and before long I had informed the local police of my misgivings. Consequently, I believe I am the only museum professional to have ever had the distinct terror of becoming fully acquainted with an individual intent on robbing my museum.

To best appreciate the link between the two museums and how this story plays out, it is important to convey their histories and the fascinating personalities that made them possible. All museums have interesting stories regarding their early development, but these two have a special affinity in that the one in Boston directly inspired its Glens Falls little sister. It's about the personalities of the collectors as well as the intriguing world of art collecting—its triumphs and its pitfalls. And to understand my direct involvement in this impoverished little upstate New York museum, I shall give some space to explain my career as it relates to the museum. This is a story about the amazing similarities of art crimes in two very comparable museums—a story enveloped in their histories as well as with my personal story.

Chapter 2

The Hydes and Mrs. Gardner

How young Brian McDevitt discovered The Hyde Collection in remote Upstate New York for his first attempt at the "art theft business" has always been perplexing to me. Not that it wasn't a good idea to find an impoverished, out-of-the-way art museum for his practice run, but more to my mystification is, just how in the hell did he become aware of The Hyde? It's been one of the biggest frustrations during my museum career, that almost every time I bring up the subject of The Hyde Collection in conversation, I get the same blank stare and response, "What's The Hyde?" To this very day, the museum remains a hidden treasure known mostly to the locals and a few serious art aficionados.

Without a doubt, The Hyde Collection has been the victim of its remote location, and therefore no matter how fine its art collection, there has been little attention given to it since it was launched as a public institution in 1963, following the death of its unpretentious founder, Charlotte Pruyn Hyde. She, too, no doubt set the pace for its near anonymity; given her very private manner, she was certainly not a dynamic force in the art world that would have attracted the attention of the arts cognoscenti.

Yet The Hyde is not unique. Smaller, out-of-the-way art museums sadly get overlooked by great urban behemoths like New York's Metropolitan Museum of Art or Washington's National Gallery of Art. Even smaller urban museums like the Phillips Collection in Washington, DC, or the Isabella Stewart Gardner Museum in Boston, are at least on people's radar. That's not true of so many wonderful little gem institutions like The Hyde Collection, located two hundred miles north of the Big Apple. Among other such marvelous, remote little art treasuries are the Hill-Stead Museum in Farmington, Connecticut, and the Maryhill Museum of Art in Goldendale, Washington. These small cultural oases are not only overlooked by the arts cognoscenti (or, as I sometimes call them, the "cogno-snotty"), but also, sadly at times, even by their own communities.

One wonders how and why such stellar little art treasuries can end up in far-flung locations. Typically, they were founded by regional enlightened and worldly individuals who were financially comfortable, were usually associated with local economic entities, and were dedicated and leading citizens of their rural communities. They generally began assembling a few objects of fine and decorative arts as a way of demonstrating their wealth and finer tastes, and gradually they evolved into serious collectors. Collecting became an avocation, and toward the end of their lives, they had amassed a considerable number of significant objects. Faced with their mortality, their greatest challenge was how best to provide for their treasures once they were no longer living members of their communities. Many, like Mrs. Hyde, were such devoted citizens that they formed wills and trusts, fashioning nonprofit museums from their homes and collections in perpetuity for the enlightenment and education of their local citizenry. They wanted to give back to their communities what they had been so privileged to acquire from the wealth that was generated in those communities. But just in case, most trusts were cautiously drafted with contingency options, usually willing their art to institutions of higher learning or major urban museums should their future creations cease to thrive in an uncultivated wilderness.

The story of the founding of The Hyde Collection follows this extraordinary tradition. Charlotte Pruyn Hyde (1867–1963), the museum's founder, was the eldest daughter of Samuel and Eliza Jane Pruyn. She had two younger sisters, Mary Pruyn Hoopes and Eliza Pruyn Cunningham. The Dutch Pruyn family arrived in America in the mid-seventeenth century and initially settled in the Albany, New York, region. They soon became successful and ambitious farmers. Samuel Pruyn (1820–1908), Charlotte's father, left farming for the lumbering business, working initially at a lumber mill in Stillwater, New York, before settling in Glens Falls. At the time, Glens Falls was a little hamlet on the northeast side of the Hudson River overlooking the steep falls, which was a natural location for a boundless source of waterpower. With thousands of wooded acres in the Adirondacks, west and north of Glens Falls, the region prospered, with over twenty sawmills supplying lumber for the growing cities on the East Coast.

In 1865, Samuel formed a partnership with brothers Jeremiah and Daniel Finch and purchased a dilapidated sawmill. They quickly turned it into a thriving business following the increasing demand for lumber after the Civil War. Eventually the company was also involved in the quarrying of black marble, as well as the sale of lime and grain. Ever the insightful businessmen, by the turn of the century they had transformed the lumber business into a pulp-paper mill, producing newsprint for the burgeoning newspaper industry. The Pruyn family purchased the business from the Finch brothers in 1909, making them the company's sole operator. In the mid-1940s, sensing new

market demands, Finch Pruyn & Company (Pruyn retained the company's original name) began the production of high-quality printing papers for the book publishing world. To this very day, the company, now called Finch Paper, and no longer owned by the Pruyn family, is a successful business producing over 250,000 tons of paper annually and employing hundreds of people in the Glens Falls region.

Sam Pruyn married Eliza Jane Baldwin (1834–1915) in 1860; she was the daughter of James and Charlotte Baldwin. Income from the growing mill provided the Pruyns a comfortable lifestyle. They built a large Victorian Italianate-style family home on Glens Falls's Elm Street and set about filling it with children: three daughters, as mentioned above, and a son, who unfortunately died in infancy. Sam Pruyn was well regarded in his community. He was a trustee of the little village and was occupied in improvwwing Glens Falls's water system, among many of his involvements. Both he and his wife were well known locally for their generous philanthropy—setting a pace that their eldest daughter would eventually emulate.

The Pruyns' oldest daughter, Charlotte, after completing her primary education in Glens Falls and Albany, was sent to Boston in 1888 to attend a one-year finishing school—typical of so many young women from well-to-do American families, because college educations were not an option for females. It was there that she met the young Harvard Law student Louis Fiske Hyde (1866–1934), who happened to be staying at the same boardinghouse. The two struck up a friendship that eventually led to their marriage thirteen years later, in 1901. In those intervening years, Louis Hyde, after graduating with honors from Harvard, initially worked for a Boston law firm; followed by a position with the law department of the Boston Elevated Railway Company. The young married couple settled in Hingham, Massachusetts, where, three years later, Charlotte gave birth to their only child, Mary Van Ness Hyde.

While living in the intellectual crucible of Boston, the young couple began to hone their sensitivities to the fine arts. There were the flourishing Museum of Fine Arts, the Boston Public Library, and numerous concerts and lectures to stimulate their cultural appetites. However, the single most influential Boston figure for the Hydes was Isabella Stewart Gardner (1840–1924). Isabella was the daughter of a wealthy New Yorker, and her husband, Jack, was from one of Boston's more influential families. Isabella was not one for following tradition. She had a conspicuous sense of herself and enjoyed making waves that would inevitaby spawn gossip amid Boston's blue bloods. Her eccentric behavior was the fodder for the city's tabloids. After losing her only child at age two, and learning that she was henceforth infertile, she escaped a lengthy mourning period by immersing herself in the pursuit of art. Gardner employed the young art historian Bernard Berenson—a fellow Harvard acquaintance of

Louis Hyde—to assist her in accumulating great works of art and to educate her about the idiosyncrasies of the art world. Gardner inherited two million dollars—valued at approximately 67 million in today's dollars—and she put it to work acquiring some fabulous Old Master paintings. Following the death of her husband in 1898, she devoted the remainder of her life to passionately acquiring art, constructing a home in the Boston Fens for her collection, and preparing it for a future public museum.

However, the word *home* is a little too modest a descriptor because Isabella, undeniably as a way of snubbing the Boston blue bloods, constructed a full-fledged Venetian Renaissance Palazzo, "à la Gardner." This was nothing like the fashionable Georgian or Beaux Arts–styled structures owned by most of Boston's affluent. Gardner and her architect fashioned a Venetian pastiche using actual architectural remnants salvaged from Venice. It is a deceiving structure because of its simple blockish exterior, which does not allude to its magnificent interior. Built around a large, remarkably wrought courtyard naturally lit by a windowed roof, it permitted a year-round safe environment for tropical plants—a necessity given Boston's seasonal climate swings—and a suitable atmosphere and illumination for maintaining and viewing art. Three floors of the four-story structure are open to the courtyard by authentic remnants of Venetian Gothic-styled lancet windows and doorways with balconies and colonnades—just the opposite of Venetian structures where these architectural features punctuate building exteriors. The courtyard floor is scattered with ancient statues and architectural fragments among lush tropical foliage and seasonal flowers. Galleries on the first, second, and third floors circle the windowed courtyard, allowing peekaboo views into its lush ambience. Totally separated from her superlative art collection, the fourth floor was Mrs. Gardner's personal residence.

Relying primarily on Bernard Berenson's art history acumen and his triumphant sleuthing, Gardner accumulated a superlative Old Master collection, including works by Botticelli, Raphael, Titian, Rembrandt, and Vermeer, as well as numerous American works of art. She installed her collection in a decidedly idiosyncratic and exotic fashion among a mix of period furnishings, oriental objects, and an assortment of decorative arts pieces—totaling over 2,500 objects. The installation was her personal work of art, or as the Germans would call it, her *gesamtkunstwerk*. She mixed paintings and objects in often-eccentric configurations, using historic fabrics on walls or draped on furniture and even covering some delicate, light-sensitive art pieces and documents with period Renaissance velvets to be lifted away when viewing. She officially opened her museum, called Fenway Court, in 1903, permitting limited public access by reservation only. It was not until after her death in 1924 that the museum became a fully public institution. She was the first American to establish an art collector's personal museum, paving the way for

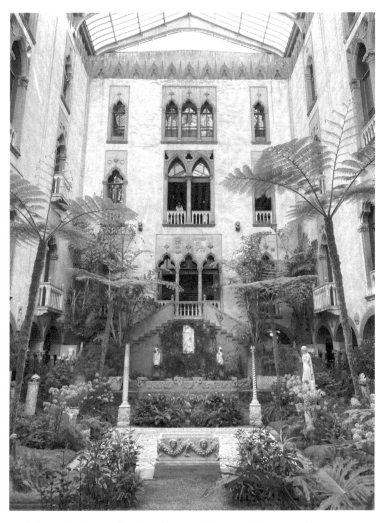

Courtyard, Isabella Stewart Gardner Museum, Boston, Massachusetts.
Image used under license from Shutterstock.com photograph by Yegor Pavlovskyi

notable future art collectors such as Henry Clay Frick, Henry and Arabella Huntington, Robert and Mildred Bliss, Albert Barnes, Charlotte Hyde, and Marjorie Post to create museums out of their own artistic ensembles. For Gardner, it was essential that visitors experience her entire assembly of works of fine and decorative arts, to enjoy them as she had in a domestic scale. Without a doubt she also wanted her museum to reflect her personal lifestyle, a way of snubbing her nose at the conservative Boston cave dwellers. It is, indeed, a striking contrast from viewing objects of art in sterile museum

galleries, which are often devoid of contextual settings. Today, in fact, many serious museum visitors admit that they much prefer the domestic scale and personality of these collector's creations in which to experience works of art.

There is no documented evidence confirming that the young newlyweds, Louis and Charlotte Hyde, had any direct contact with Isabella Stewart Gardner; however, it is possible that their shared association with Bernard Berenson might have enabled a meeting. When Gardner opened her home to the public in 1903, on a restricted basis, there was considerable media coverage, causing a great deal of excitement among Boston's elite to get a peek at just what "Mrs. Jack," as she was often called, had pulled off. She undeniably caused quite a stir in the staid New England city, and by all accounts, her creation was well received. How could anyone fault her for the splendid art collection she had accumulated, including one of Titian's major masterpieces, the *Rape of Europa*? As visitors ambled their way through the light-filled Venetian-esque structure with the fragrance of masses of flowers filling the air and stunning masterpieces around every corner, it could only have been an incomparable experience. One can imagine that the Hydes were among the earliest of awestruck visitors. Here in Boston was the closest thing to a European manor house filled with authentic, timeworn furnishings and great art that gave the impression that the structure had been occupied by wealthy aristocrats for generations. Most likely, the Hydes visited often and must have occasionally attended the musical presentations in the grand, exotic courtyard that were periodically sponsored by Mrs. Gardner. Whatever took place between the Hydes and Mrs. Gardner is unknown, but she made an incredible and lasting impact on the young couple that set them on the same trajectory for the rest of their lives.

Charlotte Hyde's father, Samuel, was successful in persuading her husband, Louis, to relinquish his job in Boston and move to Glens Falls to take on the vice president position of the family paper company. Enlightened by their educations, the cultural milieu of Boston, occasional European trips, and attendance at expositions like the World's Columbian Exposition in Chicago, the Hydes returned to rural Upstate New York in 1907 with a plan in mind. Unfortunately, Samuel Pruyn died the following year. Prior to their relocation, an agreement had been made among the three Pruyn sisters to establish a family compound. They purchased a seven-acre site on Warren Street in Glens Falls. It was located on a bluff immediately above the family paper company, which was situated on the shores of the Hudson River. The first family home to be built on the compound was for Maurice and Mary Hoopes (Mary was Charlotte's middle sister, and her husband was the president of Finch Pruyn). One can assume that Louis Hyde was tasked with finding an architect, because their choice was the eminent Boston firm of Bigelow and Wadsworth. Henry Forbes Bigelow (1867–1929), famed for several Beaux

Arts–styled commercial and domestic structures in the greater Boston region, designed all three of the sisters' homes, as well as the headquarters building for the family paper company. For the Hoopeses Bigelow designed a colonial revival–style home. In 1910, he designed for Mrs. Hyde's younger sister, Nell, a smaller Flemish-style home. She was not married at the time and was very much interested in the arts and crafts movement, and, in fact, was an amateur potter; therefore, Bigelow designed a small pottery studio for the basement of her home. Between these two structures, Bigelow was charged with designing the most prestigious structure of the three for Louis and Charlotte.

Unquestionably, Isabella Stewart Gardner's home was the principal influence for the design and layout of Hyde House. Built as a Florentine Renaissance–styled palazzo, the two-and-a-half-story, stucco structure was constructed around a central courtyard lit by a large glass skylight that was motorized and could be slid open on tracks during optimal weather. All first-floor rooms opened into the courtyard, and the upper rooms had windows overlooking the brightly lit court surrounded by tropical plants growing in formal planting beds. Much smaller in scale than Gardner's palazzo, Hyde House was designed to fully function as a home with kitchen, dining room, library, and guest room on the first floor and a *piano nobile*–like picture gallery on the second floor surrounded by bedrooms. There was no attempt to incorporate large amounts of Italian antique architectural elements into the building, as had Mrs. Gardner. However, the architect was successful at achieving an old-world ambience throughout the structure with the use of oiled wood paneling, mottled stucco walls, marble columns, chestnut trusses, carved gilt consoles, wrought-iron gates and balconies, and earthy Mercer tiles for flooring in the ground-floor rooms, with occasional antique architectural features such as fireplaces and a rustic Italian Renaissance fountain in the courtyard. What the Hydes created in Glens Falls is, beyond doubt, a smaller replica of Mrs. Gardner's Fenway Court, assembled by people with a good deal less ego and financial backing, but nonetheless as wonderfully inspired.

It took two years to complete Hyde House, and in 1912, the Hydes took possession of their beautiful home after living in temporary housing nearby. They then set about seeking suitable furnishings that would enhance what Bigelow had designed for them. What the Hydes learned from Gardner, as well as from a growing interior design movement in America, was to look beyond newly made replicas of past furniture styles, disregarding the artificiality of Victoriana. The goal was to seek genuine antique pieces that would impart authenticity, and for the Hydes, would be suitable for their Italian Renaissance–styled home. They departed for Europe in 1913 and found numerous furniture pieces in Paris shops and galleries that spoke to

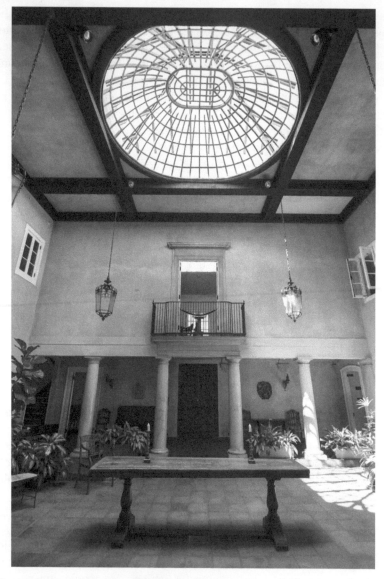

Hyde House Courtyard, 2014, The Hyde Collection, Glens Falls, New York.
Photograph by Josh Williams, Photography

the Hydes' unpretentiousness. These included masculine sixteenth- and seventeenth-century Italian pieces—refectory table, Savonarola chairs, marriage chests—as well as similar-period Dutch and French pieces that fit contentedly within the Mediterranean earthiness of Hyde House. For the bedrooms, they selected primarily eighteenth-century French furnishings with occasional

Italian pieces that, again, were less ornate and more appropriate for the severity of their surroundings. Charlotte was fond of textiles, and she collected a large number of fragments of Italian Renaissance cut-and-voided velvets, predominantly extracted from worn-out liturgical vestments, in warm, muted tones that she fashioned into furniture upholstery and throws. Their attempt was to emulate the domestic interiors of European homes, and more pointedly, Isabella Gardner's Fenway Court. They were assembling a period stage set upon which the Old Master works of art they would eventually acquire would be suitably ensconced. The architect Henry Forbes Bigelow was so taken with Hyde House that he built a similar-style home for himself in the prestigious Beacon Hill section of Boston. His conceptualization of the house was published in the June 7, 1916, edition of The *American Architect* magazine. He described it thusly:

> Wherever . . . [one] turns his eye . . . [one] meets some bit that has associations of days abroad or revives memories dear to the heart of every collector. Bit by bit this refining process goes on and it is only men of such temperamental qualities that can appreciate the comfort those artistic tendencies will secure with such a house and the large measure of satisfaction its possession affords.[1]

NOTE

1. Henry Forbes Bigelow, *American Architect*, Vol. CIX, Number 2111, June 7, 1916, 374.

Chapter 3
Acquiring Art on a Budget

What generally comes to mind when one thinks of serious art collectors are the super-rich robber barons of the Gilded Age—people such as J. P. Morgan, Henry Clay Frick, or Andrew W. Mellon. These exceptionally wealthy individuals, who quite often made their prosperity off the backs and blood of their poorly paid employees, began collecting art—the pastime of European kings and aristocracy—to express their prominent stature. Take industrialist Frick, for example, who amassed his fortunes in the production of steel. He started as a supplier of coke, a critical ingredient for the manufacturing of steel. It was a dirty, labor-intensive process that polluted the Pennsylvania countryside and destroyed the health of many of his workers and their families. Frick was an extremely harsh and excessive employer who fought labor unions vociferously, and when his employees staged a strike to demand better working conditions, he fought them tooth and nail. Over time, his reputation fell to that of "the most hated man in America." Frick became immensely wealthy, and over the years, he followed the tradition of several of his fellow American robber barons who had the means for extensive travel to Europe and realized they could rival European aristocracy by building palace-sized mansions in America and filling them with the trappings of wealth, including significant Old Master paintings. Late in Frick's life, he built a Beaux Arts–styled mansion in New York City, where he installed the best of his collection—some absolutely stellar works of art by such noted artists as Vermeer, Fragonard, and Rembrandt. Facing his mortality, he gave his home and art collection to the public after his death—undoubtedly an act to assuage his cruel reputation. Indeed, it wasn't until many of these wealthy American industrialists were seriously approaching their demise, and in need of laundering their esteem, did they consider donating their treasures to established museums, or even creating new ones like Mellon, who founded America's National Gallery of Art in Washington, DC. It was their way of masking their sins with the whole cloth of art. And in 1913, when the US tax code permitted giving away a portion of their wealth as an economic benefit, it was yet another opportunity

to take advantage. Much has been written about the plunder of art from Old World Europe to New World America, and the characters with larger-than-life egos who lived in their rarified worlds surrounded by magnificent Old Master works of art. Certainly, donating their treasures to museums was an act to cleanse their consciences, but on the other hand, America has greatly benefited from their largess. All of our major "big box," or should I say, "marble box" museums—New York's Metropolitan, Boston's Museum of Fine Arts, Chicago's Art Institute, Cleveland's Museum of Art, the list goes on—are the beneficiaries of, in the current language of the day, "the one percent." And the tradition continues today. Multibillionaire Alice Walton, daughter of Sam Walton, founder of Walmart, recently opened her art museum, Crystal Bridges, in rural Arkansas. Her excessive wealth has enabled her to collect major pieces of American art with abandon to fill her museum. In some respects, like Frick, she, too, recognizes the need to rehabilitate the family's reputation for continuing to destroy the economy and vitality of so many small American towns with their one-stop shopping warehouses of cheap merchandise, paying their employees substandard wages, and fighting unionization with a passion—good old American capitalism at its finest.

As noted, serious collectors must be among the very wealthy to successfully reel in great art. From the early twentieth century until now, values for recognized masterpieces have grown astronomically. Today an Impressionist painting can fetch twenty to one hundred million dollars easily. However, there are a few rare, enlightened individuals who collect objects in categories that have not yet been claimed as serious art, and they have amassed distinguished collections with modest financial investments, only to eventually reap the reward when the market caught up with their discoveries.

While we have established that determined art collecting is the avocation of the very rich, there are collectors who have amassed quite wonderful things with much less wealth. Among them, Louis and Charlotte Hyde are prime examples. Without doubt, the family paper mill provided them and their family a comfortable lifestyle, but they can't be classified as being in the realm of the noted robber barons. They traveled widely, both nationally and internationally and they shared with the family an apartment in East Side, New York City, as well as a cottage on the shores of Lake George near Glens Falls. But they were not excessively wealthy, and in addition, they were very much philanthropic throughout their lives, supporting many efforts to enhance the architectural and cultural heritage of Glens Falls. The small New York apartment afforded them a landing in which to roam art galleries, acquiring knowledge about the world of art and making occasional, carefully selected purchases. Often Charlotte would spend long spans of time in the City, enjoying its cultural advantages, while Louis divided his time between New York and Glens Falls attending to business.

After the Hydes' initial European forays to acquire period furnishings for their new home, they began to take on the quest for works of art. They were incredibly private people and left few records. Nevertheless, we know that one of their earliest purchases was a small Degas drawing of a dancer tying her scarf. It was acquired in Paris in 1918 from an auction of the artist's works that had remained in his studio after his death the previous year. In 1919, they purchased two large French antique tapestries from the New York gallery French and Company, which they installed at either end of the Hyde House second-floor picture gallery. These date around 1500 and depict the triumphs of love and faith. In the first half of the twentieth century, antique tapestries were highly valued, comparable in some instances to the value of Old Master paintings; however, no records exist as to what the Hydes paid for them.

While no doubt attempting to somewhat emulate Isabella Stewart Gardner, they must have been rather taken aback at the cutthroat world of the art market. It's a rarefied milieu in which gallery dealers can be seriously overzealous in their attributions of works of art. There aren't many absolutes in this market; unsigned and even signed works of art can look correct, but the possibility of fakery and misattribution is rampant. In the early 1920s, the Hydes made several favorable purchases, including the small oil painting *Paolo and Francesca* by the eighteenth-century French artist Jean-Auguste Ingres. However, by 1924, they had enlisted the aid of Isabella Gardner's advisor, Bernard Berenson, to assist them in purchasing their first significant Old Master work of art, Sandro Botticelli's *Annunciation*. It's a diminutive (7 x 10 inches) tempera painting on a wooden panel, assumed to be a predella, a smaller painting assembled into a large altarpiece. Even though it was somewhat frayed on its surface, Berenson wrote about it thusly in the June 1924 edition of the magazine *Art In America*: "'Mere size is something' says Browning, and I never felt the significance of this unexpected declaration as much as I did in the presence of a tiny oblong panel belonging to Mr. Louis Hyde of Glens Falls, New York for it lacks nothing that makes a masterpiece except size."[1] This early purchase signifies the seriousness of the Hydes' intent. Nearly all the great American art collectors began their quest by purchasing second-rate paintings and/or sentimental French Academic canvases. Collectors like Henry Clay Frick spent untold amounts of capital accumulating paintings of little or no artistic merit. It wasn't until years into his pursuit of art that he began to seek out notable Old Masters. On the other hand, the Hydes, stimulated by what they witnessed in Boston, started their collecting pursuit on a much more enlightened basis. They were determined to bring to their remote Glens Falls abode works of art by well-known artists. Berenson's quote relating to size is telling, however, in what the Hydes could afford; with their limited funds, they could only manage the purchase of smaller works of

art. As they continued to assemble their wonderful collection, they acquired numerous unfinished oil sketches, drawings, and many paintings of male subjects—the market has always favored paintings of women or children, which almost always fetch much higher values than those of males.

In those early years, they were purchasing two or three works of art annually, mostly on their own, and not only were they buying European Old Master paintings, but they were also acquiring works by leading American artists such as Thomas Eakins, Abbott Thayer, James McNeill Whistler, and Winslow Homer. History has proven that their judgment and cautious research paid off, for they accumulated several notable treasures. Proof of their seriousness is their personal library, which contained several books related to the history of art, as well as exhibition publications and sales catalogs. I consider them scholarly art collectors who had to make art purchases wisely, as opposed to serendipitous wealthy collectors who could afford to take chances and eventually dispose of their mistakes.

After their success at landing a Botticelli with the aid of an art expert, in the early 1930s the Hydes again sought the services of a professional. In order to give weight to their growing collection, they very much desired to possess a Rembrandt painting—owning a work by the revered Dutch master was the ultimate expression of distinguished art collectors. They had previously acquired a small Rembrandt etching of his mother and an exquisite pen-and-ink drawing by him of two robed Old Testament gentlemen shaking hands. Through a mutual friend, they became acquainted with the noted German art historian Wilhelm Reinhold Valentiner, who at the time was director of the Detroit Museum of Art. Valentiner was a published scholar on Rembrandt and therefore it seemed fitting to the Hydes that they turn to him to assist in locating a painting by the renowned Dutch painter. In 1931, Valentiner traveled to Glens Falls to meet them and stayed with them for a brief time. He later wrote, "It will always be a charming remembrance. I enjoyed so much the quiet and artistic atmosphere in your beautiful home, your lovely garden and the fascinating visit to the paper mill." One can only assume that the Hydes were hoping Valentiner would be able to find a Rembrandt that was not already in the marketplace. Being that the artist's work was in high demand, and gallery owners were legend in their astronomical prices, they were no doubt looking for one that they could well afford and one that would be authenticated by a noted world authority. Two years later, the Hydes proudly hung their most prestigious new acquisition, Rembrandt's *Christ with Arms Folded*, in their handsome, book-filled library. The painting is related to a series of religious portraits undertaken by Rembrandt toward the end of his career. It depicts a pointedly ethnic Jewish countenance of a somber Christ in a three-quarter length portrait with his crossed hands on his chest. His face and hands glow in a spiritual luminosity that is swallowed in Rembrandt's

emblematic mystical darkness. Through Valentiner's contacts, he discovered the magnificent painting in Russia. At the time the Soviets were commencing a grand scheme of selling off confiscated works of fine and decorative arts seized from palaces of the imperial family and of Russian aristocrats as well as liturgical objects from Orthodox churches—all considered by the Soviets as decadent baubles. Stalin's goal was to raise hard currency for his grand industrialization schemes. The Hyde's Rembrandt painting has a fascinating provenance. In Russia it was owned by Count Alexander Orloff-Davidoff in St Petersburg. After it was confiscated by the Soviets it was exhibited at the Pushkin Museum in Moscow where it was cut out of its frame by thieves but luckily returned at some point. The earliest recorded owner of the painting was Napoleon's minister to Rome, Cardinal Joseph Fesch. Both Fesch and Davidoff were distinguished art collectors, which contributes to the painting's importance and value.

Acquiring a Rembrandt at the height of the Great Depression was no easy accomplishment for the Hydes. But conversely, because of the financial distress of the times, it might have been their only opportunity, due to a diminished competition from the art market. Louis received a letter from Valentiner on April 5, 1933, informing him of the newly discovered Rembrandt, which was followed a few days later by a photograph. The sale was being handled for the Soviets by Lilienfeld Galleries in Berlin—its price was $43,000. The Hydes initially dismissed the possibility of purchasing the painting because of its staggering price, but eventually they decided that they must at least go and view it. On June 25, they were on the S.S. *Bremen*, sailing for Germany. Once in Berlin, they were taken straightaway to see it. Mrs. Hyde recalled that even in its tattered condition, she thought it was absolutely beautiful. Later that day, the Hydes engaged in some serious negotiations with the Lilienfeld Gallery representative, in which Louis made a final offer below the asking price. The Russians stuck to their guns, and the Hydes went off to the celebrated Carlsbad spa for three weeks, assuming all was lost. A couple of weeks later, while still at the spa, Louis received a letter from Valentiner informing him that he had succeeded in getting the Russians to reduce the price to $33,400 (equivalent to over $400,000 today). The deal was struck, and in late August 1933, the Hydes received their treasured Rembrandt in Glens Falls.

I believe for Louis and Charlotte Hyde, this was the defining moment when they crossed the dividing line from amateurs to serious art collectors. By 1933, they had accumulated some thirty noteworthy works of art, but their new Rembrandt placed them in the international realm of historical collectors. This was fortunate timing for the upstate New York couple, and no doubt, they must have spent many happy evenings in their library basking in the radiant glow of their newest acquisition.

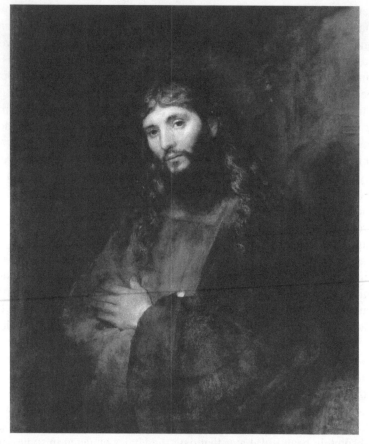

Rembrandt van Rijn (Dutch, 1606–1669), *Christ with Arms Folded*, ca. 1657–1661, oil on canvas, 43 x 35 1/2 in.
The Hyde Collection, Glens Falls, New York, The Hyde Collection Trust, 1971.37, Photograph: McLaughlinphoto.com

Unfortunately, Louis passed away the following year on the 24th of September. The Hydes had been married for thirty-three years and, in that time, had successfully launched an impressive avocation, and they were well underway toward building their dream. Charlotte, now widowed at age sixty-seven, was suddenly faced with the dilemma of either progressing or concluding their art-collecting avocation. The Hydes were enormously private individuals, and regrettably, we have no insight into their art-collecting philosophy. It is uncertain as to who of the couple was the moving force that ignited their passion. My sense is that this was a mutual pursuit. Louis's exposure to the arts through his Harvard education, including his association with Harvard's noted art history scholar, Charles Eliot Norton, must have contributed a

learned focus to the pair. However, Charlotte appears to have infused the couple with determined eagerness and motivation to acquire art historical knowledge. That seems to be borne out by her almost-immediate return to building their collection after Louis's death. The following year, she acquired the rather somber, heavily impastoed small painting *Stag in the Forest of Arden*, by the American artist Albert Pinkham Ryder—perhaps an expression of the painful loss of her husband.

For the next couple of years, she acquired only a few works of art, and undoubtedly, without her devoted partner, the process must have been less exhilarating. During that time, she purchased an out-and-out forgery—a small oil on canvas painting purporting to have been created by Jan Vermeer. Titled *Girl with a Blue Bow*, it depicts a young lady with pear-shaped pearl earrings looking directly out at the viewer with the hint of a possible breaking smile. One could understand Charlotte's desire to own a Vermeer; like a Rembrandt, works by these artists were symbols of a sophisticated collection. The painting appeared in the British art market in the mid-1930s with a claim that it had been hanging in a family collection for generations. There were questions regarding its authenticity by some scholars, while others were quite comfortable in assigning it to Vermeer. Nevertheless, Charlotte took a chance and purchased it in 1937 from New York's Schaffer Galleries. Most likely she was bolstered by an enthusiastic article in the prestigious art publication the *Burlington Magazine* two years earlier, claiming it to be absolutely genuine. By the late 1940s, however, it was pretty much determined to be a forgery, and as the years passed, with more in-depth investigations by art historians and conservators, there were indications that it might well have been painted by the infamous mid-twentieth-century forger of Vermeer, Han van Meegeren. And, indeed, it has since been officially confirmed as being created by the legendary faker of Vermeers. One of the scholars who approved of Vermeer's attribution was Wilhelm Valentiner, who had discovered and authenticated the Hydes' recently acquired Rembrandt. How could she go wrong? And while still in the throes of the Depression, Charlotte, now without the cautionary advice of her late husband, was able to cobble together the asking price of $50,000. It was possibly the most money the Hydes had ever spent on a single work of art.

Whether it was the uncertainty of her most recent acquisition, or merely the need for a learned second opinion, in the same year of her Vermeer purchase, Charlotte hired the young art historian Otto Wittmann Jr. to be her curator. He had recently graduated from Harvard, having attended the highly recognized art museum training program taught by Paul J. Sachs—the first such course in America. Hiring a curator was a major step for Charlotte, and perhaps a forecast of her intention to establish a future museum. Among his tasks, in addition to assisting Charlotte in acquiring works of art, was

to conduct research and catalog the collection, and most indicative of what was to come, to introduce it to the local citizens on a limited basis. Having a scholar at her disposal prompted additional opportunities. Before long, Otto was conducting illustrated art history lectures open to the public in her home and curating temporary exhibitions in Crandall Library—Glens Falls's attractive little library designed by the noted New York architect Charles Adams Platt. In fact, it was Glens Falls's enlightened resident Louis Fiske Hyde who was responsible for hiring Platt, as well as attracting Ralph Adams Cram to design their house of worship, the First Presbyterian Church. Charlotte's determination to sponsor temporary art exhibitions in the library reflected her desire to introduce to the local citizenry cultural opportunities found only in much-larger cities. Through her associations with art personalities and gallery directors, Otto Wittmann was able to borrow significant works of European and American art, allowing for some exceptional exhibitions. This was obviously an era when security for such prestigious loans was not taken as seriously as it is today.

With Wittmann at her side, she continued to acquire some major works of art: three sparkling watercolor paintings by Winslow Homer, a dramatic pen-and-ink drawing by Vincent van Gogh titled *Corner of a Field*, and a brilliant oil on canvas titled *Waterfall near Ornans* by Gustave Courbet. In her mind, perhaps the most important painting she acquired with his assistance was the *Portrait of a Young Man*, attributed to Raphael Sanzio and purchased in 1939 from the London dealer Agnew and Sons Ltd., and again with advice from Wilhelm Valentiner. With this purchase, Mrs. Hyde was clearly aiming to strengthen her collection with another distinguished Old Master. At the time, the painting was known as the "Whitney Raphael," because it had been previously owned by William Collins Whitney, secretary of the navy under President Cleveland, and had only recently come back on the market following Whitney's death. What Mrs. Hyde didn't know then was that before it was owned by Whitney, Agnew had attempted to sell it to Isabella Stewart Gardner, who was very much charmed by it. However, when Gardner contacted her advisor, Bernard Berenson, for advice, he pointedly turned her against it, saying that it was not painted by Raphael. She eventually acquired the much-less-attractive portrait of Tommaso Inghirami. Regrettably, today both portraits have questionable attributions.

Mrs. Hyde placed her Raphael painting in the second-floor Picture Gallery above her diminutive Botticelli and near a silver point drawing, or cartoon, for the *Mona Lisa* presumed to have been drawn by Leonardo da Vinci, that she had purchased that same year from the personal collection of an acquaintance, the British art historian and former director of the National Gallery of Ireland, Langton Douglas. She must have been ecstatic having landed works by a triumvirate of Italian Renaissance painters. For young Otto Wittmann, it

surely would have been inspiring to assist Mrs. Hyde in expanding her collection with such notable works of art. However, his Glens Falls experience ended all too soon when he was drafted into the army in 1941, as the Second World War was escalating, leaving Mrs. Hyde alone once again to take on the collecting task by herself. During the War, Wittmann joined the noted team of cultural preservationists, the Monuments Men. He later became director of the prestigious Toledo Museum of Art in Toledo, Ohio.

Charlotte's isolation didn't last long because, after contacting Valentiner at the Detroit Institute of Arts for help in finding a substitute for Wittmann, he recommended a young Harvard graduate by the name of Joseph Jeffers Dodge. Dodge had interviewed for a position at the Arts Institute, but he came in second; he had apparently impressed Valentiner sufficiently to recommend him to Charlotte. She must have been equally impressed with Dodge because, like Wittmann and her beloved late husband, he, too, was a Harvard graduate, even having graduated with honors. Her enthusiasm for him might also have been bolstered by the fact that Dodge had an eyesight defect, making it doubtful he would ever be drafted for military service. He was hired in late 1941. Dodge, fondly called Jerry by his acquaintances, had a much more outgoing personality than his predecessor. Furthermore, he was not only formally schooled in the history of art, but he was also a budding painter. At Harvard, he became captivated with the painting techniques of the Old Masters, which ignited in him a passion for the making of art and eventually in teaching it as well. It must have been a thrilling challenge for him to take on the position of curator for Mrs. Hyde. Her maturing collection was gaining in number, and so many of her works of art were unfinished paintings or studies and drawings, which would have resonated with Dodge's abiding interest in the techniques of Old Masters paintings. One of the first paintings he assisted Charlotte in acquiring was Peter Paul Rubens's *Man in Armor*. The oil on wooden panel is one of many stock oil study portraits undertaken by Rubens that he would later incorporate into large, finished compositions. It was a fitting complement to a Rubens oil study already in the collection titled *Head of a Negro*, which Mrs. Hyde purchased in 1938. Dodge was so taken by this acquisition that he wrote a scholarly article about it, which was published in the 1942 spring edition of The *Art Quarterly*.

Dodge's gregarious persona must have been a palpable contrast to the more reserved Mrs. Hyde. Yet they apparently engendered a considerable comradeship, in that he was enormously influential in assisting Charlotte with her collecting pursuits throughout his long association with her. In his oral history, which was undertaken much later in life, he described her fondly:

> She was kind of a funny woman in a way. She was very short and round. You could say that she was fat and jolly. She had thick glasses and dressed very

plainly in simple black dresses and a cloth coat. Some [art] dealers told me about this rather plainly dressed woman who would appear and look around and ask questions and so forth. Nobody took her seriously for a while until gradually word got around that she was building up quite an art collection.[2]

It was Jerry Dodge who insisted that Charlotte consider acquiring more contemporary works of art to round out her collection. This suggests that she was already determined to create an art museum for Glens Falls, and therefore, he wanted it to be more comprehensive. Dodge was clearly successful in developing in her an appreciation for the contributions Pablo Picasso was making it in the art world, because she purchased three of his works. In 1943, she acquired Picasso's *Boy Holding a Blue Vase*, painted in 1905, at the end of his Rose Period. The following year, she purchased his pen and ink drawing titled *Four Figures*, and her most adventurous acquisition was the early cubist painting *Fan, Salt Box, Mellon*, painted in 1909, which is considered one of his masterpieces—now in the Cleveland Museum of Art. Over the next few years, she acquired more works by early-twentieth-century painters, including two more Degas drawings, a Cézanne watercolor study, Renoir's oil portrait of his son Coco, and the exquisite small oil painting *Banks of the Seine near Courbevoie* by Georges Seurat. These more contemporary purchases did not, however, prevent Charlotte from continuing to fill missing gaps of the Old Masters that would facilitate making the collection a superb teaching tool. With the occasional aid of her scholarly advisor, Wilhelm Valentiner, and her curator, Jerry Dodge, at her side, between the years 1941 and her death in 1963, she landed some wonderful works of art—including paintings, studies, and drawings by Tiepolo, Fragonard, Tintoretto, Hans Bol, Veronese, El Greco, Claude, and Guardi. And she also continued to acquire works by major American painters such as John Frederick Peto and Childe Hassam. As the collection grew, she installed paintings throughout the living spaces of Hyde House. Most of them were small in scale and quite appropriate for the smaller rooms of the house, such as her modest dining room and the guest bedrooms. Dodge often remarked about Charlotte Hyde's keen sense of color, noting that she had a nearly perfect eye when it came to determining color matches. While in a New York gallery, for instance, she would observe that a painting's certain color matched the draperies in her library, and sure enough, when it arrived in Glens Falls, the color match was exact. Dodge later also observed that Mrs. Hyde

> responded to works of art in much the same way she responded to people. She was particularly sympathetic, for example, toward those who expressed themselves best, not verbally, but through eloquent gestures and telling expressions. This, perhaps, is what made her so keenly appreciative in portraiture of the subtlest nuances of expression and gesture, as well as the quality of the gestural

notation with which an artist set down the visage and character of a sitter. Indeed, the vivid presences brought to The Hyde Collection by its portraits are among its most memorable treasures.[3]

Charlotte Hyde's choice of Jerry Dodge could not have been more fortuitous. He settled harmoniously into the greater Glens Falls community, as well as into its small artistic milieu. He and his second wife, Dorothy, were close friends with the noted American contemporary sculptor David Smith and his wife, the artist Dorothy Dehner, who lived a few miles north of Glens Falls above the little town of Bolton Landing on the shores of Lake George. The noted magazine illustrator Douglas Crockwell lived in Glens Falls, and the two became close friends as well. Dodge continued the educational outreach activities initiated by Wittmann, including mounting temporary exhibitions sponsored by Mrs. Hyde at the Crandall Library. He also began teaching drawing and painting in the courtyard of Hyde House, which garnered much appreciation from budding local artists. Dodge was very much a worldly individual with many varied interests, and he did not isolate himself in the small Upstate hamlet. One of his closest Harvard classmates was the Broadway lyricist and librettist Alan Jay Lerner. Jerry traveled to New York often to attend Broadway openings and numerous other musical events—another one of his close friends was big-band leader Duke Ellington. Lore has it that Jerry Dodge was the inspiration for the Gene Kelly character Jerry Mulligan in Lerner's movie-musical *American in Paris*.

In 1952, Charlotte placed a plaque in the outer vestibule of the front entrance to Hyde House claiming, *The Hyde Collection, to the Memory of Samuel Pruyn and Eliza Baldwin Pruyn*. That year, she established The Hyde Collection Trust, and in it are the only words ever written articulating her personal desires for her future museum. In the preface of the trust document, it was noted that her museum was to "promote and cultivate the study and improvement of the fine arts for the education and benefit of the residents of Glens Falls and vicinity and the general public." Charlotte and her husband had assembled a little over a hundred works of art. In addition, their home was furnished exclusively with period Italian Renaissance and French and Italian eighteenth-century antiques. The Hydes were what I call "cerebral collectors," always studious and cautious when adding pieces of art to their collection. They were undeniably little fish swimming cautiously in the rarified "art world pond" and competing with infamously wealthy art-collecting sharks. And because of their limited financial means, they often had to settle for lesser-known pieces. Nonetheless, they assembled a magnificent small collection spanning the history of art from the late Gothic period to the mid-twentieth century. It has been called by some, one of America's greatest small art museums and by others the "mini-Gardner." Yet even to this day,

it is not a well-known institution. Located almost equidistant between New York City and Montreal, along Interstate 87 in the foothills of the Adirondack Mountains, one must be highly motivated to find their way to Glens Falls. Its anonymity may also reflect the personality of the Hydes, who had an aversion to excessive public exposure. Dodge later recalled that Mrs. Hyde was deeply concerned that her collection "might receive what she considered to be undue public attention."[4] Which, indeed, reflects her reserved personality, quite the opposite from Isabella Stewart Gardner.

When establishing museums, art collectors are not only exposing their collection to the public, but they also are revealing their tastes and personalities, and even more concerning, the credibility of their accumulated treasures. It's a "buyers beware" environment in the art market, and the Hydes, like their wealthier art-collecting colleagues, found themselves with a few questionable possessions even though they relied heavily on advice from their professional consultants. In some instances, these revelations are not discovered for years as art historians eventually sort through the maze of art historical complexities and scientific investigative procedures. There are a few works of art in The Hyde Collection that have diminished reputations—they have gone from *by* a specific artist to *attributed to*, or *follower of*, or, in the case of the Vermeer, to an out-and-out forgery. This is the risk of art collecting, and nearly every collector has gotten burnt at one time or another. Wealthy collectors simply rid themselves of their tarnished purchases and seek alternatives. This is not as easy for collectors on a budget. Yet Mrs. Hyde was not completely passive when she learned of some of her failed purchases. In the early 1950s, when she discovered that the National Gallery of Art in Washington, DC, had, through chemical analysis, determined that two of their Vermeers were the product of the faker Han van Meegeren, she ordered an analysis of her painting. When the results were affirmed as being the same, she contacted Hanns Schaffer, the owner of the gallery who had sold her the painting, and demanded the return of her $50,000. Unfortunately, she was informed that the painting had not been owned by Schaffer, but it was in his gallery on consignment, and its European owner had gone underground; she was unsuccessful in retrieving her money.

In managing The Hyde Collection, I was not embarrassed to highlight the few questionable works of art and discuss them within the context of the pitfalls of collecting. However, not all museum directors are comfortable with my vision. Most museums feel it's their business to display only authentic works of art—that is what a museum is all about, the truth. While I concur regarding art displayed in formal encyclopedic museums, within the environment of a collector's home, how better to tell that story and inform novice collectors about the challenge of acquiring Old Master paintings?

Experiencing The Hyde's art collection within its original architectural surroundings is delightful. One can sense the thrill it must have been to gradually

acquire each of the works of art displayed there, as well as how incredible it must have been to be able to live with them, viewing them throughout the day as the sun made its pathway across the sky. But what is even more unique about The Hyde is that it was built just yards above the pulp paper mill that made it all possible. In a perceptive opinion piece in the March 7, 2014, *Boston Globe*, titled "Ugly Mills, and the Art They Gave Us," columnist Joan Wickersham observed:

> Part of what makes the Hyde Collection moving is that it is local, and it is small. When you visit a big museum, you think about the paintings, not about how they got there. It may be beautiful, but it's an institution. The Hyde Collection is a house. We walk through the dining room, the library, the bedrooms, marveling not just at the quality of the art, but also at what might seem like the weirdness, the anomaly, of the collection being here, in this large but rather ordinary house [Here I beg to differ.] whose western windows look out at the sprawling paper mill. But why shouldn't it be here? Henry Frick's Museum in New York City is tied to the coke ovens of Pennsylvania, but you'd never know it, strolling through the cool marble halls of the Frick Collection. The proximity of the Hyde Collection and the mill offers a startling, tangible picture of where money comes from and how art museums are made.[5]

No other art collector's personal museum can tell the whole story about its founding. I can remember thinking in those early years of my association with the museum that, wouldn't it be great if the museum were located elsewhere so that one didn't have to smell the acrid, sulfurous odors emitting from the factory below? But as time went on, I began to appreciate the story it told. In finishing her article, Wickersham noted: "As we leave The Hyde Collection, I take another look at the paper mill, its tangle of enormous arms and offshoots splayed against the darkening sky. I still think it's oddly alive. But the creature that looks as if it's going to climb the hill to eat the museum is actually the creature that fed it."

NOTES

1. Bernard Berenson, "An Annunciation by Botticelli," *Art In America*, XII, June 1924, 180.
2. Debra Murphy-Livingston, "Passion & Clarity: The Art of Joseph Jeffers Dodge", The Cummer Museum of Art & Gardens, 2002, 21.
3. Ibid.
4. Noel Suter, "The Surprising Hyde Collection," *Museum Magazine*, September/October 1982, Vol. 3, No. 4, 26.
5. Joan Wickersham, "Ugly Mills, and the Art They Gave Us," *Boston Globe*, March 7, 2014, http://wwwbostonglobe.com/opinion.

Chapter 4

The Transition

In the winter of 1961, Jerry Dodge received a call from a trustee of the Cummer Museum of Art in Jacksonville, Florida, informing him that they were interested in him for the director's position. The Cummer's former director had died, and the board was anxious to find a replacement because they were about to open the museum to the public. Dodge traveled to Florida and was immediately struck by the similarities to Mrs. Hyde's collection. Its founder, Nina May Cummer, and her late husband, Arthur, began amassing Old Master works of art in the early 1900s. Following Arthur's death in 1943, Mrs. Cummer started to more aggressively collect works of art, with plans to create a museum in her home on the banks of the St. John's River. She eventually established a foundation and selected trustees to oversee her museum. Mrs. Cummer died in 1958, and the trustees she chose began a thoughtful process of staffing with professionals and transforming her home to function as a public institution.

While the Cummer's art collection was smaller and less prestigious than Mrs. Hyde's, Jerry Dodge found that it very much resonated with him, again a diverse mix of European Old Master and American paintings. For sure, he must have been challenged by the opportunity to take on a leadership role as museum director in a city that was openly receptive to having a new art museum. And no doubt escaping the brutal Adirondack winters for sunny Florida must have also played into his decision. He enthusiastically accepted the position, left Mrs. Hyde's employ after twenty years of service, moved his family and belongings to Jacksonville, and was able to coordinate a formal opening of the Cummer on November 11, 1962.

Unquestionably during Charlotte Hyde's later years, her collecting activities were beginning to wane. Yet at the age of ninety-five, having just lost her second curator, she knew it would be important to maintain the art educational outreach that had been established. Again, she turned to Harvard and hired the fresh new graduate John K. Howat to assume her established curatorial and educational programs. Five months into his new position, Charlotte

Pruyn Hyde quietly passed away in her Glens Falls home, on August 28, 1963. The local newspaper, the *Post-Star*, noted of her passing that her art collection was "the finest of its kind outside New York City and Buffalo." And that she "was a patron of music also, and a generous contributor to many other phases of the cultural life of the community. Her quiet philanthropy was known to few except those directly concerned."[1] In retrospect, it is fascinating to contrast the two nascent institutions, The Hyde and Dodge's new institution, the Cummer Gallery. The well-being of any nonprofit institution lies in the dynamism of its trustees, the foresight of its founding documents, a substantial endowment, and the receptiveness of its community. In the 1960s, the population of the greater Glens Falls region was approximately 18,500, people in contrast to Jacksonville's slightly over 200,000. One can assume that the populace of rural Glens Falls was much less enthused about a new art museum than the northern Florida city on the banks of the St. John's River. As a museum professional, Jerry Dodge made the wise decision to seek a museum with a larger audience, even though its collection was not nearly as strong and as well rounded as that of The Hyde.

For young John Howat, fresh out of school, his challenge was enormous. While Charlotte Hyde had for several years established a respectable range of educational activities related to her growing art collection, which should have laid the foundation for an active art museum following her death, she apparently had not sufficiently schooled the trustees she'd selected, who, after her death, abruptly found themselves in charge of a new museum. When, in 1952, Charlotte created The Hyde Collection Trust, she had established a rather meager endowment. For the twelve members of her board of trustees, to oversee her future museum and its endowment, she had selected family members, good friends, and local businessmen—all well-intentioned individuals, but somewhat lacking in enthusiasm and sophistication when it came to operating a serious art museum. And, in her mind, to ensure long-term stability for her museum, Charlotte made them lifetime members, which stymied the possibility for bringing new, more urbane individuals into the trustee fold. Three months after Mrs. Hyde's death, the doors of her home were officially opened to the citizens of Glens Falls. Records are scant about the first few years of The Hyde's public persona, but suffice it to say, it began its institutional journey in a rather rocky fashion. Howat was the single paid staff member, but being professionally trained, he maintained high standards with the expectation he would have the backing of the board. He was under a false assumption that they were prepared to take their responsibilities more seriously. During the short time he remained in his position as director/curator, he was successful only in establishing the Volunteer Council to assist him in opening the museum on a regular basis. His second accomplishment was to retrofit the Hyde's former unattached two-car garage, located within

an enclosed courtyard off the mansion's kitchen, into a makeshift gallery for temporary exhibitions—thereby eliminating the need to rely on the Crandall Library for future exhibits. He was thwarted in his ambitions to formalize the museum at any higher level of operation and resigned in frustration. At his last board meeting, he submitted into the minutes a document strongly recommending to the trustees that they establish a direction for the institution, suggesting that the initial collection was only the basis for an outstanding art museum, that it needed growth, professional staffing, curatorial interpretation, and educational programming.

Howat left in 1964, and his document was wholly ignored. He eventually became the curator of American art at New York's Metropolitan Museum of Art. Unconcerned with Mrs. Hyde's insistence that her curators be Harvard-educated professionals, the trustees chose its own chairman, the commercial magazine illustrator Douglass Crockwell, to be Howat's replacement. Crockwell, titled acting director, carried on with the nascent programming set out by Howat and curated a few exhibitions that were mostly related to his interest in commercial art. The board did allow him to hire a curator on a part-time basis, James K. Kettlewell, an art historian and full-time professor at nearby Skidmore College. In 1968, Doug Crockwell died, and for three years The Hyde was under the stormy direction of a dictatorial quasi–family member by the name of John Cunningham who had some uncertain connection to the New York art gallery world. He coerced the board, because of a serious need for roof repairs and to infuse the museum's flagging endowment, into selling two of Mrs. Hyde's most important paintings. Without any formal deaccessioning proceedings, or even a single discussion with the part-time curator, James Kettlewell, the board selected Picasso's 1909 cubist painting, *Fan, Saltbox, Mellon*, and an early painting by the French cubist painter Georges Braque to be sold at auction. The trustees were made to believe, by this questionable character, that Mrs. Hyde didn't really like these paintings, and moreover, that cubism was considered only a passing fad. The paintings sold for nearly a million dollars, but unfortunately, the museum only realized about one-third of the profit. There is much uncertainty about where the remainder of the money landed, but the sale of these significant works of art set off a storm within the Glens Falls small community of art-concerned citizens. Had this happened in more recent times, the trustees would have been in the middle of a national scandal, because today it is considered unethical for a museum to cannibalize parts of its collection for any reason other than to replace the art with superior alternatives. The Association of Art Museum Directors would have blasted the trustees publicly, and no doubt, the museum would have been under investigation by New York state's attorney general. However, the trustees faced no retribution save for some local unpleasant

controversy—the roof was repaired, and the remainder of the money was placed in the endowment.

In 1971, the position of acting director was next filled by another board member, A. Morton Raych, a full-time high school art teacher at a nearby school. For the next few years, Raych and Kettlewell, who had also been elected to the Hyde's board, engaged in the production of some rather ambitious exhibitions in the small garage-gallery. No doubt the most noteworthy exhibit was *David Smith of Bolton Landing* in the summer of 1973. Forty works of art by the noted abstract sculptor were installed within the small gallery and its outdoor courtyard as well as the interior courtyard of Hyde House. This was the third exhibit of Smith's works, the first being in 1964, when David Smith himself assembled a small number of his abstract pieces as the inaugural exhibition for the new garage-gallery. To complete the picture of nepotism, it must be noted that Smith, likewise, was a member of The Hyde's board until his untimely death in 1965.

Because of The Hyde's location in the foothills of the Adirondacks, nine miles south of Lake George and fifteen miles north of Saratoga Springs, most of the heavy visiting traffic occurs during the summer months, when the area is teeming with vacationers. It made good sense, therefore, that The Hyde's annual temporary exhibitions be staged during the summer months. In those years between the museum's inaugural Smith exhibition and the late 1970s, there were some ambitious small exhibitions, generally related to works by artists who are represented in the collection, or by artists of note who had lived in the greater Adirondack region—exhibitions featuring the works of Rembrandt van Rijn, Henry O. Tanner, Elihu Vedder, Rockwell Kent, and Douglass Crockwell. Most of them were funded by grants from the New York State Council for the Arts.

During those years, the small staff of mostly part-time individuals could be counted on one hand. Supporting this skeleton crew was a cadre of approximately one hundred volunteers, primarily local ladies, who were the institutional face to the visiting public. Some volunteers were trained as docents, and others were charged with assisting visitors and functioning as guards. The atmosphere was terribly casual, as guides took visitors around Hyde House with classical music playing in the background from Mrs. Hyde's seventy-eight record collections. There were no labels on the paintings, which gave the docents a great sense of power. They held the keys of knowledge and with pride identified works in the collection, often with the preface, "I bet you don't know who painted this?" In addition to annual small exhibitions, there were art classes, lectures, school tours, and an occasional concert, very much in the tradition that Mrs. Hyde had sponsored during her lifetime. Visitation was limited to five days a week: Tuesdays, Wednesdays, Fridays, Saturdays, and Sundays from 2:00 to 5:00 p.m. In those early years, there were no more

than four to six thousand visitors annually. Generally, it could be said of the place that it was very, very casual and perhaps a bit provincial. But it also must be noted that the dedicated staff and volunteers had a tremendous affection and respect for The Hyde and its founders. To them, it was Glens Falls's most important institution—and they were undeniably spot-on. This was, however, not the general sentiment of the community at large. Rural Glens Falls and its surrounding region are primarily habited by a blue-collar citizenry whose interests principally center on all manner of sports activities, as well as their kids and their churches. Rembrandt, Botticelli and Picasso had little relevance for them, and unfortunately little meaning for most of the leading city fathers. The museum was like a hundred-carat diamond hood ornament stuck on a rusty, beat-up pickup truck. The truck's collective landlord—the community leaders—had little regard for it except that it was acceptable to occasionally promote it in their public relations literature. Funding, signage, and enthusiastic support was nearly nonexistent.

In assessing the museum's early public years and its paucity of visibility, I believe one must look to its founder. The Hydes were extremely private people. Noel Suter, author of one of the first serious magazine articles about the museum, in the September/October 1982 edition of the *Museum Magazine*, wrote thusly of the Hydes' personalities: they "could hardly have been more unlike that of the flamboyant [Isabella Stewart] Gardner. Unassuming to the point of self-effacement, they nurtured the late Victorian proprieties and cared little for the social maelstrom that centered around Jack Gardner's widow."[2] Without a doubt, they were polar opposites of Mrs. Gardner. During the thirty years that Charlotte outlived her husband, she quietly, almost surreptitiously, prepared her future museum for its public launching. While she instructed her curators to present lectures, exhibitions, and art classes on her behalf, they were offered to a small cadre of arts-interested residents of the greater Glens Falls region. To be sure, the Hydes were well-respected members of their community. They were tremendously generous and highly esteemed for their extensive philanthropy, but most likely not always fully appreciated by the general public, who, if they had heard of the Hydes' art-collecting avocation, it would have seemed extraordinarily out of their spheres of comfort. Mirroring the Hydes' extreme modesty were their relatives, many of whom were on the museum's board of trustees and who solely continued to provide financial support because of the museum's paltry endowment. They were some of the most gracious people I have ever known. But because of their timidity, they were excessively sensitive to any overt activities that could possibly elicit a spate of uncertain publicity. For obvious reasons, therefore, non-family board members, to avoid having to open their pocketbooks, deferred to the family trustees for all decision-making. Given these dynamics, it is obvious why this unquestionably important little arts institution floundered in the wilderness

for so many years of its infancy—its remoteness, its low-keyed founders, its financial distress, and its provincial board.

The experiment of operating a new art museum in the wilderness was attempted more recently, as the Walmart heir, Alice Walton, opened her Crystal Bridges Museum of American Art in November of 2011. Located in the remote little town of Bentonville, Arkansas, with a population of thirty-five thousand people, it is far from any major urban area. Fortunately for its future, that is where the comparison to The Hyde Collection ceases. Walton was highly visible over many years, snatching up major works of American art for unbelievable sums of money—no one can compete with the Walmart fortune. She turned to a celebrity architect, the Boston-based Moshe Safdie, to design a spectacular, contemporary-styled museum structure; she hired a first-rate professional staff, endowed her museum with eight hundred million dollars, and launched her new institution with a plethora of publicity. Indeed, Crystal Bridges Museum has not languished in obscurity. David Velasco wrote thusly of it in the March 2012 edition of *Artforum International*, that "there's something crazily quixotic about Alice Walton's ludicrous, shiny and fanciful new museum. It is something Walt Disney might have hallucinated while visiting Isabella Stewart Gardner's ersatz Renaissance palace in Boston."[3] I shudder to think of the horror such a public statement would have caused the family members of The Hyde Collection's board of trustees had such a statement ever depicted their museum during those early years of administering it in Glens Falls.

With all due respect, it must be noted that it is not atypical for nascent art museums to go through rough periods of adjustment as they stumble along in the process of gaining traction as a professionally run institution. Whether they are community art museums or art collector personal museums like The Hyde, unless the founders are sufficiently sophisticated to know the requirements of operating a public museum, as it appears Alice Walton is, things can easily get out of hand, and they become particularly complicated when there is a challenge in funding them. Several personal art museum founders like Mrs. Hyde have had difficulties visualizing what the transition from a private home into a public museum really requires. Issues of security (which looms large in this story), public amenities, and education are rarely taken into consideration. One excellent symbol of Mrs. Hyde's oversight was the single public toilet in the museum—a 1912 wooden-seated crapper (meaning it was made by the Thomas Crapper & Company) greeted visitors. It might have seemed somewhat romantically quaint, but it was not very functional when a busload of out-of-town ladies visited the museum.

NOTES

1. "Mrs. Charlotte P. Hyde Dies at Her Home Here," *Post-Star*, Glens Falls, New York, August 29, 1963, https//www.newspapers.com/article/the-post-star-obituary-for-charlott-pru/75899599.
2. Noel Suter, *Museum Magazine*, September/October 1982, Vol. 3, No. 4, 24.
3. David Velasco, "The Crystal Bridges Museum of Art," *Artforum International*, March 2012, Vol. 50, No. 7, https:www.artforum.com.

Chapter 5
A Career Move

The routine of annual summer exhibitions and occasional educational outreach programs seemed to occupy most of The Hyde Collection's efforts during the 1970s. Funding was in short supply, requiring the small part-time staff to seek state and federal grants generally to support exhibitions and to provide financial assistance for art conservation projects. During Mrs. Hyde's lifetime, little or no conservation was undertaken on her art collection; she was too engaged in assembling it to worry excessively about its physical condition. Refurbishment needed to be done on several works of art, as well as on some of the more important furnishings. Rembrandt's painting of *Christ with Arms Folded*, for instance, was in mediocre condition when the Hydes acquired it. The canvas was showing signs of wear over its entire surface, and in some small areas, the paint had been worn off completely and retouched by a clumsy restorer in the past. In examining it more closely, X-ray films revealed its former brutal history of being crudely slashed out of its frame as though it was being retrofitted for an oval frame. It is to Kettlewell's credit that he insisted upon a program to address the physical condition of The Hyde's works of art. With the aid of a few small grants, and no doubt family member contributions, a plan was established to undertake a moderate conservation program. Various works of art, including the Rembrandt, were sent out to expert East Coast art conservation labs to undergo treatments. These were not done all at once but parceled out over the years.

At some point in the late 1960s or early 1970s, the museum's physical plant was increased in size with an additional building. Mrs. Hyde's youngest sister Nell's home was deeded into the Hyde Trust and immediately became yet another financial burden. Known as Cunningham House, it had various uses during these early years, including space for art classes and rental space for an interesting mix of Glens Falls art-associated vagrants. With the addition of this house, the trust owned approximately five acres of land surrounding the two homes. The once-formal gardens were in tatters, and both stucco structures were beginning to appear worse for the wear. Ivy and Virginia

creeper vines were enveloping both structures, and while they might have looked romantic, the vines were inflicting damage on their crumbling stucco surfaces.

By the mid-1970s, there began to be some slight agitation from a small contingent of arts-savvy residents, including some of the museum's volunteers, that the board was lacking in its oversight of the museum. It started with the angst over the sale of the two cubist paintings, but other problems began to emerge as well. The entire physical plant was beginning to look terribly run-down, some of the programs were less than professional, and the Volunteer Council seemed to have a disproportionate grip on the operations of the place. It was understandable that they would take a lead role given that the staff were mostly part-timers and the board seemed to demonstrate little visible enthusiasm for the museum. Normally it was the volunteers who interacted with the public, and they often received feedback from more savvy museum visitors suggesting that, with a collection of this caliber, it needed to have a more professional and structured operation.

Most likely in reaction to some of this negative feedback, or due to ongoing tensions regarding the sale of the two cubist paintings, or possibly the forlorn look of the place, in early 1978, an ad for a museum director was placed in the American Alliance of Museums' monthly newsletter, the *AVISO*. The board, under the leadership of Dr. Richard Day, a leading regional medical doctor, had finally reached a decision that it was time for new leadership—this time a museum professional. In all fairness, they allowed locals to apply, including the former part-time director, Mort Raych.

At that time in my career, I was the assistant to the director of the Krannert Art Museum at the University of Illinois, Champaign-Urbana. Just a brief note about me: I am a native of Washington state, and I have always had an abiding passion for the visual arts starting when I was just a kid. Following a stint in the navy, I headed for college, earning a bachelor's degree from Portland State University, Portland, Oregon and a master's degree from the George Washington University in Washington, DC. My master's degree was in art history with museology experience—a fairly nascent museum training program at GWU in collaboration with the Smithsonian's National Museum of American Art. My first job, at the age of thirty-four, was as the director of a small history museum in Portsmouth, Virginia. I was hired there with the specific task of establishing a community arts center, which I successfully accomplished, but I was lured away after a year in Portsmouth to the University of Illinois.

By 1978, I was in my third year at the Krannert and had reached the conclusion that it was time for me to move on. The museum's then-director, Muriel B. Christison, and I were not on the best of terms. She was a strong-willed individual; a woman director at a time when American museum leadership

was strongly male-dominated. She no doubt had fought her way through the maze of chauvinism at prior positions, particularly her previous job at the Virginia Museum of Fine Arts. My sense of my status at the Krannert was as a male punching bag—in an obvious psychological need to even the score.

In early 1978, after many long talks with my encouraging wife, it was decided that I should begin the process of applying for a new job. We had purchased our first home and were happily settling down in a vibrant college community. However, my future there seemed uncertain, and a change of venue became obvious. In my haste, I applied to almost every museum position listed in *AVISO*, and for many of them, I was sorely unqualified, having only four years of actual museum work experience. Consequently, there were several rejection letters nicely phrased to lessen the blow; still, I had some promising interviews, including for director jobs for the Knoxville Museum of Art and the Swope Art Museum in Terre Haute, Indiana. In the second or third round of application letters was an appeal to the search committee for the director position of The Hyde Collection in Glens Falls, New York.

Sometime in the spring of 1978, I found myself in upstate New York's quaint Hudson River town of Glens Falls, driving down Warren Street, passing small, boarded-up businesses and dilapidated Victorian manses, past the stone-crenellated old Armory structure, until on the right, I spotted the blocky Italian Renaissance–styled stucco structure topped with a balustrade. It was nearly covered in ivy vines and partially hidden by giant sweet gum and silver maple trees. There was a semicircular drive in front of the structure and a dilapidated iron fence facing Warren Street with a tiny two-by-two-foot sign partially hidden in foliage announcing *The Hyde Collection (art museum) 161 Warren Street*. I remember thinking at the time that it reminded me of an old, downtrodden, homeless woman with sagging stockings—a sad, forlorn institution that desperately needed love and attention. It was a stark contrast from the Krannert Art Museum, from whence I had just come, which was a state-of-the-art, contemporary-designed museum facility under the supervisory care of a proud university.

I was met at the tattered mansion's intimidating front door by the three-trustee search committee: Katy Birdsall, Andy Biondolillo, and Henry Musser (all non-family members)—the museum was not open to the public. From the small dark foyer, I could see the glaring brightness of the open sunlit courtyard, which was forested with tropical dracaena and philodendron plants growing up to the ceiling in a jungle-like tangle. I could hear the melodic splashing of the Italian Renaissance fountain on the left, summoning an exotic atmosphere that I was fully unprepared to experience. It was like a very small version of the Gardner Museum in Boston. The committee members were delightfully welcoming, each more friendly than the other. These were small-town people who seemed to have great pride in their museum,

tempered with a sincere concern for its condition and a visible desire to make it better. They slowly toured me through the Hyde House living spaces, each filled with fabulous works of art—some quite recognizable and others leaving doubts in my mind as to their authenticity. This was a museum I had never heard of before, and the preliminary research before my visit, in those pre-Google days, gave me only a scant sense of the place and its collection. There were no doubts about the Winslow Homer watercolors and the Thomas Eakins paintings, but a few of the European Old Masters, including some of the Renaissance painters, left me skeptical—they appeared genuine, but I'd never seen them before, and I pondered how they could possibly be authentic in this remote part of the world.

After about a forty-five-minute tour, Katy and Andy departed, leaving me to have a serious discussion with Henry. A friendly and gregarious individual, he was head of the Adirondack Community College Art Department and current acting director of The Hyde as well as one of its trustees. Henry pulled no punches and was brutally honest in describing the museum's failures and challenges, as well as its potentials. It was clear he was anxiously hopeful that the director's search would soon be successful so he could get on with his life. He gave me a brief history of the various former and current personalities affiliated with The Hyde, noting with some hesitation the sparse amateur staff. We must have talked for a couple of hours before I departed for Urbana-Champaign. The trip home on the plane gave me optimal time to pore over the various small Hyde-exhibition pamphlets Henry had given me and to ponder seriously the possibility of taking on such a challenge.

Back in Illinois, I remember having many ambivalent thoughts about what it would be like to live and work in remote Upstate New York. In chatting about The Hyde with my colleagues at the University, most of the responses did not bode well: "Glens Falls—where's that? Oh, you mean Watkins Glen, or are you talking about Hyde Park—I've never heard of The Hyde Collection, where's Glens Falls?" That seemed to be the universal response. Then, in late July, I received a call at work from Dr. Day, president of The Hyde's board, enthusiastically announcing that the search committee had selected me for the director's position. I thanked him graciously and said that I needed to ponder this exciting offer carefully and discuss it with my wife, and that I would get back to him with a decision in a few days.

Becky and I spent many long conversations analyzing the pros and cons of a move of this magnitude. She was well aware of my dissatisfaction at the Krannert. My relationship with Muriel Christison had been slowly deteriorating, and the future didn't look promising. But what would it be like living in the foothills of the Adirondack Mountains? While we were living in a rural situation in Illinois, at least it was in an energetic college town; would we find the same stimulating environment in rural New York? There was lots of

give-and-take, but bless her, she agreed that I needed a change, and she was willing to take the risk. How lucky I was then, and have been throughout my museum career, to have such a wonderful loving and supporting wife. Admittedly, Becky, a registered nurse, was not too happy with her hospital job in Champaign, which, no doubt, flavored her supportive stance.

The next few weeks were filled with contract signing, a resignation, real estate negotiations, and a car trip to Glens Falls with Becky to search for a new home. We arrived there in the heat of the tourist season. The Hyde put us up at Glens Falls's Queensbury Hotel (which will play an important role as this story unfolds), and we immediately found a realtor to assist us in our search. After viewing a few not-so-exciting houses, we happily discovered our dream house on beautiful tree-lined Coolidge Avenue. It was probably a Sears and Roebucks kit house, built most likely in the nineteen teens, which had been recently modernized. The two-story, slate-roofed house with a large front porch seemed to beckon to us. It imparted an instantaneous relaxed, homey impression, yet it was formal enough for entertaining. An offer was made, and we succeeded in purchasing the house. After a day or two spent driving around the region to acquaint ourselves with the rugged, yet spectacular lower Adirondack region and Lake George, we drove back to Illinois to tie up loose ends for the big relocation. Our little house in Champaign sold within a month of being listed, and before long, the Bekins truck was backed in the driveway devouring our few belongings.

I started my new job at The Hyde on September 1, 1978. A possible omen that was to portend the rocky road ahead was good old Ed Sass, the Bekins driver, who was delayed several days in arriving at our house on Coolidge Avenue. When he opened his partially filled truck, our belongings, broken from their mooring straps—many of them damaged—were scattered throughout the van, and, worse for me, he had lost the wardrobe box containing all of my formal clothes. I was dressed rather casually during those first few weeks on the job until my wardrobe finally arrived.

The contrast could not have been greater. Coming from the totally professional Krannert Art Museum, accredited by the American Alliance of Museums, with all the required policies and procedures proudly in place, The Hyde reeked of amateurism. The skeleton staff, well intentioned as they were, were "playing museum." These were rural community folks who were given positions of responsibility far beyond their means. A perfect example of their naiveté was the museum's brochure, which, while it mentioned a few noted artists in the collection, had as its primary message that the museum was fully air-conditioned—to attract the Adirondack region's sweaty summer tourists. The tiny staff whom I adopted included Muriel Eichler, the only full-time person besides me, who was the secretary/bookkeeper/volunteer manager. Her daughter-in-law, Fran Eichler, was the part-time so-called associate curator

because of her love of antiques. There was a janitor–cum–fixit man, Earl Marcellus, a sweet, innocent gent who was not too energetic. The only professional attached to the museum when I arrived was the very part-time curator of the collection, James Kettlewell. As noted earlier, Jim was a professor of art history at Skidmore College in Saratoga Springs, where he lived. He was Harvard-educated with a master's degree in art history, and, like Mrs. Hyde's first curator, Otto Wittmann Jr., a student of the noted Harvard Museum training class conducted by Paul Sachs. Jim could best be described as a befuddled, forgetful professor-type who considered himself a distinguished expert on the entire history of art. But I must say, even though he was rarely present at the museum—he had no regular hours—Jim was well intentioned and incredibly dedicated to the art collection. The other dedicated body of individuals was the nearly one hundred volunteers known as the Volunteer Council. There were always five or six of them on-duty when the museum opened to the public, and they performed the duties of greeters, docents, shop sales ladies, and guards. Yes, guards. The museum had no formal security staff and simply relied on volunteers, mostly ladies, to protect the collection—a museum with an Old Master art collection worth countless millions. After hours, the building was under electronic surveillance provided by the local security agent, Mahoney Notifier, located about four blocks from the museum.

Despite the obvious challenges ahead of me, I was ecstatic about The Hyde's magnificent art collection installed so harmoniously within the Italian Renaissance–styled architectural surroundings and the time-worn antique furnishings. While I initially had some doubts about the collection, Kettlewell set me straight on its importance. When I found myself facing some adversity—which happened quite often—spending time alone with the Old Masters in that beautiful and somewhat tattered surrounding was an incredible elixir.

I stepped into this position knowing full well the museum's operational inadequacies, but the real impact took a while for me to grasp. I spent the first two months gathering facts, meeting with board members and civic leaders, and cautiously making operational changes to better comply with standard museum procedures. In retrospect, I was probably much too cocky in my zeal to correct mistakes. I'm sure I stepped on many toes while trying to right the ship, which I was convinced was taking on water and gravely listing like the *Titanic*. While I had met with the executive board committee earlier, my first full-board meeting wasn't until November 1978. In full "overconfident" mode, I announced during the director's report that, "We have only two alternatives: either seal the operation and create a mausoleum to Mrs. Hyde or allow it to operate as a professional public museum; if I am to stay, we must choose the latter!" I can only imagine what went through the minds of the more-staid members of the board, especially some of the family members.

I guess it was my former Catholic upbringing that shaped my overt candid appraisal of the situation, but perhaps it was necessary for these gentle people to be shocked into realizing that the place was under new management. At least I wasn't fired after the meeting.

At the beginning of my leadership of The Hyde, the museum's endowment was hovering around one million dollars (equivalent to almost five million today). It was being managed by a local bank whose president was a member of the board. The finance committee, which the bank president led, was drawing off 5 percent of the endowment as the basis of the museum's budget, which was combined with some meager local and grant financial support. My first year, I overspent the budget of $91,946 by $11,000, and the following year there was a $22,000 deficit in my endeavor to bring order out of chaos and embark on assembling the necessary operational systems. There was no office equipment save for a couple of old, beaten-up typewriters and a derelict adding machine. Accumulations of business and collection records were scattered all over the place, as there was no organized filing system. No one had ever tallied the annual attendance; it seemed like every step I took, there were more questions than answers. And then there was the physical plant, which seemed to be crumbling around me. Not only did the exterior of the buildings appear sadly worn, but the interiors were equally in need of cleaning, painting, and reorganization. I was appalled at the lack of attention to safety and security in Hyde House, related to both the public and the art collection. Often, I made decisions that I felt were common sense and mandatory without seeking board approval. One particular incident comes to mind. After experiencing several public functions in the museum where large groups of people were assembled—for concerts, lectures, holiday parties, or exhibition openings—I became concerned that there could be serious repercussions should there be some type of emergency. It seemed only appropriate to invite representatives of the police and fire departments to help me assess the challenges. Well, this led to some serious code violations, which required immediate attention or a whopping fine. We had to install lighted exit signs, take chains off exterior French doors for emergency exits, and, most costly, repair and revamp the imposing front entrance—the doors had to be made to swing outward. These unbudgeted expenses were not well accepted by several members of the board. One of Mrs. Hyde's nephews and board member, Sam Hoopes, noted in a letter to the board president related to my job evaluation, "Regardless of his motives I feel that Fred was way out of line doing this [inviting the fire and police personnel to the museum]. As much as we need him, I don't think that we can afford his 'end justifies the means' attitude."

I was constantly hampered by a lack of cash in my zeal to do what was necessary to operate a more professional museum. It seemed like it was nearly impossible to forge ahead when the checkbook was always at zero. During

my second year, I became more than frustrated over the fact that we desperately needed a Xerox machine. Grant applications in particular required copious copies of supporting material to adequately justify financial needs. I was constantly jumping in the car and driving across town to a trustee's business office to use their copy machines. There I would stand in line and wait my turn, often getting chilling looks from secretarial staffs. After I finally reached the breaking point, the staff and I decided to undertake a garage sale to earn the necessary funds for a copy machine. I'm embarrassed to this day for insisting that we rummage the basements and attics of Hyde and Cunningham Houses for non-collection objects to sell. There were old chairs, crockery, rugs, and loads of needlework found in a trunk in the Cunningham House attic. Objects that probably should have been evaluated for possible accession into the collection were sadly lost forever. Needless to say, with the cachet of the museum, the crowds came, and we earned enough money to purchase our first Xerox machine. The pure stupidity of a very frustrated new director.

A project that was launched well before my tenure was preliminary research for a catalog of the collection. At this juncture in the museum's history, there wasn't a definitive publication describing the collection or its founders. Kettlewell had been contacting various art experts to glean more knowledge on specific works of art in the museum. Research had been dragging on with little or no direction when I arrived on the scene, and Kettlewell was hard to pin down due to his full-time teaching schedule at Skidmore, as well as his characteristic muddled predisposition. He obviously knew a great deal about the collection, gleaned over the years he was affiliated with the museum, though much of it was held in his head. There were some curatorial files in the museum, but unfortunately, they were very incomplete. Critical information about many of the works of art that should have been available just didn't exist. It was terribly confusing for me as the new guy in charge, particularly in my endeavors at teaching docents, giving VIP tours, or talking to members of the press. I was obviously at an enormous disadvantage when communicating to others about The Hyde's remarkable collection, and it was downright embarrassing when attempting to respond to queries from colleagues in the field. Almost every time I seriously needed specific scholarly information, the files were inadequate or nonexistent and Kettlewell was unavailable in Saratoga. By late 1979, I was putting pressure on him to take the catalog project more seriously, as I wanted to seek funding for this initiative from various granting agencies. The bulk of the work would be on his shoulders since part-time Fran Eichler was not a professionally trained museum person and was certainly not capable of undertaking serious scholarly research.

As I was reaching my one-year anniversary, I had a pretty good grasp of the institution and its exigent weaknesses as well as its important strengths. In

September, the board requested a self-evaluation of my work to date. Using the American Alliance of Museums' (AAM) formal definition of a *museum* as an evaluative platform, I described my accomplishments and failures in eight pages, ending with my priorities for the year ahead. There were six goals, including securing grant funding for the catalog publication, hiring an additional professional staff member, working toward AAM accreditation, and seeking increased community financial support. My self-evaluation was curt and to the point and not well accepted by several board members. One wrote the board chair suggesting, "He's not very diplomatic about— 'it's got to be my way' or, 'I know best' attitude. Maybe that's good for us, we were definitely in pretty bad shape." That was one of the kinder responses. While I knew my diplomacy was in short supply, I felt I was up to my neck in alligator-infested waters in managing what seemed to be a sinking ship, and I was astounded at the pervasive complacency of the board. They obviously knew the institution was in a serious condition, that was why they hired me, but their and my time frames were at odds. Undoubtedly, much of their anxiety pertained to the museum's financial status and more likely, their fear of having to make larger personal contributions.

A small membership program was already in place when I started my employment, but there was very little additional financial support from the community. Family board members were reluctant, or perhaps embarrassed, to admit that the museum had financial challenges for fear that it would reflect on the Hydes. It took some strong convincing from me and a few non-family trustees to help them appreciate that increased public support was critical for the community to personally embrace the museum. Gradually they relented, and I was allowed to become more vocal. I wrote editorials in the local paper, I went before the City Council, and we became much more aggressive with the membership program. Between 1977 and 1980, local financial support of the museum grew from 11.4 percent to 32.0 percent.

Little by little, the board began to accept my resolute management style as accomplishments became more visible. They approved the 1980 budget, which included an additional full-time professional staff member. The early part of the year was extraordinarily busy. Installing temporary exhibitions, shepherding Kettlewell's catalog project, meeting with dignitaries, writing grants, and maintaining the wide-ranging museum operations kept me running. My work schedule was a twelve-day stretch with two days off, punctuated by many evening meetings and events. No board member could ever question my dedication. In the early fall, I hired Cecilia Esposito, a new master's graduate from Syracuse University's museum training program. Her title was assistant to the director. Ceil was a godsend; she understood what needed to be done with little direction. It was exhilarating to have a professional colleague on staff to take some of the pressure off me and to assist in the growing

list of projects, from preparatory work for temporary exhibitions to reorganizing files and records. She was a competent multitasker, taking on the duties of a museum registrar, exhibits preparator, and numerous additional operational functions. Good-natured and always willing to concentrate on yet another project, Ceil made an enormous difference in the working atmosphere of the museum, which led to an increasing number of professional accomplishments. She had a great sense of humor that helped to lighten my mood as well as my conviction that what we were achieving was absolutely necessary to elevate The Hyde to its fitting professional position.

Chapter 6

Young Mr. Vanderbilt

It appeared to me during the twelve years I directed The Hyde that Glens Falls was the rather sad, blue-collar stepchild of the lower Adirondack region. Nine miles to its north is the honky-tonk glitz of Lake George Village, with the Great Escape amusement park and a plethora of tourist traps and family-style motels to absorb the tribes of New Jersey and Brooklyn tourists who swarm into the region during the hot summer months. Fifteen miles to its south is the classy small town of Saratoga Springs, known historically as a watering hole for the rich and famous, beginning in the 1880s. It is the home of the famed mineral springs and spas, with their elegant grand hotels, various now-defunct casinos with their slippery underworld celebrities, the Saratoga Race Course, and of more recent fame, the Saratoga Performing Arts Center (SPAC), summer home of the Philadelphia Orchestra and the New York City Ballet. Throughout the summer, Saratoga is lively quarters to a moving feast of lofty social and cultural activities and major fundraising events. Star of the show was Marylou Whitney, with her socialite entourage making constant headlines in the local papers and the *New York Times*, hosting highly visible fundraisers for various Saratoga and New York City cultural organizations.

Poor Glens Falls and the surrounding little burgs of Queensbury, South Glens Falls, and Hudson Falls—they sat on the sidelines while their big sisters danced. Fortunately, some of the local businesses and motels attracted spillover crowds during Saratoga's high racing season and for sundry Lake George activities. Culturally the region just couldn't compete. Two of Glens Falls wealthy ladies—Polly Beeman, Mrs. Hyde's niece, and Helen Froehlich—with the additional support of a few local citizens and business, funded the Lake George Opera Festival. It was staged at the Queensbury High School Auditorium and was really quite accomplished, but in an unfortunate pedestrian setting. It started in 1962 as a small venture at the Diamond Point Theater on the shores of Lake George, and it eventually grew with local financial backing—in an attempt to add to the region's cultural diversity and clearly to compete with Saratoga. And then there was The Hyde Collection,

an absolute cultural gem of the highest caliber, lost in the wilderness of Glens Falls. Even though the museum had sponsored some rather ambitious temporary summer exhibitions, there was never sufficient funding for advertising and promotion. Additionally, and most significantly, it was under the leadership of an extremely entrenched board of trustees of local citizens who wouldn't for a minute contemplate the possibility of adding outsiders to their comfortable inner circle. Having distinguished personalities from Saratoga, Albany, or even New York City on the board could open important doors for the museum, but that wasn't a subject I could ever entertain with the board leadership. To make things worse, the local chamber of commerce and tourist bureaus were lukewarm when it came to promoting the museum or any of its regional cultural attributes. I can remember moaning to my local colleagues of having a bad case of "Saratoga envy." What a contrast it was to drive down the busy streets of Saratoga or even Lake George Village, teeming with tourists in the summer months, and then come back to staid Glens Falls with its downtown sprinkled with vacant stores and a few weary pedestrians. In 1979, the good city fathers opened a new civic center near the heart of town. It was a multipurpose structure primarily designed to house a hockey farm team of the Detroit Red Wings, known as the Adirondack Red Wings. Determined to pump new life into the little burg, the city fathers, led by a local enthusiastic hockey coach and guru by the name of Ned Harkness, were banking on the strategy that since Glens Falls wasn't a summer attraction, its best bet was to seek a draw that would have year-round visibility. It was pretty successful in its early years, attracting sports enthusiasts from all over the lower Adirondack region, and particularly Albany, forty-five miles to its south. Indeed, there was immense citizen pride in this new venture, which no doubt added to my frustration. When I personally addressed the Glens Falls City Council to request increased annual funding for The Hyde, it was nearly impossible to build a case that the museum would bring visitors to town—I remember lots of snickering and yawning. I must say it was terribly frustrating to compete with the blue-collar, sports-minded locals who couldn't conceive of how a dull, old Rembrandt painting or those other muddy daubs on canvases might have any relevance to elevating the city's posture. There was no doubt that I had an uphill challenge in making this little gem a recognized attribute of their community, but I was a tenacious bastard and wasn't about to give up easily.

In the late spring of 1980, I began to hear rumors of this so-called wealthy guy who had recently come to town and was staying at the Queensbury Hotel. There was lots of gossip about him being a Vanderbilt and that he was being driven around town by a chauffeur in a classy silver-gray Bentley with its steering wheel on the right. Word had it that he was a suave, young guy with a bit of an East Coast accent who was tossing twenty-dollar tips to

all who served him. I must say, it was hard to believe. Why would such a sophisticated, wealthy individual find Glens Falls attractive or worthwhile? Sporadic rumors filled my ears throughout the summer and into the early fall. I assumed he was hobnobbing with the bigwigs in Saratoga Springs during the summer's social fundraising activities. And with all the wonderful hotels there, like the Gideon Putnam, why would this Vanderbilt person be staying at the rather-dated Queensbury Hotel? Every once in a while one of my volunteers would tell me yet another story about this rich fellow that I needed to hear. And they often ended their tale with, "Do you suppose he might be someone who would be willing to help The Hyde?" Given our sorry financial standing, I must admit I was secretly hoping this wealthy character would someday come knocking on the door with a fistful of Vanderbilt dollars ready to help my poor, fledgling institution.

Friday, October 31, Halloween day, was one of those typically crazy times in which Cecilia and I were frantically trying to finish the installation of a temporary exhibition in the museum's unattached garage-gallery in time for its formal opening the following day. It was an exhibition of prints from the Skidmore College print collection and was organized by Jim Kettlewell. He was there that day, overseeing the labels for the exhibits, when, around three in the afternoon, one of the volunteers scurried across the outdoor courtyard and into the gallery and blurted out that a chauffeur-driven car was in front of the museum and, "I think it's that Vanderbilt guy everyone's been talking about." Kettlewell hurriedly went back into the museum to meet him; he was an easy sucker for highbrow people.

Ten minutes later, he came flying into the gallery to retrieve me from my frenzied duties to "greet this very important guy who wants to meet you." I remember kibitzing with him, "Do you truly think he's a real Vanderbilt?" There, inside Hyde House's sky-lit, tropical courtyard, was a very young—seemingly no more than in his early twenties—extremely well-dressed, and reasonably handsome man. He was about five-foot-eight, with reddish-brown hair and probing blue eyes. He grabbed my hand and, with an aggressive handshake, said in an obvious East Coast, Boston-ish accent, "Hello, my name is Paul Sterling Vanderbilt, it's so nice to meet you." He then assertively launched into a conversation, proclaiming that he was very intrigued with Glens Falls and had been hearing wonderful things about The Hyde Collection. He spoke effusively about how he loved art museums and enthusiastically described how much he cherished visiting various museums in New York City, especially the Metropolitan Museum of Art. He said he'd heard that The Hyde had some important Old Master paintings like New York's Metropolitan Museum of Art had, and he was very much interested in having a tour to learn more about this important Glens Falls treasure.

We chatted a bit longer, and I finally had to explain that I was under a lot of pressure to complete the installation of a new exhibition. Kettlewell, overhearing our conversation, suggested to Mr. Vanderbilt that he would be most welcome to attend the next evening's exhibition opening. He seemed pleased to be invited and agreed that he would try to attend. The two of us then set a date for him to return for a tour of the museum and an opportunity for a business meeting. He wanted me to know that he would very much like to help the museum in any way he could. I checked my calendar and we agreed to meet the following Wednesday, November 5. He then abruptly turned and exited the museum, climbing into his chauffeur-driven Bentley.

The volunteers and Kettlewell were all in a twitter, checking the sign-in book to view his bold signature—*Paul Sterling Vanderbilt, Cady Hill Saratoga*—which didn't conform to the rumors about him being in residence at the local hotel. But wow, Cady Hill was the palatial Saratoga home of the notorious Mary Lou Whitney; what could be a better address?

There was lots of prattle about how this might be a fortuitous opportunity for The Hyde. While I didn't exclaim it openly to Jim and the volunteers, I had an almost-immediate queasy intuition about him, but I just couldn't put my finger on what it was. With a heavy workload still pending, I went back to help Ceil complete the instillation. We joked about my meeting with Vanderbilt, dreaming that this might be the guy who was going to give us millions for our endowment. When I went home that night, I likewise teased with my wife, Becky, bragging that "I've finally gotten to lay my eyes on the famed Mr. Vanderbilt. The Hyde's going to be rich now."

Those of us in the trenches of the nonprofit world, particularly those who lead institutions that are not well funded, fantasize about the miraculous wealthy donor who comes out of nowhere, immediately falls in love with our mission, then opens his checkbook and writes a check with multiple zeros at the end. It's a continuing dichotomy for administrators in charge: we must exude confidence in our institutions at all times, while living in constant fear of financial disaster. We find ourselves scrutinizing any- and everyone who appears to have wealth while avoiding being too obvious. Nevertheless, common knowledge in our business, where there has been success in developing a loyal financial supporter, is that it requires long-term cultivation. Rarely will someone make a large donation during an initial meeting. For best results, serious patronage necessitates dedication to an institution and its mission, as well as the desire to make a difference and, by all means, to receive a great deal of visible recognition. Most donors want to be lauded and acknowledged for their generosity. We often consider ourselves "whores for the arts" as we meander through the potholes and minefields of our realm in search of sufficient funding to keep our institutions afloat. And it can be ugly in rural regions, where there is more than one cultural organization in

serious financial need. For The Hyde, our competition was the Lake George Opera Festival, the Crandall Library, the Chapman Historical Museum, the Lower Adirondack Regional Arts Council, and a few smaller arts groups, all dependent upon an incredibly small number of arts supporters—albeit a few fairly wealthy, old-moneyed families.

The opening for the exhibition *Prints from the Skidmore College Print Collection* was a two-hour affair, beginning at 6:00 p.m. As usual, the Hyde House interior courtyard was reconfigured to accommodate food and drink. The large Italian Renaissance refectory table was scattered with various platters of cheeses, including a large wheel of brie and baskets of crackers and small slices of crusty artesian bread—made by the favored local Villa Bakery. Across the courtyard on a wrought-iron, glass-topped table were several bottles of inexpensive white wine and various containers of soft drinks. Small paper plates, white cocktail napkins, and plastic drink glasses were standard fare. This had been quickly assembled by a few loyal members of the Volunteer Council, with the helpful hands of Cecilia, after the museum had closed to the public. Volunteers replenished food, poured drinks, and made nice to the public. Attendees to Hyde exhibit openings were the customary small number of arts-savvy community members, a few volunteers, and unfortunately, hardly ever any trustees. For this event, the usual characters showed up, with the exception of an additional few Skidmore College students, known locally as "Skiddies," and two or three faculty members, including, of course, Jim Kettlewell. The exhibit of approximately fifty prints included mostly Old Master impressions by such notables as Albrecht Dürer, Jacques Callot, and Giovanni Battista Piranesi. This was a low-budget exhibition for The Hyde and included only a small wall text and object labels—a printed catalog was not an affordable option.

Typically, several guests arrived prior to six, no doubt to ensure they would not lose out on the food and drink. Soon more guests arrived and began milling about, forming into small groups gathering to chat among themselves. Frustratingly, only a few visitors actually went to view the exhibition, which required them to abandon their drinks and exit the courtyard for the former Hyde kitchen, which had been transformed into the museum sales shop, through the back door, down the steps to the outdoor courtyard, and into the side door of the garage/gallery. Not a pleasant trip during inclement weather and on cold fall and winter evenings.

Halfway through the opening, I noticed, out of the corner of my eye as I was chatting with some guests, that Paul Vanderbilt was in the foyer, having just arrived. Of course, Kettlewell immediately swooped to greet our auspicious guest, and without delay, he began introducing Mr. Vanderbilt to various attendees with much aplomb. After several minutes, Paul headed my way. Again, he was well dressed, in a finely tailored suit and striped blue shirt. It

was clear that he wanted to engage me in a lengthy conversation, for he kept moving me away from my other guests. We began with some typical small talk, but almost immediately he was vigorously assuring me of his importance in the world. I soon learned that he had been a trustee of the Whitney Museum of American Art in New York City, but he had recently vacated his position because he disagreed with the museum's acquisition policy. He then began dropping names of various arts-world celebrities and wealthy individuals whom he claimed were all close acquaintances. He wanted me to know that he was a Harvard graduate and a freelance writer focusing mostly on political subjects, and that he had written several articles for the *New York Times*. However, he noted that he was currently working on an article about the intrigues of art theft. Then, changing the subject, he wanted me to know just how much he loved the lower Adirondack region, the mountains, Lake George, and of course, Saratoga. The beautiful area was most conducive to his writing efforts. He said that Kettlewell had told him about the Cunningham House next door, that it was vacant and how wonderful it would be if he could rent it from the museum. He mused that it might be the perfect space for him to do his writing. He said he would very much like to see it and wondered if it would be possible for him to have a tour of the building.

I must admit that using the structure as a rental was not in my plans because it had been used for ongoing art classes and various programmatic functions; however, to humor him, I agreed to take him through the space during our scheduled 2:00 p.m. meeting the next Wednesday. We said our goodbyes, and I turned to my other guests, as the evening event was nearly over. Jim was all in a flutter, expressing grand expectations that we might just have ourselves an angel, and how wonderful it would be if he would take The Hyde under his wing and help us financially. He lectured me about the importance of maintaining my enthusiasm, that this could really pay off. I guess the incredulity was showing on my face, for again, Vanderbilt's overt eagerness, his braggadocio, and his apparent youth were causing me some understandable misgivings.

As the head of a small staff, my days were filled with all manner of responsibilities ranging from the mundane to the decidedly esoteric. The week of November 3 that year was typical. On Monday at 10:00 in the morning, I was briefing docents on the new print exhibition, followed at 11:30 by a meeting with the Volunteer Education Committee. The afternoon was filled with a two-hour docent training session, and at 4:00 I was meeting with the board Membership Committee. I seemed to have little time to decompress, but it was necessary to keep up these activities because I was building a new momentum for the sleepy Hyde.

The week progressed accordingly, and at 2:00 that Wednesday afternoon, I had my first formal meeting with Paul Sterling Vanderbilt. The

chauffeur-driven silver-gray Bentley arrived promptly, disgorging its youthful passenger. Paul was again very well groomed. He wore a stylish wool overcoat over a well-fitted dark suit and what appeared to be classy Italian shoes. After some brief pleasantries, I went into our small office and grabbed the Cunningham House keys, and we headed out of Hyde House through the back door, the exterior court, and the lawn for a quick tour of the unkempt, old mansion.

The structure, designed by the same architect, was similarly configured as Hyde House with all the living spaces facing into an open two-story court, though it was smaller in scale and much less ornate. We entered the front door and stepped into the court, which was strewn with easels and art supplies, for it had been used for museum-sponsored art classes. I gave him a thorough walkthrough, including the second-floor bedrooms and Mrs. Cunningham's basement ceramic studio, which was cluttered with storage boxes and an assortment of junk. I could tell on his face that he had expected more habitable conditions, but out of his mouth came words like, "This place would work fine," and "I could see my writing study there."

After our speedy tour, he asked me if we couldn't find somewhere in the museum to sit and talk. We headed back to Hyde House and the first-floor courtyard with its exotic tropical plantings. I pulled up two of the Hydes' timeworn, wrought-iron chairs next to the tinkling Renaissance fountain, where we sat and talked to nearly closing time. His questions were intense. "Tell me about your trustees." "How many are there?" "What are your plans for the museum?" "Tell me about your security." "How many guards do you have?" "What are your long-term plans for the house next door?" It was immediately clear that he had an agenda.

What surprised me most, or perhaps I should say petrified me, was his fascination with art theft. He kept going back to that subject, basing it on the article he said he was writing, asking me if I knew about certain theft incidents at other museums and then directing the conversation back to questions about The Hyde's security and whether we had ever had any robbery attempts. Were the glass windows and doors secure, and was the museum manned on a twenty-four-hour basis? He went on for some time intensely describing a private Palm Beach home with an extensive valuable art collection that had recently been looted, resulting in the loss of some very valuable paintings. He expounded upon a crazy story of a cat-type burglar wearing suction-cup shoes that allowed him to traverse the ceiling to avoid setting off the mansion's elaborate alarm system. But the scariest moment of our conversation took place when he fantasized about where stolen art ended up. He was sure it was easy to fence works of art in Europe or Asia, but most likely Japan, where they would be swallowed up and never see the light of day again.

Chapter 6

Paul ended our lengthy conversation with a few requests. Since he had been a trustee of the Whitney Museum, would it be possible for him to become a member of The Hyde's board, and now that he had seen the Cunningham House, what were the chances that he could rent it? He said he was getting tired of staying at the Queensbury Hotel, and wouldn't it be wonderful to live so close to this magnificent museum? He emphasized that he truly needed a quiet place to write. My response to him was measured, for he really had raised my suspicions. I told him I would take his requests into consideration and would talk to the chairman of the board. He ended our visit by announcing that he truly wanted to support the museum. He alluded to his family wealth and how much he could do to help.

I must admit, by the time I was assisting him with his overcoat, the hair on the back of my neck was standing on end. His immaturity was troubling, as were his piercing questions about our security. What was that all about? Was he really a wealthy Vanderbilt? If so, why would he be so assertive about his wealth? Something about him seemed terribly wrong, but on the other hand, wouldn't it be wonderful if he was authentic and could really bestow the museum with some much-needed financial backing? Would the board really accept an outsider in their ranks, and if so, would this brash character make the cut?

On our way to his Bentley, Paul sternly reiterated his requests and said he would be giving me a call in the next few days to see if the board had approved his wishes. The Bentley door slammed shut, and the car sped away, leaving my mind in a muddle, wondering what in the hell had just happened. Was this a good thing or a bad thing? Should I really talk to the board chair or simply ignore this whole bizarre episode? In retrospect, having now pondered that weird conversation for a number of years, I see that Vanderbilt's smarmy attempt to worm security information out of me was truly prescient. He was hoping I would be so entranced by his fantasy tales of cat burglars and famous art heists that I would spill my guts about The Hyde's security inadequacies. What kind of a fool did he think I was?

Life continued in its typical hurried craze. The following day, Cecilia was away, leading a group of volunteers and museum members on a trip to Chicago with a specially planned tour of the Art Institute. Friday was one of those typical Adirondack fall, bone-chilling, rainy days when I would have given anything to stay at home, but no such luck. I had to attend an 8:30 a.m. meeting with some of the regional cultural organization leaders at the Queensbury Hotel. When I got back to The Hyde mid-morning, there were plenty of projects to keep me busy, particularly in the absence of Ceil.

Sometime in the late afternoon, Muriel Eichler, our secretary, informed me that Paul Vanderbilt was on the line and wanted desperately to talk to me. When I picked up the phone, I could tell he was rather anxious. I thought to

myself, *I hope he's not calling about his damn requests.* But quite the contrary, he said he had been conducting some personal research on The Hyde Collection and had been surveying various regional business owners as to their awareness of the museum and was shocked at their seeming lack of interest. "I just can't understand why they are so unaware of your magnificent museum." Then he dropped the bomb that instantly irritated the hell out of me. "Earlier today, I called the Brooke Astor Foundation to see if I could arrange for some funding for the museum, and their representative told me they only fund New York City arts organizations. But just now, I got off the phone with Brooke Astor herself, and she said she may possibly be interested but wanted to know more about The Hyde and wondered if it was possible to see a portfolio of the museum's works of art."

I told him sternly that I was surprised he had done this behind my back, that I needed to be directly involved in all funding requests. While he might think he knew the museum and wanted to help, I had the institutional knowledge that was necessary when making such appeals. I followed with, "And who in the world have you been talking to in the community?" He didn't respond to my question, but just elevated the tone of his voice in a brusque manner. He said that, if possible, he would like to meet with me on Monday the 17th to further discuss obtaining a portfolio. I checked my calendar and said we could meet at 10:00 a.m. There was no further discussion; he obviously knew he had overstepped the line. When I hung up, I remember thinking, *This guy really is getting out of control. Who does he think he is to be advocating for the museum without my knowledge?*

That weekend was consumed by my requirement to be on duty at The Hyde during public hours. However, throughout the blur of operational activities, I continued to dwell upon the strange discourse I had had during Wednesday's meeting with Vanderbilt, as well as the unbelievable telephone conversation on Friday. *A portfolio—what's that all about?* I have a bad habit, when faced with unpleasant decisions, to put them on ice and tread water, hoping a magical decision is coming in the near future. At that time, it seemed completely absurd to me to address his request with any member of the board. Even though he was riding around in a Bentley and dressed to the nines, how could I completely trust this character? And why on earth would I want him living right next door, breathing down my back?

Later on, I jokingly discussed his demands with my staff and got mixed responses. Kettlewell, ever the optimist, expressed hope that this guy could really make a difference to the museum, whereas Cecilia suggested caution in making any rash decisions. I knew it would be a hideous disaster if I chose to ignore someone of wealth who might be willing to help the museum, but on the other hand, I could get the institution into an untenable situation should this guy be a phony—and starting from my initial hesitant impression of him

followed by our various conversations, it was truthfully hard to take him seriously—especially now that he was calling local citizens and foundations on the museum's behalf.

A few days later, I received yet another phone call from the irritating Mr. Vanderbilt. "Well, Fred, have you talked to the board about my requests?" he asked curtly in his New England accent. "You know I have recently moved out of the Queensbury Hotel. As I told you, it's not very pleasant being there. I'm temporarily staying with a friend but would so very much like to be ensconced in the Cunningham House." I explained to him that I had been very busy and had not yet had an opportunity to talk with the board members. He no doubt saw through my delay tactics and seemed frustrated at my response. We chatted a bit longer, and I said that, in fact, the board executive committee would be meeting in a few days, and I was planning on discussing his request with them at that time. He reminded me of our November 17th meeting and told me he expected to hear a positive response.

I now had to come to grips with this situation and could no longer remain in my vague, procrastination-holding pattern. The person whom I always turned to for sage and sometimes "cold water in the face" advice was Becky. Being a registered nurse, she sees the world through incredibly practical eyes. She knows what real life-and-death situations are, and she is superb at cutting through the murkiness when assisting me with work decisions that are all too often clouded with sentimentality and/or subterfuge—she has been a godsend throughout my career.

As one could guess, she agreed with my initial gut reaction that this guy was probably a phony. We decided it would be wise for me to inform the executive committee about Mr. Vanderbilt and his requests, as well as my growing concerns about him—it was better they know up front than be blindsided should this guy do something stupid. I decided I would recommend to the committee that I keep him at bay, suggesting to him that because he was an outsider, the board would require some concrete biographical information as a matter of due diligence.

I don't know when the light bulb went off in my addled brain, but a day or two later, it suddenly dawned on me that Mr. Vanderbilt had indeed, given me some important clues. I really didn't have to wait for him to give me a written biography to conduct some sleuthing on my own. I would call Tom Armstrong, then-director of the Whitney Museum in New York, and inquire about Vanderbilt's position on the Whitney's board. Following an initial conversation with Tom's secretary, he returned my call promptly and was amazingly helpful. When I told him this very persistent, twenty-something character named Paul Sterling Vanderbilt was nosing around my museum and claimed he had been a trustee of the Whitney, Tom paused and then chuckled. "Never heard of the guy," he said, and, as I had already presumed, "No

one that young would ever be accepted on my board." That immediately sent chills up my spine and led me to expound on the whole story of my recent adventure with Mr. Vanderbilt. "Have you checked the New York Social Register?" Tom asked. I admitted I had not thought of that, and he suggested it might be another way of getting a read on this guy. He then said, "Wait a minute, I know a member of the Vanderbilt family, and she's a hoot." He told me she was a fabulous individual who would be worth calling. He gave me her telephone number and emphasized, "You might learn a lot about this guy from her." I thanked him profusely, and he ended our conversation with, "Good luck. I think you've got a real concern on your hands, hope all goes well."

My next call was to a "real" Vanderbilt, and was she ever informative. "Never heard of him!" was her response following my first question about our famous Paul. When I recounted the details of his showy performance in our innocent little berg of Glens Falls, she howled. "Believe me, that does not sound at all like any Vanderbilt I know. We keep a low profile. A Vanderbilt wouldn't be doling out big tips, and believe me, they wouldn't be driving around town in a Bentley." We had a lively conversation, and, like Tom, she warned, "You'd better watch out for that guy."

My final call was to the New York Social Register, and as anticipated after my two previous calls, there was no record of a Paul Sterling Vanderbilt on file. By now my hair was on fire. The next day, I decided for the hell of it I should likewise check with the Brooke Astor Foundation to see if I would get the same response, and indeed, they, too, had no record of a call from my good friend Paul regarding a request for funding. I decided it was silly to bother Brooke Astor herself; this guy without a doubt was stringing me along.

The dynamics now had abruptly changed; I was no longer in that quasi-hopeful state that just maybe, *just maybe*, he was an eccentric, rich guy who could really make a difference. I was now sure Vanderbilt was a phony of the first order and very possibly up to something unseemly. It was clear I could no longer handle this matter on my own. Ceil and I had several conversations about what to do next. I knew I had to inform the board, but whom else at this point? When I told Ceil that it might be wise for me to contact the police, she laughed and said, "Those local yokels will think you're crazy." I agreed with her that, most likely, they would probably think I was some kind of artsy lightweight with a silly premonition that some mean guy wanted to beat me up. But I couldn't let the idea go, given the fact that this chap had been blatantly lying to me about his identity—what else could he be making up, and what were his motives? Most disconcerting was his perverse fascination with art theft, as well as his urgent desire to live right next door to the museum. As a leader of the institution, I was sure it would not bode well if I just stood by biting my fingernails while Mr. Paul, or whoever he was, was plotting some

kind of dastardly heist, and I sensed it but had withheld this information from the police. I finally decided the hell with it—I was just going to take a chance. To my surprise, my phone conversation with the Glens Falls Police Department was at once reassuring. I initially spoke with the sergeant on duty, who asked pertinent questions, and after his grilling, said, "I think you need to talk to Chief Duggan." He, too, was attentive to my tale and likewise asked about the details of my various conversations with Vanderbilt. He admitted that he was aware of the guy. No doubt others in the community had made queries about this outlandish character. Certainly, Vanderbilt stood out like a sore thumb in dowdy little Glens Falls, driving around town in his flashy car. The chief thanked me and said the police would be keeping a watchful eye on the museum and to please get back to him if there were other dubious incidents. I hung up the phone, greatly relieved that I at least had been taken seriously and not pandered to like a wimp.

The following day, Thursday, November 13, was slated for the trustee executive committee meeting. The chair of the board, Dr. Day, was passively interested in my Vanderbilt tale, including my conversations with Tom Armstrong and the Vanderbilt family member, as well as my call to the local police; he asked a few questions but didn't seem overly concerned. A couple of ladies on the board giggled about how handsome Vanderbilt was, having seen him in the Queensbury Hotel dining room. I informed them of his requests to be on the board and his desire to rent the Cunningham House; after some loud, nervous laughter, they agreed with me that we would be wise to keep him at bay. The rest of the meeting was business as usual. After the board members left the museum, I felt somewhat relieved that I had now included them in this strange turn of events. I wasn't sure if they were as troubled as I was, but at least they were in the loop should this dastardly character pull off something dreadful.

Late the next morning, after I returned from a meeting in Scotia, New York, a little burg north of Schenectady, I received yet another unanticipated phone call from Vanderbilt. The guy was beginning to drive me crazy. He was enormously effusive—rather smarmy, in fact—informing me how much he wanted to help the museum. Because it was such an important cultural gem, he said, he wanted to appeal to some of his wealthy acquaintances, including Brooke Astor, as well as some of his family members, detailing its significance in hopes of garnering some financial support. I was uncertain about confronting him at that moment about my various enlightened phone conversations that exposed his lies. But then I thought it might be interesting to play along to see where he was heading. At least he remembered my demand to inform me prior to going off half-cocked. He said that in order for him to make a successful appeal, however, he really needed a portfolio of photographs of the major art works in the collection, with as much descriptive

information about them as I could muster. And he needed it immediately because he was planning a trip to New York City the next week—he also had to cancel our meeting planned for next Monday, the 17th.

I was absolutely flabbergasted at his audacity. The guy was becoming more and more transparent with every conversation. It appeared obvious to me that what he wanted was a visual shopping list to hand over to some underworld character. In a stern voice, I told him that would be absolutely impossible; that our curatorial files were sadly inadequate, including stock photographs of collection objects. I reminded him of our current priority of publishing a catalog of the collection, but it was still a distant dream. We desperately needed funding for even such basic needs as typewriters to prepare the manuscript, let alone for the eventual cost of printing the publication.

I could tell he was angry, and perhaps even a bit suspect that I might be on to him. He made an attempt at once to mollify me by noting that he had talked to an IBM representative about getting a computerized word processor for the Hyde, which would very much accelerate our catalog project. I informed him that I had already ordered an IBM Selectric typewriter, but it would not be delivered for several months due to their high demand. He laughed and said he was sure he could get us a couple of typewriters sooner than that. We chatted a bit longer, and after requesting once more that I try my best to put together a portfolio, he asked if we could reschedule our meeting for Friday, November 21st. When I hung up the phone, Ceil was heading into my office, and I said, "This asshole Vanderbilt is driving me nuts. He's up to no good; what is he going to do next?"

I didn't have to wait long for an answer. In the mid-afternoon, Joan Youngken, curator of the Chapman Historical Museum, called to tell me that her husband, Rich, had witnessed a rather disturbing incident concerning Paul Vanderbilt the day before. She asked if there was a chance I could meet with him later that afternoon. Joan's boss, Joseph Cutshall-King, the director of the Chapman, was, besides Ceil, one of the few individuals in Glens Falls in whom I could completely confide. Over the past few days, I had been informing him about my strange encounters with Mr. Paul. At first, I think he was envious of our promising "Vanderbilt windfall," but eventually, like me, he began to have serious doubts. When Joan told him what her husband had witnessed, he'd said, "You'd better call Fred."

About 4:30 in the afternoon, Rich Youngken showed up at the museum. He was an independent contractor for the city of Glens Falls, conducting preliminary research on some of the city's earliest buildings in preparation for them to be listed on the National Register of Historical Structures. Rich said that the day before, he had been in the Glens Falls's Office of City Planning, and while he was reviewing some drawings, Vanderbilt showed up at about closing time, requesting that he be allowed to see building plans for the

Hyde and Cunningham Houses. He told the office staff that The Hyde was in the accreditation process, and he was on the accrediting team and needed to see plans of the structures to review any additions to the buildings, elevator shafts, etc. They allowed him to view the drawings but refused his request to borrow them. I was absolutely horrified as Rich unfolded his story, and I thought to myself, *This guy Vanderbilt has got the biggest balls around and is truly planning something pretty serious.*

After Rich left, I placed another call to the chief of police, James Duggan, to inform him of yet more Paul Sterling Vanderbilt incidents that were really scaring the holy hell out of me. I was informed by him that he was going to contact the New York Bureau of Criminal Investigation—the BCI, as he called it—and that he or someone from the bureau would be getting back to me.

I had the weekend to ponder Vanderbilt's escalating antics. Ceil had the museum duty; therefore, I had an opportunity to decompress and try to put some perspective on this whole convoluted mess. As always, Becky was a supportive sounding board for my flights of worst-case scenarios. The obvious reality was that there wasn't much more that could be done. I had notified the police and board members, and I had kept Vanderbilt at bay. The fact was, he was only acting suspiciously and hadn't actually done anything illegal, at least nothing I knew of. In those late-twentieth-century, pre-9/11 years, there wasn't much more the law could do, particularly relating to matters of the art world. As it was, I was pretty astounded that Chief Duggan had taken me as seriously as he had.

Sometime during the weekend, whether it was at the grocery store or somewhere during my weekly chores, I got wind of yet another interesting tidbit of Vanderbilt lore. I really don't remember who told me, but the local scuttlebutt was that he was no longer driving his Bentley, that he had recently rented a Mercury Zephyr from one of the local car dealerships, Den Wilhelm. What in the world was going on? Was he beginning to sense that he was being too ostentatious, and the locals were catching on, or maybe his money was running low, and he just couldn't afford it any longer?

Monday came around all too quickly. I was facing yet another hectic week of round-robin activities, and those two short days off just didn't seem long enough. I couldn't shake the latest piece of Vanderbilt gossip about his car, so one of my first tasks when I got to work was to call Mrs. Wilhelm at the car dealership to see if she could offer any insights about her interaction with Vanderbilt. I was surprised at her eagerness to convey her observations. She said there was something strange about this guy that made her somewhat suspicious. She was also taken aback about his insistence on paying in cash. Then she dropped yet another bombshell that nearly blew my mind. "Fred, is it true that you had hired a new employee?" she said. "One of my mechanics

told me he overheard Vanderbilt saying he was your new curator." *Good God*, I thought to myself, *this guy doesn't know much about living in a small town.*

After thanking Mrs. Wilhelm, I immediately called Chief Duggan to inform him of this latest turn of events, just in case he didn't have enough proof that I was facing a crazy person who obviously was up to something untoward. Duggan reported that so far in their investigation, Vanderbilt did not appear to have a criminal record. I said I was glad to hear that but hoped he would be able to increase the surveillance of the museum, that this guy seemed awfully suspicious given his ongoing scary antics. He agreed and hung up.

About 10:00 a.m. that same day, I received a call from BCI state police Investigator James Babcock. He said he was planning to drive up to Glens Falls from Albany and wanted to meet with me in the early afternoon. When I hung up, I breathed a sigh of relief. *Now maybe I can get some action in determining what is really going on here.*

Babcock arrived at about 1:00 p.m., a short, wiry character with an intense, penetrating gaze. He told me Chief Duggan had informed him about a suspicious character in town and wanted me to tell him as much as I could about what I had experienced. This was yet another pleasant surprise in that he, too, was listening intently, asking pertinent questions, and even taking notes. We must have talked for almost an hour before I ran out of steam and told him I had a group of docents arriving on the hour for a docent training session. He was considerate of my hectic schedule and said that he would stay in touch. He cautioned me that I should keep the police informed of any additional suspicious activities. I bade him goodbye at the museum's front door as hordes of umbrella-brandishing, chatty, and inquisitive docents descended on us, notebooks in hand, ready for their training program.

At the end of this emotionally exhausting day, after conducting a two-hour slide program placing The Hyde's works of art within the continuum of the history of art, I was off to New York City to attend a two-day seminar sponsored by the Gallery Association of New York State on energy management for museums. This was in response to the energy crisis during the Carter administration, when museums, too, were seriously grappling with best practices in staving energy costs from skyrocketing.

The seminar was held at the Metropolitan Museum of Art. There were various sessions conducted by representatives from other New York State museums, as well as Metropolitan staff who took us on a range of field trips within the vast caverns of the Met, including a hair-raising walk on the roof of the museum to view some of their new, efficient HVAC equipment. *Wow, if only The Hyde could afford anything half as fancy as the Met.*

Getting away from rural Glens Falls was always a refreshing experience for me, especially when the occasions were work-related like the energy

seminar. Being able to converse with colleagues from museums all over New York state opened my eyes to innovative ideas and helped me appreciate the fact that I wasn't the only museum director beating my head against the wall. I confided to a few more familiar colleagues of my daunting Vanderbilt story, and while there were guffaws of laughter about his palpable amateurism, there were also cautionary suggestions, all of which I had already undertaken.

I was back in the office Thursday, blurry-eyed and overwhelmed. The contrast between the Met and The Hyde was mind-boggling—they had hundreds of visitors, flanks of guards, professionally designed displays, large support staff, and a clean well-organized infrastructure. I'm quite sure that its then-director, Philippe de Montebello, didn't have to occasionally sweep museum floors or clean toilets, but, indeed, I was not Philippe, and The Hyde was not the Met. Guarding myself from silly jealousies and seemingly overwhelming obstacles was an occasional reality; however, by then I was more than convinced of the efficacy of The Hyde, its wonderful art collection, and the fascinating history of its founders. This institution had extraordinary potential; I just needed to remain focused and to methodically make changes based on professional best practices. Someday, I felt, my tenaciousness would pay off—that is, if the board didn't fire me first!

I spent the remainder of that Thursday afternoon assisting sculptor David Stromeyer de-install his gigantic, abstract rusted-steel sculpture that had been installed on the lawn between the Hyde and Cunningham Houses during the last six months. David, who was gaining in reputation in Upstate New York as a promising young sculptor, was very much inspired by such noted artists as Mark Di Suvero and David Smith. I must admit my decision to place a massive contemporary sculpture on the museum grounds had not been broadly appreciated by the trustees. On this Thursday, Stromeyer and his wife showed up about 1:30 p.m. with a large flatbed truck. It was my responsibility to round up a backhoe and driver, which I did after much pleading with the director of the city's public works department. There were a few touchy moments as the large sculpture was gingerly lifted onto the truck, with Stromeyer nervously shouting orders. By the late afternoon, I was greatly relieved to see the truck depart for his studio in Vermont. And no doubt, the trustees would be relieved to know this "rusted piece of junk," as they called it, was no longer desecrating their museum grounds.

Just before 5:00 p.m., when the visitors and volunteers had left for the day, the doorbell rang. Ceil went to answer it, and there, standing in all his fineries, was the infamous Mr. Vanderbilt. He asked her if she could go fetch me because he had something he wanted to show me. I grabbed my coat and headed outdoors. Paul was standing in front of a rented Rolls-Royce, not a Bentley this time, with a chauffeur at the wheel. I wondered to myself what this was all about—where was his Mercury Zephyr?

Mr. Vanderbilt greeted me with a big smile and apologized for not having made an appointment and being so late in the day, but he wanted me to know he was delivering some gifts for the museum and was anxious to have me see them. He turned to the chauffeur, whom he called Giles, and asked him to open the trunk for us. Giles was dressed conservatively, and wearing a fancy pair of leather gloves, he slowly opened the trunk to reveal three red IBM Selectric typewriters. Affixed on the upper front of each of them was a plastic presentation label with the words, "For The Hyde Collection."

I was blown away and said, "Where did you get these?" He said he had been able to purchase them in New York City earlier in the week. Paul then went on to expound, "I am a writer, and I wanted to give the museum something that represents me. And I know how much you need typewriters, given your big catalog project."

Paul, Giles, and I each grabbed a typewriter out of the trunk and carried them into the small museum office. I made nice to him as best I could, but found it difficult to be excessively enthusiastic. Something about this new act of supposed generosity seriously added to my growing suspicion. We talked briefly, and he reminded me of our meeting the next day at 10:00 a.m. I remember thinking, *Do I have to deal with this asshole again so soon?*

After Paul had been driven away by his chauffeur, Giles, I howled to Ceil, "What the goddamn fucking shit is this guy into?" in a very un-museum-director spate of profanity. When we went back inside the museum, we began to further evaluate this questionable act of generosity. Why didn't these "new" typewriters come in their boxes? Well, yes, he'd had to take them out to apply the so-called gift labels, but then, where were all of the typical instruction booklets and warranties? Upon further inspection, they didn't quite appear new: the cords were banded with rubber bands, and their red cases seemed slightly worn—not what they should have looked like had they recently been lifted out of their factory-issued boxes. The most puzzling fact, however, was how he could have just walked into a business equipment store in New York and driven away with three new typewriters. I'd had a recent experience on which to base that suspicion. As noted, a few weeks earlier I had begun the process of purchasing a Selectric typewriter for the museum. My quest had started at Russell & Wait, a local Glens Falls's office supply store, and I was directed by them to an IBM sales representative in Albany. The IBM guy took my order, but to my great anguish, he explained that it would probably take at least four months for the delivery. The demand for them was astronomical, and the company was having a difficult time keeping up. And now Vanderbilt had just shown up with three of them—and it was obvious he hadn't placed his order four months earlier. This was definitely getting out of hand. It was becoming more evident to me that this dubious character was up to something really scary. Given my deep suspicion, I decided that the new typewriters

were not to be used. I ordered them to be put away until we could get to the bottom of this.

On Friday morning, it was snowing large, fat, goose-feather flakes that were rapidly covering the grass in front of the museum. The first thing I did when I got settled in my office was to call my IBM contact in Albany. After informing him of this wacky situation, he said it sounded rather suspicious and was glad to hear that we hadn't put them to use. He said he very much wanted to see them, but he wouldn't be in Glens Falls until the following Monday.

Exactly at 10:00 a.m., Paul showed up for his meeting with me. He carried a brown paper bag, which, when he shed his overcoat, he opened and extracted a handful of typewriter instructions, boxes of typewriter tape, and three Selectric metal font-balls. He sheepishly said that he'd forgotten to include them when he'd delivered the typewriters the night before. We went upstairs to my office, and he immediately began quizzing me about the status of my conversations with the board about him renting the Cunningham House and becoming a trustee. He was acting very smarmy, reminding me how much he was trying to help The Hyde. Giving us typewriters would significantly aid in our catalog project.

I listened patiently and then delivered the bad news that the board was somewhat reticent to grant his wishes of being a trustee or renting the Cunningham House without knowing more about him. I reminded him this was a rather insular board made up of local individuals mostly chosen by Mrs. Hyde, and that they would need to have some in-depth biographical information and perhaps even references to whom they could talk. I explained to him that it was typical of nonprofit boards to be cautious about those whom they accept into their fold. And that, while his Vanderbilt name was certainly recognizable, there would have to be some investment of time to get to know him. "Paul, you are an unknown in this community. How do we even know you are a Vanderbilt?" He looked a bit shocked, but he attempted to hide his unhappiness by sheepishly saying he was really disappointed but understood their concern. He would pull together some information about himself for them to review. Our meeting quickly ended. He stood up and sped out of my office, clearly rattled about what he had just heard.

Throughout the remainder of the day, I discussed the insane typewriter incident with a few individuals, including Dick Day, the board chair. He called me regarding a couple of operational issues, and during the course of our conversation, I unfurled this latest incident. For some reason, this got his attention, particularly when I told him the Selectric I had ordered for the museum—which the board had finally let me put into the budget—was unobtainable for at least four months. He said, "Fred, I'm getting a little concerned about this character. Have you been keeping the police up-to-date?" I assured

him that I had been doing everything possible to keep them in the loop and that even the BCI were now involved. That seemed to placate his anxiety.

I went home that evening with a head full of confusion. The smelly mound of Vanderbilt-related crap was growing exponentially, and my imagination was beginning to work overtime. I really needed some time off to ponder this latest episode. On Saturday, Becky and I had a delightful evening with friends, and then, in what seemed like a snap-of-the-finger, I was already facing Sunday evening with the dread of a blurred week ahead.

About 8:10 in the evening, the phone rang, and it was Dick Day, nearly out of breath. "Fred, are you watching *60 Minutes* tonight? They're doing a segment on IBM's Selectric Typewriters." I thanked him for the alert, then quickly ran upstairs to our little TV room and turned to the local CBS station. The title of the segment was "The IBM Caper." It focused on the growing crime wave of pilfered Selectrics in California. In those pre-PC days, it's hard to comprehend that typewriters could have been in such high demand. But the Selectric was one of IBM's star products, bringing higher efficiency to businesses. They were not cheap, selling for about $900—the obvious reason the poor Hyde didn't have one. Selectrics were being stolen from commercial offices at an alarming rate, valued then at about $500 million annually. They were then cleaned up and sold at half price by dubious fencers. The shocking revelation in the news segment was the blasé attitude of the buyers, who had little concern about the origin of their purchases. The segment focused on a program of the California Department of Justice's computerization of stolen typewriter serial numbers and their success at retrieving them.

At the end of the fifteen-minute television segment, Dr. Day called me again, now nearly apoplectic. "Jesus, Fred, do you know anything about those goddamn typewriters? And where could that idiot have gotten them?" I told him again what little I knew, and that an IBM rep from Albany would be there the next day to examine them. I could tell the good doctor was not completely comfortable with my response, which was, indeed, confirmed about a half hour later. The telephone rang again, but this time it was a Glens Falls police officer. He informed me he had gotten a frantic call from Dr. Day, who was very upset and insisting on having increased police surveillance of the museum. I told the officer it was not a bad idea, because we were becoming more and more concerned about Vanderbilt's strange antics. His response was not what I expected: "Now, Mr. Fisher, you need to know that we've done quite a bit of checking up on this Vanderbilt guy, and from what little we can tell, he's okay. He's just a rich kid who's a little eccentric. I say if he wants to give the museum a gift of some typewriters, for God's sake, use them." My heart sank, but I wasn't about to argue with him. I decided I would have a serious conversation with Chief Duggan early the next week.

Chapter 6

The serendipitous *60 Minutes* program placed a whole new emphasis on the three mysterious red Selectric typewriters temporarily stored in one of the second-floor former maids' rooms that now functioned as cramped offices. Fran, who had the weekend duty, arrived at the museum a bit late, and before she took her coat off, she ran up to my office to inform me she'd gotten a call from "that Vanderbilt character," asking if the staff was using our new typewriters. She told him they were locked in an upstairs office with orders from me that they weren't to be used. When he heard that, he'd flown off the handle and was very unpleasant to her. Fran looked a bit weary and said, "Fred, I think that guy is a loose cannon." I responded, "Fran, I'm afraid you're right."

The shortened three-day Thanksgiving week ahead was chock-full of activities. It began with Monday's Volunteer Council executive committee meeting, scheduled for ten. I found it difficult to concentrate during the meeting, knowing that the IBM sales rep would be arriving at any moment. I excused myself from the meeting when the doorbell rang about quarter to eleven. There he was, looking particularly serious as I led him into the museum's courtyard, which was abuzz with the cacophony of volunteers who were finishing up their meeting. Ceil joined us as we headed up the back stairway. The small upstairs office was just too dark and cramped, so we each grabbed a typewriter and headed for the first-floor interior courtyard, which was now returning to its peaceful state as the volunteers were exiting the building. The museum being closed on Mondays allowed us to freely use public spaces; therefore, we carefully placed the Selectrics on the long Italian Renaissance refectory table.

The IBM representative scratched his head as he carefully examined each individual machine. He grabbed a pen and a small writing pad out of his shirt pocket and began writing down the serial number of each typewriter. He then turned to me and asked if I wouldn't mind if he pried off one of the so-called presentation labels. At this point, I could have not cared less, particularly if it would help get to the bottom of this latest Vanderbilt escapade. I nodded affirmatively, and he began struggling with one end of the plastic, gold-colored label emblazoned with "For The Hyde Collection." When he was able to partially detach it, I could see the corner of another label underneath. After it was fully removed, we could see a small black label with white lettering stating it was the property of a business machine rental firm with a Madison Avenue, New York City, address. "Holy shit!" I shouted. "That bastard."

Ceil and I looked at each other and chuckled nervously. It truly was shades of Sunday's *60 Minute* program. "Well, Mr. Fisher, I think you may have a problem on your hands. I'm not so sure these are legitimate gifts." The IBM representative then asked to use our phone to call the regional IBM headquarters and have them check the serial numbers. He came back into the courtyard a few minutes later, shaking his head. "I'm sorry to tell you, but this

Vanderbilt chap only paid a two-hundred-dollar, one-month's rental fee for these three typewriters. Based on the fact that he gave them to you as a gift, I don't think you want to keep them." I was in full agreement. We desperately needed a new typewriter but not that bad.

After a brief conversation, the man thanked me for alerting him and reiterated that the demand for Selectrics was creating some "unfortunate misdeeds." He promised to try to fill our order as expeditiously as possible, and we said our goodbyes at the front door. Before I could get back to my office, Muriel Eichler waved me into the business office and informed me, with her hand covering the telephone speaker, that Vanderbilt was on the phone and was anxious to talk to me. "Jesus, won't this asshole ever leave me alone?" I muttered and took the phone from her.

"Fred, I would like to meet with you as soon as possible," he said in a demanding voice. "I don't like the way things are going and how you are treating me!" I reminded him that this was a short holiday week, and I had a busy calendar. That didn't seem to matter with him, and after flipping through my pocket calendar, I informed him that the only available time I had was at three o'clock Wednesday afternoon, the day before Thanksgiving. He agreed and hung up before I had a chance to utter anything else.

This newest typewriter incident placed legitimate significance on what appeared to be a possible illegal intent by Vanderbilt—giving the museum a so-called gift of rented or stolen typewriters. I would like to think now our local police might judge him more critically than just considering him a rich, eccentric kid. There were several calls I needed to make, beginning with Police Chief Duggan. When I informed him of this latest caper, he said "Wow, I need to let Babcock know about this." Dick Day was next on my phone list, and he was frantic to learn all the minute details; after hearing the latest, he requested that I keep him informed. In the midafternoon, I received a call from BCI Inspector Babcock, and we talked for quite a while. He asked me numerous detailed questions, suggesting he was fully engaged and becoming much more concerned that this jerk was really up to something. I told him Vanderbilt had scheduled a meeting with me for Wednesday at three and asked him about how best to handle myself. "Should I be confrontational, or should I just play along with him?" He was silent for a moment and then said, "I want to be there." He indicated this was getting really worrisome, and he felt it was important for him to be in the building should anything get out of hand. We agreed that he would come to the museum at two, allowing us sufficient time to make plans. I was very much relieved to know he was taking this seriously. After our call, I breathed a sigh of relief, sensing that the few of us who were directly involved with this unseemly individual would now be getting some valid outside support.

Monday ended with a few more unrelated meetings. Trying to maintain a business-as-usual demeanor was getting more difficult, as my thoughts kept reverting to the pending meeting with Vanderbilt and how best to handle him. Because the holidays were rapidly approaching, Tuesday was consumed with meetings with the Volunteer Council decorating committee. I was approaching my third Christmas at The Hyde and was becoming a little more imaginative each year in decorating and staging holiday-related activities in the museum. In the past, before I arrived on the scene, there had not been much emphasis placed on Christmas decorations or activities, most likely due to family resistance and a lack of funds. But knowing that the holidays can be a major opportunity to entice locals to a return visit to the museum, particularly a house museum, I was making headway in breaking barriers. Over the last two years we had been able to grow new public enthusiasm for The Hyde. In decorating, I felt it was appropriate to emphasize the Italian Renaissance style of the architecture, collection, and furnishings. With two Della Robbia sculptures in the collection, it seemed only natural to decorate the museum with greens, fruits, and flowers reflective of the Della Robbia style. And now, with Ceil on staff, her Italian heritage, engendered a new boost of enthusiasm for the decorating committee and me. We were planning two holiday events, a professional musical group called L'Ensemble to perform on Saturday, December 13, and on the following Saturday, a holiday program by another musical group, the Saratoga Singers, to perform that evening. There were plenty of activities and operational issues to occupy every minute of my day, but my thoughts were periodically interrupted with flashes of concern about Vanderbilt's motives.

Wednesday was a cold, dark, day with periodic rain showers mixed with wet snow. However, the following day was Thanksgiving, so it was only natural that winter was hovering just around the corner. In the foothills of the Adirondacks, Thanksgivings were often as white as the Christmases. The morning started out with a jumble of business activities. Jim Kettlewell was now heavily engaged in the museum's catalog project, and Ceil and I had the responsibility of reading and editing some of his manuscripts. In retrospect I realize we were not qualified to undertake such a momentous task. There should have been several scholars involved—specialists in various art historical fields—as well as a professional editor. But the finances weren't available, and I felt an urgent need for a comprehensive overview of the collection, both written and visual. So few people were aware of this magnificent small art museum, it seemed like plain common sense that it would aid in spreading the word. Therefore, it was up to Ceil and me to take on the added responsibility, and for much of Wednesday morning, we were cloistered in the small third-floor workspace, the former office of Mrs. Hyde's curators, poring over Jim's esoteric script.

Before I knew it, it was two o'clock, and Officer Jim Babcock had arrived, with two additional plainclothes officers, setting the stage for the most important meeting yet with the infamous Paul Sterling Vanderbilt—or whatever his actual name was. Babcock first identified himself by showing me his BCI badge and then introducing his two fellow officers. There were only a few visitors meandering through the museum, and the four of us sat in the courtyard for a few minutes so I could update them all on Vanderbilt's latest capers. We also explored the various options for my conversation with him: how best to address the typewriter issue and what his reaction might be.

Babcock requested that I show him my second-floor office, where Paul and I would be meeting. It was a small, stuffy, rabbit warren of spaces. There were three tiny former maids' bedrooms retrofitted into makeshift offices—one each for Kettlewell, Ceil, and me—as well as a cramped bathroom. I showed him my office, and after he wandered through each of the minuscule spaces, he announced that he wanted to be hiding in Ceil's office next to mine during the meeting with Paul. "Just in case he tries anything serious, and so I can hear your conversations." God, it hadn't ever occurred to me that he might get violent, but I guess the good BCI state police investigator wanted to cover all the bases.

Babcock suggested that the other two officers circulate through the museum as though they were visitors and act as backup support should things get out of hand. He then asked me for a quick tour of the museum for the three of them so they would have a better sense of the layout of the place. As we walked through the various gallery rooms, I suggested that it might be a good idea if I tried to get Vanderbilt's fingerprints on something. Undoubtedly, I had been watching way too many TV murder mysteries. He hesitated for a moment and then agreed it was probably not a bad idea. I excused myself and went to the former Hyde kitchen pantry, where the staff coffeepot was located, retrieved a clear glass cup from the shelves, and quickly washed and carefully dried it, keeping it covered with a paper towel.

At about ten minutes before the appointed time Vanderbilt was slated to arrive, Babcock said he thought it was time to sequester himself in Ceil's office. We decided he would keep the door open slightly to be able to better hear our conversation. It was also agreed that if Vanderbilt saw Babcock in the office and asked who he was, I would tell him he was a curator from another museum doing research on one of our paintings that was slated to be lent to his museum for a special exhibition. Babcock went on his way, and I busied myself with a few operational matters.

Three o'clock came and went, and no Vanderbilt. This was unusual because the guy, if nothing else, had been exceedingly punctual for every meeting we had ever scheduled. About twenty minutes after three, I walked up to my office to check on Babcock. I told him how surprised I was that

Paul hadn't shown yet and wondered out loud if I was being stood up. He said, "Let's not give up yet, but I need to get out of this stuffy office for a few minutes." I agreed, and he said he was going to roam around the museum to look at some of the paintings. By now, there were a few more visitors touring the galleries, generating the typical staccato prattle that ricocheted throughout the structure.

I settled into my office, fidgeting with papers but clearly unable to concentrate on anything. At about 3:45, Babcock stuck his head in my office and said, "Well, what do you think? Is this asshole going to show or not?" Just as I was about to abort "Mission Vanderbilt," the phone rang. It was Muriel Eichler in the front office saying that my guest had just arrived: "Do you want to come down and greet him?" I told her I would and hung up the phone. Babcock quickly squirreled himself into Ceil's office, partially closing the door behind him, and I headed downstairs.

Dressed in his handsome overcoat and carrying a leather briefcase, Paul greeted me with a curt apology, saying that he'd been detained because some business transactions took longer than expected. I took his coat and hung it on the rack in the foyer, then suggested, because it was so bitterly cold outside, that I get him a nice, warm cup of coffee. He agreed, and I left him standing momentarily in the courtyard. I quickly went back to the pantry and cautiously poured coffee into the newly cleaned glass mug and my personal ceramic mug, which probably hadn't been washed for at least three months. I placed them on a small tray, picking up the glass mug with a paper towel around its handle to avoid leaving my own fingerprints. I then carried the tray out to the courtyard. As I approached him, he said, "I must talk to you in private. Is there a chance we can go to your office?"

Vanderbilt followed me up the steep back stairway. I wasn't sure if he saw Babcock in Ceil's office, but at least he didn't mention it. The three Selectric typewriters were stashed in Kettlewell's office and were partially visible, which undoubtedly must have raised his ire. He sat down on the chair next to my desk and put his briefcase on his lap as I placed the tray with coffee cups on my cluttered desk near him. The look on his face and his demeanor were unlike that of any of our previous meetings. He was clearly irritated.

"Fred, I am not very happy with you and your damn trustees. What's wrong with them? Why wouldn't they want someone of my social standing? Isn't that what museum boards do? And what's taking them so long in deciding about me renting the Cunningham House? Damn, Fred this is driving me crazy."

"Well, Paul, as I told you the other day, you are new to this community, and the board needs to get to know you first. Which, if I had some personal credentials and references as they requested, we could get the process started. What more can I say, Paul?"

"Look, Fred, I'm not sure I believe you anymore. I really don't think you're a very good director of this place. You know I am from a wealthy family, and truthfully I want to help the museum, but all you have done is drag your feet. Look, I'm sick and tired of all of this." He began leafing through his open briefcase, and in an elevated, angered voice, then said, "You should know that I have in here a thirty-thousand-dollar cashier's check for The Hyde from one of my Rockefeller acquaintances, but because you have done nothing for me, and you're such an unprofessional museum director, I'm going to give it back to him! In fact, you'll never, ever see any money from me or any of my friends." He stopped and took a drink of coffee from his cup and then spouted, "Look, I was nice enough to give the museum those typewriters last week, and what have you done for me? Nothing. And from what I've heard and seen, you aren't even using them!"

That was the perfect segue for me to introduce the subject I had been preoccupied with over the last few days. I had assumed it would be difficult, but, his fuming rampage now made it a lot easier.

"Well, Paul, let's talk about those typewriters." I dove into the whole messy story: the *60 Minutes* segment, the IBM representative who discovered the rental company labels, the serial numbers, the fact that they were rentals and not gifts. I said, "Just what do you want me to do with those damn things now?"

He looked at me a bit startled, then down at his briefcase while fidgeting through it as though he was searching for something. He then said, "Okay, if that's what you think of my generosity, I'll be more than happy to take them back with me now." He once again began to harangue me about my ineptitude, then brought up the thirty-thousand-dollar check again, chastising me by saying, "I wonder what your trustees would say if they knew that your incompetence lost them this much money." He slammed his briefcase closed and stood up. "I'm sorry, but it's time for us to part company. Clearly you're not doing anything for your institution, so why should I do anything to help you? Can you please help me with those damn typewriters?"

We walked to Kettlewell's office, and each grabbed one; he had a difficult time managing his with his briefcase, but he was able to follow me awkwardly downstairs. We set them on the refectory table, and while I returned for the third typewriter, he went to the foyer to retrieve his overcoat. Each of us carried one to the door, and there outside was the Rolls-Royce with his driver, Giles, who, when he saw us, jumped out and unlocked the trunk. Giles grabbed my typewriter, and I went back inside to retrieve the third. When they were safely stashed in the trunk, Vanderbilt turned toward me, and we shook hands. He coolly said, "It's been nice." I turned my back on him and went back inside the museum as the Rolls sped away on the circular drive.

Chapter 6

When I entered, Babcock was standing at the top of the back stairway, looking rather bewildered. "Well, I couldn't hear very much of your conversation, but it sounded like he was pissed. How did it go?" I was unnerved and a bit shaky as I spewed the essence of our little spat. "I guess our so-called friendship is over. The big question now is, just what do you think he's going to do?" Babcock shook his head and said, "Who knows? It sounds like he's nothing but a spoiled, arrogant kid. Maybe now he'll just go away."

We chatted a bit longer, and when I asked him if he would like to take the coffee cup with Vanderbilt's fingerprints, Babcock said, "No, just keep it in case he tries something else." He reminded me that Paul really hadn't committed any crime yet, and he'd taken back the rented typewriters. I followed him down the stairs and through the courtyard, where the other two officers were waiting. As I was helping him with his overcoat, he said, "Call us if anything else happens, but most likely, I think this jerk will finally leave you alone." I thanked him, and when I opened the front door for him to leave, I could feel the blast of cold air hit me in the face. I thought to myself, *What a strange winter day this has been.*

Ceil came out of the first-floor business office and said, "Sounds like things didn't go too well with Mr. V." I filled her in on our conversation as best as I could recall, and she laughingly said, "You're lucky he didn't punch your lights out about those stupid typewriters." I went upstairs to my office to retrieve the glass coffee cup. With a paper towel, I gingerly lifted it onto the tray and took it downstairs to the pantry. I carefully emptied it and asked Ceil to hold open a plastic sandwich bag into which the cup was placed, hopefully without smudging his fingerprints or planting some of mine in the process.

It was nearly five, all the visitors had left the museum, and the volunteers were finishing up with their duties and putting on their wraps. Ceil and I wished them all a happy Thanksgiving and locked the front door after they exited. We went back to the business office and chatted a moment with Muriel and Fran. I told them the details of my uncomfortable conversation with Vanderbilt. I must say, even though he was an ass, and his blustering was all show, it's never easy to be told that you're a worthless director and have failed your institution. My staff, however, was incredibly supportive of me, and we joked about the craziness of the day's events, collectively hoping that perhaps this would be the last time we ever put our eyes on this "arrogant shit." We finished up our day's activities and wished each other a happy Thanksgiving.

Ceil left first because she had a long drive ahead of her in her ramshackle, little Volkswagen Beetle to be with her family in Plattsburg. Fran and Muriel departed a few minutes later, leaving me to finish up with a few items of business before I rattled downstairs to set the security system and swiftly exit the museum. I jumped into my Volvo and happily headed home. It was

satisfying to know that I would have a day away from this insane place. I didn't really care about the holiday; all I wanted was some time away from work to decompress. Unfortunately, I had to be back at work that Friday, and I was facing weekend duty as well, so I had to make the best of the day ahead.

The Thanksgiving holiday was quiet for Becky and me. Her family lived in Indiana and most of mine in Washington state, so traveling to be with family members was out of the question, particularly given my overload of responsibilities. Further, Becky was working nights at the Glens Falls Hospital, and she had the duty over Thanksgiving. It was up to me to cook our holiday meal, a job I found not too distressing because I'd had plenty of cooking experience during my life and I actually consider food preparation a somewhat-creative outlet.

The museum was busy both on Friday and over the weekend. Even though there were a couple of inches of snow on the ground, visitors found their way to The Hyde. This was typical of holiday weekends; attendance is usually increased due to families looking for options to entertain their out-of-town guests. I must say, working on the weekends gave me a superb opportunity to converse with museum visitors, and getting direct feedback from the public is a splendid way to understand the institution's impact on people. For some, particularly the dilettantes, who thought they knew more about art than they really did, the collection was "full of fakes." They'd never seen that Rembrandt painting before, so it must be a fake, particularly since it was up here in the boondocks. For others, those schooled in the arts, touring The Hyde was almost a "religious" experience. There is a fresh, unexpected discovery around every corner—Rubens, Eakins, Renoir, Matisse, Homer, van Gogh—all agreeably displayed within the context and scale of a personal home. It was a special delight to speak to those visitors and answer endless questions about the Hydes and their collecting avocation. The more I could learn about the public's reaction to the museum, the better it was for me to plan for its future. And I fondly remember many pleasant weekends interacting with our visiting public.

Typical of the season, the days between Thanksgiving and Christmas are a whirlwind of activities. As noted, for the museum world, it's a fortuitous opportunity to entice the public to attend special seasonal programming and holiday decorations. Therefore, the week after Thanksgiving, the staff, volunteers, and I were in planning and implementation mode in preparation for the anticipated crowds. I tried as best I could to put "Mr. V" and his escapades out of my mind. There were arts- and business-related meetings away in Albany and Saratoga and several within the Glens Falls region to keep me occupied. And as the museum director, it was necessary for me to be a member of the local Rotary Club, which required some of my time for various holiday-associated activities as well.

Top of my mind was the pending full-board meeting slated for Tuesday, December 9. I'm sure every museum executive director has misgivings about board meetings. How to keep all trustees on the same page as one stumbles through the meeting agenda? Will one of them come up with some crazy idea that makes absolutely no sense? Is there a secret cabal in the works that will blindside my plans—and/or my job? Heading the list for this meeting, since the museum operated on the calendar-year business cycle, was the 1981 budget. I was presenting the board with a $167,000 budget, thirty thousand dollars higher than the current year. However, increased public support and various state and federal grants afforded the increase, and I was confident—well, maybe excessively hopeful—that the board would pass it without too much anxiety. There was always the understanding that if we experienced a shortfall, we would hold back expenditures. But I did have a history of having made some unsubstantiated financial commitments, and a few board members had excellent memories. So, I would have to meander through that minefield carefully. As the meeting approached, it became more apparent to me that even timelier than the annual budget was a frank discussion about the frightening antics of one Mr. Paul Sterling Vanderbilt. While I had prudently updated Dr. Day as events unfolded, I needed to be sure the whole board understood the ominous nature of my dealings with this crazy character.

The day of the meeting finally arrived. Beginning at about 3:30, board members began to stagger in for the 4:00 p.m. meeting. Because the museum was still open to the public, at that hour the meeting had to be held in the Cunningham House courtyard. It wasn't the most convenient situation, but it was the only private space large enough to accommodate the board. The Hyde House courtyard was normally used for meetings during non-public hours, which everyone greatly preferred.

Earlier that day, our janitor had shoveled the snowy walkway from the parking area and swept and cleaned the Cunningham House. He and Ceil carried folding chairs from the museum and arranged them in a circle. At that time, we were too poor to even own a boardroom table, but it wouldn't have made sense anyway, because all our spaces were multipurposed and there was no place to store a large table. However, the lack of a table made meetings very clumsy and seemingly all too casual. Meeting-related papers had to be held in laps and were forever falling on the floor, making for constant interruptions. Board members would often chitchat with each other, interrupting meeting agendas, so that at times I felt as though I was attending a kindergarten class.

At about 4:15, when the last of the trustees had arrived, Dr. Day called the meeting to order. After the minutes of the last meeting were approved, the chair of the finance committee gave his report, which he delivered in his usual somber style, generating a sense of impending doom. To elevate the tone, I

cheerfully reported on our successful receipt of a programming grant from the New York State Council on the Arts, as well as some wishful desire that we would again receive an Institute of Museum Services general operating grant, which would be announced in a couple of months. We had been victorious last year, and I had high hopes for continued success.

The chairman next asked me to present the 1981 budget. After passing it out, I gingerly presented the trustees with the anticipated year-end projections and discussed the various plans for new programming and various facility repairs and improvements. As usual, instead of listening to my presentation, most of the trustees immediately went to the last page to view my projected income and expenses. There were several questions from them, some thoughtful and others obviously trying to poke holes in my math. I tried as best I could to answer each with as much enthusiasm as I could muster. Finally, Dr. Day asked for a vote, and to my surprise the budget was unanimously passed. But there was the usual caveat that I should not commit the museum to any project that wasn't already fully funded—a reference to my past performance.

There were then the usual committee reports, and the meeting ended with the director's report. After highlighting our plans for the museum holiday festivities, which I knew few, if any, board members would attend, I launched into the subject of Paul Sterling Vanderbilt. I briefly described the sequence of events, culminating with the pilfered typewriters and our last, fateful meeting with me and a state police investigator hidden in the office next to mine. I even reported on his hypothetical thirty-thousand-dollar gift, which he'd withheld due to my so-called ineptitude—I definitely needed to get that off my guilty conscience. Dr. Day occasionally chimed in to add his observations and apprehensive concerns. All I could really report to the board was that I had grave trepidations about Vanderbilt's motivations. He obviously appeared to be a suspicious character and an apparent con artist, but the staff and I had done our best to protect the museum. The local police and the BCI had been involved, and they were purportedly increasing their surveillance of the museum.

A few board members asked pertinent questions about the situation, but they seemed not overly concerned about my observations. There was a lot of prattle and laughter among them, and as I watched, I couldn't believe their seeming indifference. The meeting finally ended, followed by the usual seasonal acknowledgments among them for a merry Christmas and happy holidays as they nearly tripped on themselves exiting Cunningham House to head home for a restful evening or perhaps a holiday party. I, on the other hand, had to rush home for a quick meal so I could attend a 7:00 p.m. meeting at City Hall, where there was a public hearing concerning some federal funding options that just might be applicable to the museum. My job never

seemed to end. I often wondered what Becky must have been thinking: *Will I ever see my husband on a regular basis—does he really love me, or does he love his job more than me?*

The days following trustee meetings are always a relief—the pressure was off, and I could get on with the duties at hand. At Tuesday's meeting, I had carried out my due diligence in reporting the antics of stupid Vanderbilt, even though the board hadn't seemed overly concerned. At least they had been informed, and if anything happened from now on, we would all be in it together.

With Saturday's holiday festivities facing me, I now had to reorient myself toward decorating Hyde House. Historically, from what little I could glean, the Hydes were rather understated in embellishing their home for the holidays. A small tree on a table was characteristic of their decoration. It was located either in the central courtyard, or in other years, in their library. Following the usual Germanic decorating style, their trees were laden with shiny baubles and festooned with glittery lead tinsel. Through a couple of old photos and some conversations with family members, this was all I could glean about the Hydes' holiday decorations. While I have always been sensitive to historical accuracy, the Hydes' conservative Christmas decorations just wouldn't cut it in my zeal to attract new audiences over the holidays. Therefore, I ordered a twelve-foot spruce tree to be placed at the back of the central courtyard, and over the next couple of days, the staff and volunteers wired oranges, lemons, apples and ribbons to the branches to somewhat emulate an Italian Renaissance, Della Robbia–style appearance. We made wreaths and arrangements with the same elements and placed them in appropriate areas that would not damage works of art or furnishings. The house emanated a glorious fragrance from the evergreens and fruit, as well as several terra-cotta pots filled with paperwhite narcissus placed randomly in the courtyard planting beds. No doubt it had to be *the* most unique Christmas decoration in the entire lower Adirondack region. What I hadn't fully taken into consideration was the swiftness of fruit to spoil once it was taken out of refrigeration and pierced with wire. However, with the occasional removal of the most egregious pieces of rotted fruit, our decorations lasted throughout our planned public activities.

Before I knew it, I was facing our first holiday event. Saturday, December 13, was a typical Adirondack-region, blustery winter day, with occasional snow flurries adding about two inches to the already-accumulated white blanket. Fran Eichler had the duty that weekend, leaving me free to join an afternoon Rotary Christmas party from which I had to depart early so that I could attend to the details of The Hydes' musical evening.

Over the years, I had begun increasing the museum's musical offerings. Granted, the building was not designed for large public music events, but

the center courtyard was spacious enough to squeeze in at least sixty folding chairs, leaving an uncomfortably small space for performers—which was even smaller, now given the twelve-foot Christmas tree. Chamber music groups found the space quite enchanting and acoustically lively. Obviously, this genre of music was meant to be played in the parlors of private mansions; therefore, Hyde House emanated with suitable charm and ambience. The special event for the evening was the musical group L'Ensemble. Under the leadership of its executive director and performing soprano, Ida Faiella, there were three musicians, a cellist, a violinist, and an oboist. Ida is a vivacious individual with an oversized dose of ambition. This was her third performance at The Hyde over the year, and it was to be the most festive because of the holidays.

Musical presentations were complicated affairs at The Hyde. The building's layout was not designed for public use. While it functioned somewhat well as a museum, requiring visitors to enter in and backtrack out of various rooms in a rather awkward manner, unlike the planned access routes of a typical museum, at least one can celebrate and acknowledge its original intent as a former home. However, when functioning as a music hall, with no stage, curtains, makeup room, green room, or a performers' bathroom, things could become quite problematic. The small downstairs library, home of the Rembrandt painting, as well as paintings by van Dyck, van Mieris, Rubens, Degas, and Ingres, had to accommodate all those needs, with the exception of no bathroom—at least I hoped no one would ever pee behind the couch. It had only one access door, which was from the open courtyard; therefore, the performers, once the audience was seated, were held hostage when not performing until the end of their concert. That precious room would be filled with instrument cases, coats, backpacks, music stands, and yes, sometimes even snacks and liquid refreshments.

As the director and general overseer of events I had to remain aloof, which usually meant I stayed near the front door to greet attendees, assist with coats, and hand out programs. I generally had no control of what might be happening in the library. At one performance, not with the L'Ensemble players, I can remember going into the library while the audience was trickling in and finding a performer sitting on a folding chair pressed up against the Rembrandt with a Kentucky Fried Chicken box on his lap, tossing greasy bones into a paper bag directly under the painting—I nearly crapped my pants.

At 6:30, the front door was unlocked to accept concert attendees. Luckily, Ceil was there, as well as several volunteers to provide assistance. The concert was free to the public because L'Ensemble was a nonprofit organization and had received some financial underwriting for The Hyde concert series. The usual faces appeared at the door as our evening audience began assembling—the little community of Glens Falls had a small, but amazingly loyal

following of classical music enthusiasts. The coatrack soon filled with bulky winter coats, given the frigid evening, and the folding chairs in the courtyard were rapidly filling.

At ten minutes after seven, when it seemed as though most of the usual attendees had arrived, I walked up the center aisle and turned to the audience to welcome them to the special holiday performance of L'Ensemble and after a few additional words about future programs, I introduced Ida Faiella, who swiftly pranced out of the library. As she was being given an exceptionally warm round of applause, I walked back down the short aisle, and, instead of finding a seat near the door, I sat in the back of the courtyard, knowing that Ceil was holding the position of handling any latecomers. In her usual warm and gracious manner, Ida introduced the musicians and briefly described the evening program. Before long, her melodious soprano voice was filling the voids of Hyde House, and the audience was enraptured with her animated face and articulate libretto.

About fifteen minutes into her performance, I heard the disturbing noise of the front door grinding open, and the rustle of coats and the muted voices of Ceil and whoever those goddamned late-coming idiots were. To my shock and incredulity as they came out of the foyer door, there were Paul Sterling Vanderbilt and a rather good-looking young lady, probably a few years younger than he. They were well dressed and straightaway filled the last two seats in the back row, pushed up against the lush, tropical dracaena plants. Paul had not spotted me when he made his entry, but once seated, he began to scan the audience. Suddenly our eyes locked, and he gave me one of the coldest, dirtiest looks I have ever received. He then averted his glance and never looked my way again.

The performers slowly worked their way through the program, from Mozart, to Tchaikovsky, Rachmaninoff, and finally Kreisler. I was normally nervous about our local audience, that they might inappropriately applaud between concert movements or before the end of a piece. The audience this evening was on their best concert behavior, however, and my worries in that regard were for naught.

Halfway through the Kreisler piece I noticed my friend Paul was whispering into his consort's ear, and suddenly they stood up and walked into the foyer. A few minutes later I heard the grinding of the front door. That asshole had yet again irritated the hell out of me, but at least I wouldn't have to deal with him at the end of the concert, when attendees would be invited to join the performers for a glass of wine. Little did I know it then, but that would be the last time I would cast my eyes on this little, greasy bastard. His next move would make headlines in all the regional newspapers, and I would finally learn his real name. Yes, I would see his face again, but it would be in the press, and I would finally come to learn of his real

motivation. And it wouldn't be a surprise to me, as he was obviously way too transparent.

The concert ended with a standing ovation as the performers went into and out of the library several times to bow and enjoy the enthusiasm of our appreciative local audience. Ceil and the volunteers then entered the courtyard with trays of plastic glasses filled with wine. Ida and the performers were in high spirits, chatting among small groups of attendees while the wine was being passed. At one point during the enthusiastic post-concert festivities, Ceil grabbed my sleeve and laughingly said, "Can you believe that asshole would show up tonight? What do you think he's up to now?" I just shook my head.

Soon the crowds were placing their empty plastic wine cups on trays and heading for the coatrack. Before long, we were assisting the performers to their cars with their instruments and saying our goodbyes with hugs and wishes for a happy holiday. It was almost eleven, and we were all really tired and happy to punch in the four-digit security code, slam the back door shut, and head home. At least I would have Sunday to do some Christmas shopping—*what in the hell am I going to get for Becky?*

The following week was punctuated with meetings of various levels of importance coupled with sessions with Ceil reviewing Kettlewell's catalog copy. Because I had the weekend duty, I took Friday off to spend some precious time at home. It was already the nineteenth of December, and I'd promised Becky I would search the Christmas tree lots around town for a decent tree and install it in the living room. By the end of the day, she and I were circulating around the tree, reminiscing about our various "special ornaments" as we hung them and remembering where we were when we purchased them—what sentimental creatures we are.

I woke on Saturday to a bitterly cold morning. The accumulation of snow was slowly growing, making it more difficult to keep my driveway shoveled out and the sidewalks clear. With a public concert at The Hyde facing me that evening, I was hopeful this would be a short-lived event. I arrived at the museum around nine in the morning and proceeded with my usual routine of turning on lights and examining each room and its precious contents. There was also the need to pluck an occasional piece of rotting fruit from the holiday arrangements and from the tall tree in the courtyard; I had to retrieve a stepladder from the basement to accomplish the task. This would be a central fact to stash in my memory bank to avoid in next year's holiday decorations—no more goddamned fruit. While it made for a handsome appearance, it was just way too much trouble.

Before long, the old Hyde mansion was buzzing with activities. Our loyal volunteers began showing up for duty, and men from a piano rental firm arrived to deliver and set up a baby grand for that evening's concert. A group called the Saratoga Singers would be performing that night, and they required

a piano. The Hydes had owned a baby grand, which was now located in the second-floor picture gallery. Unfortunately, the room was too small and too packed with art treasures to function as entertaining space. Moreover, moving that piano downstairs was just too precarious, given the design of the stairway with its midway landing and change of direction to the first floor. At noon, Jim Kettlewell showed up with yet another batch of catalog entries. He and I gathered in his cramped upstairs office to review his earlier batch and go over various questionable observations that Ceil and I had discovered. This was a back-and-forth process that was taking an inordinate amount of time, but it was one I felt driven to accomplish.

Luckily it was a sunny day, eliminating any further possible snow flurries that would have required shoveling and possibly a reduced audience for the evening's performance. Adirondackers were pretty brave when it came to driving in the snow, but a heavy snowfall obviously would have kept some of them home. I had become acquainted with the Saratoga Singers through Kettlewell, and this would be their first performance at the Hyde, or, for that matter, in Glens Falls. The program was to be the opposite of the previous week's performance. It was to be a festive evening of holiday music with the usual repertoire of Christmas carols and a few Hanukkah songs scattered among them. Unfortunately, the program was less well attended than that of L'Ensemble, but Christmas was only five days away, and the competition from holiday shopping and other parties was undoubtedly fierce. The evening ended a little earlier than the previous week, and I must say I was glad because I had to be back at the museum for duty the following late morning.

I was looking forward to the next week. Now that our holiday programming was over, the pressure was off, and I could begin to relax and wind down for the Christmas holiday. There were only a couple of meetings scheduled for the early part of the week, which would allow me time to catch up on the pile of paperwork that had been growing exponentially on my desk.

The weather on Monday morning was just the opposite of Saturday's. It must have been at least ten degrees below zero. The sky was clear, but the air was fiercely biting and nearly froze my nostrils when I went down the driveway to pick up the morning *Post-Star* newspaper. There was now about a foot and a half of layered snow on the ground, with much higher mounds of the frozen white stuff at the edges of sidewalks and driveways, the buildup of numerous shovelings. The morning weather forecast called for even colder temperatures throughout the day as an arctic blast was moving through the Adirondack region.

We were a one-car family, and Becky needed the Volvo that day to do more Christmas shopping at Aviation Mall in Queensbury, just north of Glens Falls. She drove me to work around nine that morning and said she would be back a little after five to pick me up at the end of the day. The museum being

closed to the public on Mondays was an opportunity for the janitor to do a thorough housecleaning. There were a couple of volunteer groups scheduled to meet during the day, and I had a one o'clock meeting with a few representatives of the family paper company, Finch Pruyn. Other than that, I was free to attack more papers on my desk.

Ceil spent much of the morning gathering rotten fruit from our sad holiday decorations. It had become a joke between us about the smelly, decayed fruit, and we teasingly accused each other of coming up with such a crazy, stupid idea. The late afternoon dragged on like molasses out of the refrigerator, and the darkness outdoors seemed to creep up by three forty-five. The wind had picked up, and the temperature was nearly fifteen below. Muriel and Fran both requested to leave early because of holiday commitments, and I happily granted them their request. Ceil left a few minutes later, leaving me alone to close up the museum. The janitor was always gone by 3 p.m. if he couldn't sneak out earlier.

About quarter after four, I, too, had reached my limit of concentration, and I called Becky to come retrieve me. When she answered the phone, I could tell by the tone of her voice that all was not well. She was upset because our beloved dog, Nutmeg, had just vomited on the front hallway Oriental rug after coming inside following a brief outdoor potty break. One of our dog's most outrageous habits was nibbling on frozen dog poop and then depositing it in a foaming blast of vomit, usually on our indoor rugs once inside the house. This had been an ongoing issue, and it had become one of those occasional marital flashpoints when the person who discovered it was the poor bastard who had to clean it, or so the rule went. And then there were those times when we both discovered a frothing treasure at the same time. We then did what I called the "vomit dance" in deciding just who was to go for the mop and pail.

Becky's frustrated message to me that evening was, "Honey, I can't come right away because I've got to clean up after this damn dog." I was so ready to come home that I blurted out, "Becky, if you come and get me right now, I'll happily clean the vomit." She cheerfully agreed, and even before I could sign a few more letters and turn the lights out in the museum's courtyard, I heard the honk of our Volvo—we lived only about a half mile from the museum. I turned out the office lights, punched in the security code, slammed the museum's back door shut, and swiftly headed for the car. It must have been around quarter to five. The blustery cold air was piercing through my body, and it was heavenly to open the car door and feel the rush of warm air. I slid into the front seat, kissed Becky, and said, "Take me home to the vomit."

Chapter 7

Saved by the Dog

Little did I know at the time, but The Hyde's valuable art collection and my personal life might have been saved by my desire to leave work early that Monday. Most certain, my willingness to let Becky off the hook by volunteering to clean our dog's disgusting puddle of vomit played a definitive role. My usual routine at the end of the day, when the volunteers and staff had left, was to take advantage of the peace and quiet to get some paperwork off my desk. In fact, it wouldn't have been unusual for me to have worked until six or later before calling it a day. However, I was ready to leave work before five that day, probably because it was three days before Christmas and the blustering cold weather augmented my desire to be at home in front of the fireplace with its mantle brightly decorated for the holiday. Needless to say, events would have been much more harrowing had Becky decided that the tattered, old hallway Oriental rug would be ruined if she didn't clean it immediately and had postponed rescuing me until she finished the job. Knowing my sweet wife, she would have been her usual meticulous self in undertaking a thorough cleaning of good old Nutmeg's mess, which could have taken a half hour or more.

The following morning, Tuesday, December 23, Paul Sterling Vanderbilt's perplexing actions over the last couple of months came to full fruition. I was rousted out of bed around 5:30 a.m. to be informed by an Albany, New York, police officer that there had been an attempted heist at my museum. The immediate details about the attempted heist were obviously sketchy, because the two perpetrators had yet to be apprehended, but the police felt that one of them could possibly be Vanderbilt. However, I came to the instantaneous conclusion that, indeed, one of them had to be Vanderbilt. He had been way too transparent in his dealings with me; in particular was his blatant fascination with art theft—who else could it have been? But the police mentioned two individuals. That was perplexing. My mind began to work overtime pondering whom they could have been associated with. Was he working for

a major crime syndicate, was it the mafia or was he just a stupid fool orchestrating an attempted art heist on his own with a couple of goons to assist him?

By the time I arrived at work Tuesday morning, the phone was ringing off the hook. The first call was from Dr. Day, who was nearly beside himself because he had just heard the news on the local radio station. They had run a brief blast reporting that there had been an attempted heist at The Hyde Collection in Glens Falls Monday night, noting that they would expand their report once more details were available.

Muriel and Ceil arrived a bit later. Neither of them had heard about Vanderbilt's attempted heist. When I told them, after I finished my phone conversation with Dr. Day, both were beside themselves. Ceil blurted out, "Now we know what that slimy little weasel was up to!" I received several other phone calls that morning, including one from Joe Cutshall-King, director of the Chapman Historical Museum, who teasingly said, "Man, Fisher, I'm glad he went for your place and not mine." His gallows humor was well appreciated given the tensions of the morning.

In the early afternoon, having not heard a thing from any of the regional police departments, I called Chief Dugan to find out if he had any new information. Unfortunately, the chief was helplessly circuitous with his responses, and I learned little to nothing new from him. We kept the radio on in the museum's office in hopes of gathering news flashes, but what was reported throughout the afternoon was pretty much a repeat of what we already knew. In fact, it wasn't until I got home that evening and tuned in to the NBC television station in Albany, WNYT, that I got my first overview of the still-unfolding story of The Hyde caper—but the lead storyline was not an attempted art heist; it was a kidnapping. "Brian Michael McDevitt, age twenty, from Swampscott, Massachusetts, alias Paul Sterling Vanderbilt, was arrested at two p.m. today in his Glens Falls home. He was later arraigned on a charge of second-degree kidnapping and is being held in the Saratoga County Jail. Police alluded to a second suspect, but they did not provide details pending his arrest. McDevitt is alleged to have kidnapped at gunpoint a Federal Express courier by the name of Mary Winglosky in South Glens Falls in Saratoga County as she was making her deliveries. She was etherized by him and his accomplice. They then drove her truck, with her inside, toward The Hyde Collection in Glens Falls with alleged plans to enter the museum before its staff had left for the end of the day, with the apparent intent to steal many of its famed works of art. Fortunately for the museum, the perpetrators were blocked by a holiday traffic jam on the bridge crossing the Hudson River to Glens Falls and arrived minutes after the museum closed, foiling their plans. After Ms. Winglosky was revived from her induced sleep, the two assailants parted company, allowing her to return to Albany in her Federal Express truck."

I remember looking at Becky and suggesting that I truly needed a second "very large" scotch to digest what I'd just heard. Then what immediately came to mind, as my mutt dog sat near my feet with her chin on my knee, pleading for a peanut as I drank my scotch, was Nutmeg's vomit—that goddamn dog had truly saved my museum and possibly my life. "Nutmeg, I love you."

The following day, Christmas Eve, seemed totally absurd. Most of the staff were off for the holiday, so I had to take on added secretarial duties. I received a few calls from members of the press who were fishing for juicy quotes. Most of their questions were focused on values: "Just how much do you think that Rembrandt is worth?" "What's the value of the whole collection?" "How much did the Hydes pay for their collection?" For museum professionals, the financial worth of art works is restricted information. Sensationalizing our collections by attaching price tags to them is counter to our educational mission—it's the art's historical value that we would much prefer to encourage. My universal response to questions relating to the collection's total worth was "many, many millions." And then, from the last reporter who called, I learned the newest nugget of information of this slowly developing wretched story: "At 8:00 this morning, they arrested the second guy who tried to rob your place. His name is Michael Morey; I think he works at the Queensbury Hotel. I believe he's a good old Glens Falls boy." That piece of news took me aback, but then it occurred to me that if McDevitt had only been associating with local creeps, hopefully he wasn't affiliated with an underworld crime syndicate—on second thought, they might just be his hired help. *God, it will be great to get to the bottom of this mess.*

At some point later in the day, Jim Kettlewell called to expound upon the recent events. He was a little sheepish in acknowledging that I was pretty much on target to have been suspicious of this guy. Since our first encounter with Mr. Vanderbilt/McDevitt on Halloween day, Kettlewell had held out hopes, that this character could really be legitimate. However, since the typewriter incident, he had begun to side with my skepticism.

When the volunteers arrived prior to the museum opening, they were all abuzz with questions and concerns for their personal safety, as well as the safety of the collection. There were mixed reactions, between fear and ebullience: "Wow, the museum is really getting some extensive publicity now." Small-town folks thrive on recognition, but for me, this was not the kind of exposure I was seeking—believe me, I'd wanted anything but this. For the first time since I had arrived at The Hyde as its director, I fully appreciated this newest volunteer concern for their personal safety as well as the collection's. I had blithely maintained the past accepted norms of operating the museum without insisting on paid security staff. I had requested it but never insisted on it. Nevertheless, the board wouldn't even entertain such an idea

because the museum had all those devoted volunteers (mostly elderly ladies) to do the job for free. But now we'd had just had a brutal awakening—this would give me significant leverage for requiring more security in the future.

It was almost a waste of time to have opened the museum to the public on Christmas Eve. Only a few visitors trickled in during the bitter wintry afternoon. A couple of them had heard of the attempted heist and were curious, hoping that we would expound on the sensational details. I had cautioned the volunteers before opening to keep a low profile since we didn't need to make this any more far-fetched than it was, and anyway, there were too many unknowns about the developing story. By four thirty, the museum was empty of visitors, and I sent the volunteers home. There had not been any further updates on the McDevitt caper, as the story seemed to have become obscured by the revelries of the Christmas holiday. I left for home not long after the volunteers departed. I, too, "needed a little Christmas" as Jerry Herman's song from his Broadway musical *Mame* goes, to escape from this almost-otherworldly experience.

Becky and I enjoyed a quiet Christmas morning, opening gifts and nibbling on homemade cookies and moist fruitcake. It was brilliantly sunny, but the temperature was ten degrees below zero—a record-breaking cold Christmas Day in the entire Northeast region. In the early afternoon, after I helped Becky prepare some of the holiday dinner, I headed to the little newspaper shop near the Glens Falls Adirondack Trailways bus depot, to get a copy of the Albany *Times-Union*. Just possibly there might be some additional press revealing a few more details about the attempted heist. The Albany reporters I had spoken with the day before had alluded to stories they were working on. To my surprise, on the front page, above the fold, encircled by a bold black border, was one of two companion articles. One titled, "Heavy traffic foils scam to steal artworks," by staff writer Ronald Kermani, and the other, "Rembrandt would entice thieves," by Fred LeBrun, executive art editor of the *Times-Union*. It was the featured blockbuster news for Christmas Day. While the story would not have been my first choice for some much-needed press, I couldn't believe this was getting such prominent newspaper real estate. It had even superseded such interminable end-of-the-year news stories as President-elect Ronald Reagan's cabinet member appointments and the unsettling U.S. hostage mess in Iran. After I purchased the paper, I sat in my freezing Volvo, quickly scanning the articles to gain any new pertinent facts and to discover any possible misquotes from yesterday's phone interviews. When I got home, I stood in the kitchen reading the articles aloud to Becky as she was putting the finishing touches on our Christmas dinner.

Kermani's article helped a bit to clarify some of the haze that still engulfed this crazy story. The two perpetrators were both in the Saratoga County Jail, initially charged with second-degree kidnapping, as I was already aware, but

"The Art Heist That Failed: But not for lack of imagination."
Ronald Kermani, *Times-Union*, Albany, New York, January 4, 1981.

there were still pending charges of conspiracy and weapons possession. Most of Kermani's facts were gleaned from the South Glens Falls police chief, Richard Noonan, who reported that McDevitt had rented a garage in South Glens Falls that he used as a venue to lure a Federal Express driver on the pretense of retrieving a package that was being sent to one Bill Johnson. However, McDevitt wasn't at the garage for the pickup; he was shivering in an automobile within viewing distance of The Hyde, observing the museum's activities throughout the latter part of the day. He had ordered his bumbling associate, Michael Morey, to do the dirty work of overtaking the Federal Express driver. Luckily for him, the driver apparently didn't offer any resistance as Morey, brandishing a gun, entered the van and ordered her to start driving.

After a few minutes of circling through the small burg of South Glens Falls Morey made her pull into an alley and park. He next ordered her out of the truck, cuffed her hands behind her back, and taped her eyes and mouth. He then assisted her into the back of the truck with its jumble of parcels before soaking a cloth in ether and placing it over her nose. She immediately succumbed; the newspaper article noted she was knocked out for approximately ninety minutes. Luckily, for her it wasn't more consequential, because poorly administered ether can cause serious irregular breathing or even death.

Morey got into the driver's seat and headed the van to the bridge crossing the Hudson toward Glens Falls. Unfortunately for him, the two-lane bridge was clogged with rush-hour traffic, which was particularly heavy that night given the proximity to Christmas. He finally arrived to where McDevitt was parked staking out The Hyde, and the two of them hurriedly headed to the museum. One can only imagine the blistering conversation between them because of Morey's delayed arrival.

They drove into the museum's circular drive, several minutes after Becky had picked me up, in false hope that a staff member might still be present. When they determined the building to be secure, they realized that their elaborate, and might I say tremendously clumsy, plan had failed, and apparently, they didn't have a "plan B" in the works. It was clear that they had determined not to break into the building, which would have activated the museum's security system. Luckily this fool had taken my words seriously about the museum having a state-of-the-art security system—it was good, but not *that* good. Even though I knew better, it had been my standard response to anyone who questioned me about our security when the museum was unoccupied. In fact, Kermani even quoted me in his article: "They knew they wouldn't stand a chance of getting in once the main doors were locked because we have a very fine alarm system."[1]

The article went on to report that once the two perpetrators realized the failed fate of their mission, McDevitt and Morey had to drive around Glens Falls for about three hours while poor Mary Winglosky slowly revived from her induced sleep—an inconsistency because earlier in the article it had said she was only out for ninety minutes. They eventually parked the van in the lot of the Howard Johnson's Motor Inn on Aviation Road, near the Exit 19 intersection of Interstate 87 (known as the Northway). They had planted a getaway car there, and after consoling Winglosky, they jumped out of the van and drove off into the frigid darkness. The poor, befuddled Federal Express driver pulled herself together, and being a diligent employee, finished her delivery rounds before calling her boss, George Baker. He, in turn, notified the Federal Express security office, who then alerted the state and local police. Kermani completed his article by noting, "It was an elaborately planned conspiracy which had its roots in the area for about six months, police said. McDevitt was known to museum director Fred Fisher, who said Wednesday, 'the fellow made me suspicious some time ago.'"[2]

For the first time, when I read this article in the *Times-Union*, the gravity of this stunt fully sank in. It was an emotional roller coaster for Becky and me. One minute we were talking about just how serious it could have been if the sequence of events had been slightly different, and then we were howling with laughter about the two bumbling idiots arriving at the closed museum with this poor driver conked out in the back of her delivery van. Now the

humor was dissipating as the reality was spelled out in black and white in one of New York state's leading newspapers.

Fred LeBrun's companion article began with this sobering opening; "If thieves had been successful in entering the Hyde Collection gallery in Glens Falls, most certainly the number one item on their Christmas list would have been the collection's Rembrandt, *Christ with Folded Arms,* a piece that would have fetched well more than $1 million in the European underground art market. It is unlikely the thieves, even working half the night, could pack a truck with a fraction of the 120-piece Hyde Collection, valued conservatively in excess of $30 million in today's art market."[3] All of my oblique discussion with him about the value of the collection had been ignored as he determined its value on his own. No doubt in the eyes of the press, such a wild story wouldn't be as effectively scandalous if it wasn't affixed with a humongous price tag. He went on to describe the difficulties of attributing values to works of art and even noted that, "galleries are not anxious to discuss the value of a collection"

Much of LeBrun's article recalled the story of the Hydes and their marvelous art collection displayed in their home in Glens Falls. He, too, ended his article with a quote from me, in which, again, I was trying to put a positive spin on the story: "Our collection is so well documented; it would have been virtually impossible for the thieves to sell any of it on the legitimate market." That was undeniably stretching the truth quite a bit, because I had been trying without success to get the trustees to support a security staff. And it was the only reason why I had been so driven to get a catalog of the collection published so it could be disseminated to art research libraries worldwide for that very purpose.

Pieces of the puzzle were slowly beginning to come together. Over Christmas dinner, Becky and I ruminated about the various alternative scenarios that might have occurred had these two idiots been successful with their mission. Just what were their plans for me? What would they have done had several of the staff and volunteers been present as well? Were they planning to etherize all of us, or would they have used their guns to avoid being identified? McDevitt didn't seem to be the killer type—but on the other hand, just what is a "killer type"? Where were they going to take the stolen goods? Were there mafia creeps waiting in the wings to take the looted treasures off their hands? And probably our biggest worry, now that it had failed: Would there be another attempt by someone else?

"Becky, you could have been viewing my remains today at a local funeral home had those two bastards been successful."

"Please honey; let's not go there. Remember, it's Christmas."

I must say this was the most extraordinary Christmas we had ever had. In fact, it really didn't feel like a holiday; this event had, beyond doubt, overtaken our lives.

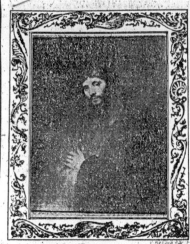
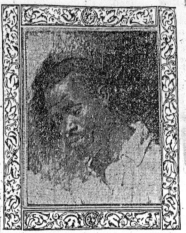

PRICELESS PAINTINGS — Rembrandt's "Christ with Folded Arms," (left), and Rubens "Head of a Negro," both painted in the middle 17th Century, were among the masterpieces art thieves had hoped to cart from the Hyde Collection. The theftattempt, however, was foiled.

Rembrandt would entice thieves

By Fred LeBrun
Executive Arts Editor

If thieves had been successful in entering the Hyde Collection gallery in Glens Falls, most certainly the number one item on their Christmas shopping list would have been the collection's Rembrandt, *Christ With Folded Arms*, a piece that would have fetched well more than $1 million in the European underground art market.

It is unlikely the thieves, even working half the night, could pack a truck with a fraction of the 120-piece Hyde Collection, valued conservatively in excess of $30 million on today's auction market.

The difficulty in fixing a value on the many masters there, the Degas, Picassos, Rubens, El Grecos, and many, many others is that they have been out of auction circulation so long it is difficult to get a fix on current value. Value of artwork is actually determined by what someone is willing to pay. A painting that was sold for $500 10 years ago but now sells for $100,000 at a Sotheby Park-Bernet auction is "worth" $100,000. Since public tastes change rapidly and whimsically, the value of many paintings is almost impossible to determine.

Additionally, galleries are not anxious to discuss the value of a collection, which was well known by Louis and Charlotte Pruyn Hyde, who at the turn of the century began accumulating paintings for their private collection.

He was graduated from Harvard Law School, and she was the daughter of local paper magnate Samuel Pruyn. They bought throughout Europe, patiently and conservatively for the most part, and without any plan — whatever moved them. But they boughtH9wisely.

As a hedge against the vagaries of public taste, the Hydes collected lesser known or appreciated works by established masters. Eventually, many of these lesser works, like El Greco's *James the Lesser*, or Ruben's masterful *Face of a Negro*, were elevated to major work

See Rembrandt, Page 4

"Rembrandt would entice thieves."
Fred LeBrun, *Times-Union*, Albany New York, December 25, 1980.

Fran Eichler took the duty Friday, the day after Christmas, and opened the museum with a few volunteers. Ceil was supposed to have worked the weekend, but because she had joined her family up north in Plattsburg for the holiday, I volunteered. Becky and I didn't have plans, and it was easier for me to be on duty than for Ceil to give up her holiday with family. I arrived at the museum about eleven thirty on Saturday and went through the usual routine of turning on lights and opening drapes to illuminate the inviting Italian Renaissance–styled interiors for public viewing.

Halfway through my rounds, the doorbell rang, announcing the first wave of volunteers who were to assist me with their friendly, small-town hospitality. Since the *Times-Union* Christmas news article and a story about the attempted heist in the local Glens Falls's *Post-Star* the following day, there was lots of buzz among the volunteers. I could tell they were invigorated and poised for many lively conversations with visitors.

And, indeed, both Saturday and Sunday were some of the busiest days I had yet experienced as the museum's director. Crowds of people from the Albany-Schenectady-Saratoga area paraded through The Hyde, most of them having never heard of the place before, looking for the thirty million dollars' worth of art works. There was a strange mix of people, typically a few arts-savvy folks, but most were thrill seekers wanting to see the valuable Rembrandt and Rubens paintings that were pictured in the *Times-Union*. The volunteers and I spent the afternoons answering questions about the collection and, of course, trying to avoid juicy details about the two perpetrators. I endeavored to downplay the sensational and highlight the strengths of the place, attempting to put a good face on our security. Unfortunately, many of the smarter visitors looked around and straight-out asked me, "Well, then, where are your uniformed security guards?" They had a damn good point, and I could only admit to them, with a red face, that as operational funds increased, we would, indeed, now be hiring more guards.

This was going to be great fodder for my trustee meeting in January. I had been requesting paid security staff for quite some time but was continually rebuffed by finance committee members as being overzealous: "God, Fred, this museum has been open to the public since 1963, and our wonderful volunteers have done a magnificent job of protecting the place. You worry way too much; we're doing just fine." I was now convinced that this scary incident, featured in all its violent details in all the regional newspapers, would beyond doubt give me the necessary ammunition to beef up our security. As time had progressed in my leadership role at The Hyde, I'd realized I could only be successful in raising the operational standards of the museum by moving slowly and incrementally. These small-town trustees, while thinking they were abundantly well-informed to operate a museum of this caliber, had a lot to learn. It was becoming increasingly evident to me that, if I were to be successful, I truly needed them to hear some external, professional voices besides mine so that they might better appreciate that I wasn't just making this stuff up—but that had to be engineered cautiously and over time. However, now that we had nearly lost the whole damn collection to a couple of petty thieves, just maybe I might be triumphant in beefing up our security.

Glens Falls's local newspaper, the *Post-Star*, first reported the attempted heist the day after Christmas. And on the following day, Saturday, an article written by Don Metivier started out by noting, "An elaborate plan to steal $50

million in art treasures from the Hyde Museum in Warren Street got fouled up by holiday traffic this week, police said."[4] Wow, the museum's collection was growing in value by the day.

Metivier had called me the day before Christmas seeking some information about my knowledge of McDevitt in preparation for his article. Much of his story was fairly like the *Times-Union* pieces. However, there were some new morsels of information that expanded the narrative a bit. McDevitt and Morey were apparently brandishing a pellet gun as opposed to a more serious weapon, which made me breathe a bit easier. They were also carrying a quantity of ether and rags to use on us once they entered the museum. In expanding on McDevitt's background, Metivier noted that while living in Glens Falls, McDevitt had a guy arrested who had come here from Massachusetts in an attempt to collect on a past debt. That fact gave me the jitters, making me even more suspicious of McDevitt's affiliation with the underworld. One last tidbit of information: in addition to his earlier visit to City Hall to review architectural plans of the Hyde and Cunningham Houses, he had also "sought information about the museum's sophisticated alarm system." I was glad Metivier used the word "sophisticated," but who in God's name did McDevitt speak with to seek information about our security system?

The *Post-Star* printed a second story about the attempted heist in its Saturday, December 27th, edition, written by Dan Amon, staff writer. After his introductory paragraph describing yet again the basic details of the caper, he mused about its sensational repute in typical small-town hype: "What one official called the most important local police case since the 1973 Robert Garrow and 1974 Cabaret multiple-murder cases apparently was foiled Monday night when holiday traffic prevented two suspects from reaching the Warren Street Museum in time."[5] The article went on to note that Michael Morey had been released on ten-thousand-dollar bail, but that McDevitt remained in the Saratoga County Jail in lieu of fifty-thousand-dollar bail. Amon completed his small news story with something I hadn't given much thought to as the whirlwind of specifics gradually unfolded: "A still-unresolved question was where McDevitt got the funds to present a lifestyle worthy of a Vanderbilt." Nonetheless, the question he posed could not be answered by the poor, underpaid staff of the humble, little *Post-Star*. That was a challenge only a more sophisticated, better-financed newspaper, like the Albany *Times-Union*, could undertake. In early January 1981, they would pursue this avenue of investigation in a three-part exposé that is the most comprehensive backstory written of the lives and antics of Brian McDevitt and his accomplice, Michael Morey.

The following Tuesday, mid-morning, Ronald Kermani, Albany *Times-Union* staff writer, met with me in my second-floor office and spent a couple

of hours teasing out the unfolding story of my two-month adventure with Brian Michael McDevitt, alias Paul Sterling Vanderbilt. Ron is a pensive individual who asked expansively relevant questions with suitable follow-up inquiries. I could tell by his line of questioning that he was working on an all-encompassing telling of the story and that he wasn't going to be satisfied until he had done some serious homework. At the end of his interview, he hinted that he might be calling me for further details and noted that he hoped his paper would support his investigation.

On New Year's Day, Kermani threw out yet another bombshell newspaper article. On the *Times-Union* front page, Kermani answered the question posed by *Post-Star*'s reporter Dan Amon as to McDevitt's capability of subsidizing his "Vanderbilt lifestyle." Under the headline, "Man in art heist try faces $100G rap," Kermani opened with, "Boston police issued an arrest warrant for Brian M. McDevitt Tuesday—the 20-year-old college student who allegedly planned to rob the Hyde Museum in Glens Falls of priceless art— on charges he stole $100,000 from a Boston bank account."[6] Apparently, this slimy character had gained access to an individual's safety deposit box at the New England Merchants National Bank in Boston and had absconded with investment bonds and cash. In the article, Kermani quoted Boston police detective Roy Prout as saying, "For one year I've been chasing this guy," and referred to him as described by his friends as a "smooth talker and aggressive manipulator." That was for damn sure. I, too, could wholly attest to that! Kermani noted that Prout had been serendipitously listening to a Boston radio news broadcast one evening that happened to report on McDevitt's failed heist in Glens Falls, and he immediately called the Saratoga authorities. The Boston arrest warrant, Kermani postulated, would be forthcoming, and most likely there would be extradition proceedings once McDevitt's legal dealings were fulfilled in Saratoga.

This newest piece of the story undoubtedly lit a fire under Kermani's backside to pursue his investigation toward an expanded exposé. It had all the components of a good crime thriller, or might I say, given the hilarious screwup of McDevitt's botched heist attempts, perhaps more of a sick comedy. Occasionally Becky and I would joke about this crazy tale being made into a Hollywood motion picture, and of course, given her tendency to keep me in my place, decided the perfect actor to play my part was Buddy Hackett, as opposed to Robert Redford, my much-preferred first choice.

Kermani's expert investigative work for the three-part serial in the *Times-Union* has become the single-best accounting of McDevitt and his Hyde Collection adventure. His meticulous research has provided many of the details for the following narrative.

NOTES

1. Ronald Kermani, "Heavy traffic foils scam to steal artworks," *Times-Union*, Albany, NY, December 25, 1980, 1.
2. Ibid.
3. Fred LeBrun, "Rembrandt would entice thieves," *Times-Union*, Albany, NY, December 25, 1980, 1.
4. Don Metivier, "Hyde Attempted Theft," *Post-Star*, Glens Falls, NY, December 27, 1980.
5. Dan Amon, "Pratt arraigns 2 Hyde Suspects," *Post-Star*, Glens Falls, NY, December 27, 1980, 9.
6. Ronald Kermani, "Man in art heist try faces $100G rap," *Times-Union*, Albany, NY, January 1, 1981, 1.

Chapter 8

Brian Michael McDevitt

Thus far, I've described the McDevitt caper frankly from my vantage point, as how I experienced his shenanigans and what I learned about them through the media once his attempted heist failed. As the story unfolded, there were several facts that were misinterpreted or just plain incorrect. In these pages, I shall examine the story through what is known about McDevitt's life, including his youthful journey in the criminal underworld leading to his eventual attempted robbery of The Hyde Collection. In addition to the excellent reporting that was accomplished by Ronald Kermani's three-part series run over consecutive days for the Albany *Times-Union*, I have relied on various contemporary news stories as well. However, what has further contributed significantly to the vivid narrative are the sworn statements given to the police once McDevitt and Morey were arrested, as well as the witness statement of the FedEx driver. These direct quotes were recorded by a stenographer and are presented here directly as transcribed. Further, my knowledge of the events was additionally enhanced by an interview with Michael Morey, as well as interviews from other individuals who had direct or indirect contact with McDevitt. There is some repetitiveness as the story unfolds, but it is essential in tying all the colorful events together.

Brian Michael McDevitt was born July 29, 1960, the first child of parents John H. and Mary A. McDevitt in Swampscott, Massachusetts. The McDevitts had three other children: Colleen, Melanie, and Sean. Brian's father had a career in education. He was a graduate of Georgetown University, Washington, DC, and later became a guidance counselor at the new suburban Swampscott High School. Little is known of Brian's early years, but based on his aggressive behavior, one can assume he must surely have been a rather precocious child. He entered high school in the fall of 1974, the same school where his dad worked as the guidance counselor. In his sophomore year, Brian was elected vice president of his class, and he was successful in maintaining that position in his junior and senior years as well. Ronald Kermani wrote in his *Times-Union* exposé, "Swampscott High School was Brian's

castle. His classmates were his serfs, and whenever McDevitt slammed his fists on the student council round table, his peers paid attention."[1]

McDevitt's interests strayed well beyond the confines of school. As early as his sophomore year, he became involved in politics. He began as a volunteer for the campaign to elect Michael J. Harrington, Democrat from Massachusetts's sixth district, to the U.S. House of Representatives. This worldly experience apparently engendered in him an obsession with politics. Later he maneuvered himself onto the state board of education as a student advisor, which allowed him some additional political leverage, whereby he joined the Michael Dukakis gubernatorial campaign as a low-level volunteer. In his senior year, he was a local unpaid helper for the Jimmy Carter presidential campaign.

One senses that McDevitt reveled in being able to ascend into the adult world. His principal, Bertrand Roger, told Kermani that he "moved into adult circles and was taken into their confidence very quickly."[2] However, he seemed to have turned off many of his classmates. David Townsend, a fellow student at Swampscott, noted that, "He was a politician from the first day anyone knew him. Everyone knew he was kind of dangerous. He was always working for his own benefit. He had great expectations, but few realizations."[3] Nevertheless, he impressed various members of the school staff. Principal Roger expounded, "If you looked at him in his senior year, you could not help to say this young man was going to go a long way. He had the tools. . . . the energy and the ambition."[4]

In addition to his participation in the student council, McDevitt engaged in a variety of extracurricular activities, including the student newspaper; the yearbook; *Seagull*, the school literary magazine; intramural tennis; and basketball; as well as becoming president of the meteorology club. His interest in meteorology, in fact, led him to write an article on tornadoes, which was published in the Bulletin of the Meteorological Society. He apparently had somewhat of an artistic bent as well, because in his junior year, he was art editor of the literary magazine, and in his senior year, he took courses in sculpture and painting, which earned him good grades. Theater likewise interested him; in his junior year, he was appointed executive producer of the junior class show.

Beyond school, Brian had a freelance gig for The *Reporter*, one of the local weekly newspapers. Giving a sense of the impression he made on school staff, he was chosen to represent Swampscott High School for the forty-ninth annual citation dinner of the National Conference of Christians and Jews—this was a kid who did not shy away from the spotlight. His principal additionally noted, "He loved to be out in front and take charge. He was a selfless kind of kid, one who was out to promote his class and school. And he was a good kid to have—he worked with you instead of against you."[5]

In McDevitt's senior year, his world enlarged. He was able to complete all his coursework credits during the first half of the year, thereby allowing him to inhale the heady political environment of Washington, DC, during the last three months of the school year. He was successful in being selected to work for the newly elected U.S. Representative, Edward Markey, Democrat from Massachusetts. Brian was a low-level worker in Markey's congressional office, performing various clerical duties but no doubt garnering social skills and making connections that would benefit him in later years.

Back in Swampscott at the end of his brief Washington stint, McDevitt ended his secondary education with notable recognition on being selected by the Daughters of the American Revolution to receive a Good Citizen Award. One wonders how someone held in such high esteem by so many adults in his community could stumble so badly in such a short amount of time. He was well equipped to sidle up to adults in order to obtain all manner of accolades, but he seemed quite unpopular with his classmates. Brian was apparently a bit of a loner when it came to his contemporaries—they clearly had a much keener ability to peg his obvious personality flaws.

In his senior year, facing the finality of his high school education, McDevitt applied to various colleges, including his father's alma mater, Georgetown University. Unfortunately, he didn't make Georgetown, but he was accepted at Bates College in the colorful little town of Lewiston, Maine—far from the politically embroiled environment of Washington, DC. From what can be gleaned about his year at Bates, he was likewise dismissed by his classmates. Kermani reported in his *Times-Union* article that a Bates College graduate noted, "He wasn't regarded very well. He had very few friends, and nobody trusted him. We all thought he was a phony."[6]

McDevitt continued to hone his charlatan skills. He passed himself off as an important Washington protégé, driving around Lewiston with a congressional parking medal on his car, flashing photos of himself with various politicos, and using official congressional stationery in an attempt to portray himself as someone he clearly wasn't. Being away from Swampscott, he felt free to pass himself off as someone with a pedigree in order to gain status, a strategy he would use quite often but with dubious success. His youth and eagerness brought about a transparency that even his Bates classmates quickly pegged as "phony." At Bates, his studies were centered on political science, and like he did in his high school experience, he involved himself in extracurricular activities, including working on the school newspaper. However, unlike his high school years, where he was enthusiastically accepted by the administration and faculty, his first year at college seemed to be far less triumphant. Brian failed to enroll for his sophomore year at Bates, ending his undergraduate education until several years later. One can only assume that by so doing, he did not ingratiate himself with his parents, particularly

his high school counselor dad. Whether he recognized that he had burnt his bridges in tiny Lewiston or that it was much too staid for his political ambitions is uncertain, but soon after he left Maine, he threw himself back into politics in Boston.

Almost immediately after Bates, young Brian joined the ill-fated presidential campaign of Republican John B. Anderson, who was competing with such noted aspirants as George H.W. Bush, Howard Baker, and Ronald Reagan. Sensing disappointment, McDevitt reverted back to the Democratic Party. He initially affixed himself to the Jerry Brown presidential bid. However, when Brown's chances appeared to be faltering, McDevitt decided to join the Ted Kennedy presidential campaign. Kennedy was more promising as the best candidate to beat President Carter, whose polling figures were sorely flagging.

Now moving in exhilarating political circles, McDevitt became more aggressive. According to Ron Kermani, Brian was fully engaged in Jerry Brown's campaign, so much so that he was known to often sleep in the office wing over the weekends—either due to a high degree of dedication or possibly because he was an unwelcome visitor at his family home. For one of his *Times-Union* articles, Kermani interviewed the building superintendent of the seventeen-story Boston office building, site of the Brown campaign office suite. The superintendent reported an obnoxious incident when McDevitt became irritated one night because he couldn't get into a locked office and kicked the door in. The super, Carmen Febbo, said, "I never liked that guy. He was a wild kid."[7]

McDevitt's behavior was transitioning from that of a ruthless undergraduate to someone bound for a life of crime. While he was ingratiating himself to a wide range of movers and shakers in Boston's political sphere, he was also seeking means to improve his financial standing. Sometime in the late spring of 1979, after he had left Bates, he devised a strategy to similarly ingratiate himself inside the banking world. He applied his sycophantic routine once again, but this time he was remarkably successful.

Much of this tale likewise must be credited to Ronald Kermani, who wrote a lengthy article in the Albany *Times-Union* in March 1981 highlighting McDevitt's ambitious scheme to fatten his wallet. His basic strategy was to become a familiar and regular bank customer at a few Boston banks in hopes that overtime bank staff would gain a level of assurance in his presence that would enable him to learn routines and have unobserved vault access. His boyish face and sociable, obsequious behavior were tools he would use for this successful venture. The Boston banks he selected were the New England Merchants National Bank and the United States Trust Corporation. In both banks, he opened regular checking and savings accounts and rented multiple safety-deposit boxes. At Merchants, he rented three boxes, and two at the

U.S. Trust. How and where he got the cash necessary to open these accounts is unknown, but he made several small withdrawals each week, one supposes to become a familiar and sociable bank customer. He proceeded to stash belongings of some kind in each of his safety-deposit boxes and then began the gradual process of visiting them on a regular basis to familiarize himself with the admission process and to become friendly with bank staff. Apparently, the layout and/or the staff of Merchants Bank must have seemed more promising because he appeared to focus most of his attention there. In early July, he increased the frequency of his visits at Merchants, and beginning on the sixteenth, he was making daily calls to the vault to scrutinize the contents of his rented boxes for several days in a row. One can presume he arrived with a briefcase each time in the pretense of adding or subtracting items; obviously he was becoming a recognizable customer and was imposing his explicit charm on unsuspecting bank attendants.

McDevitt maintained this pattern of routine safety-deposit box transactions throughout the late summer and fall of 1979. And on October 23, after visiting the New England Merchants Bank vault four times, he finally hit the jackpot big-time. Specific details have never been fully exposed, no doubt due to the bank's embarrassment and for legal and security measures as well. However, Kermani was able to garner a substantial number of facts. Sly McDevitt must have been observing other bank vault customers during his numerous forays over the summer and fall because he was able to pinpoint a safety-deposit box worth pursuing. During this propitious fourth visit to the vault, he was successful in confusing a bank attendant into giving him a key to a deposit box rented by the distinguished Boston attorney Dimitri Homsy. One can imagine the glow in McDevitt's eyes as he opened Homsy's box to discover fifty thousand dollars in cash and nearly that amount in Massachusetts-issued general-obligation bearer bonds. How lucky he was in that these types of bonds are payable to the bearer and don't require proof of ownership. Plus, he grabbed another stack of bonds worth forty thousand dollars, which, unfortunately for McDevitt, was in Homsy's name. Kermani reported that the Boston police alleged that, "The [bank] attendant, perhaps confused or not remembering which boxes were assigned to the glib and smooth-talking McDevitt, may have opened Homsy's box with the master bank key and permitted McDevitt to use one of Homsy's vault keys—which he somehow obtained—to gain access to the cash and bonds."[8] So, it is unsure if McDevitt actually had knowledge of Homsy's box or that he just hit the "safety-deposit box lottery."

After cleaning out Homsy's box, our slick young thief left the bank a much richer man. There is uncertainty as to his next moves during the month of November 1979. In fact, it wasn't until December 5, more than a month after his heist, that McDevitt showed up in the state treasurer's office to redeem his

bearer bonds. Using a Washington, DC, address, he cashed in ten five-thousand-dollar bonds and was issued two checks in his name, one for $50,000 and the other for $1,275, for earned interest. Kermani further expounded, "He [next] visited the First National Bank of Boston just down the hill from the Statehouse. He presented the two state treasurer's checks for cashing and showed the teller his U.S. House of Representatives identification issued to him when he worked for the congressman [Ed Markey], the teller's notations on the back of the $50,000 check show. The checks were cashed, and McDevitt deposited $10,000 in a First National account and left with the remaining $40,000 in cash and travelers checks."[9] This gave him sufficient cash to get out of Boston, and he soon vanished without letting any of his family or acquaintances know of his whereabouts. However, it was later discovered by the police that he supposedly spent much of the winter in Bermuda.

Attorney Homsy didn't discover his loss until two days before Halloween, which was a week after McDevitt had cleaned out his safety-deposit box. Homsy immediately reported the theft to bank officials and the Boston Police Department. Detective Roy E. Prout from the Suffolk County district attorney's office, where he focused primarily on the investigation of white-collar crime, was appointed to Homsy's case. The outraged attorney also reported the crime to the state attorney general's office and the state treasurer's office. Homsy was absolutely dumbfounded as to how the New England Merchants National Bank could have made such a stupid mistake. In an interview, he said, "I do not have any idea how he [McDevitt] got the key."[10] However, the bank's attorney, Donald Sweeney, in an attempt to save face for the bank, reported that the employees had followed all bank regulations to the tee, and that no one there was suspected of ever being involved. Eventually Homsy filed a suit against the bank for breach of contract and negligence in the Massachusetts Superior Court. Kermani noted in his *Times-Union* March 8, 1981, article, "In June 1980, the court appointed Boston attorney George Broomfield as the receiver of the items locked in McDevitt's various safe deposit boxes. McDevitt's two boxes in the US Trust Co. vault were opened in late July 1980. Police and Broomfield found three $1,000 bill wrappers but no cash."[11]

Prout, like a dog on a bone, worked feverishly to uncover details of the crime. McDevitt was identified through the use of his House of Representatives ID card for his various financial transactions in cashing in Homsy's bonds. One bank official noted, "He seemed like a pretty good kid to me, but using his own ID was probably one of his big mistakes." Detective Prout followed every lead in Boston to its logical conclusion but eventually ran into a brick wall. McDevitt's parents were interviewed and expressed frustration that they hadn't heard from him in months. However, Prout was not one to give up easily, and it wasn't until McDevitt had been captured by the South

Glens Falls Police following his attempted heist at The Hyde Collection, and all the publicity surrounding it, that Prout was able to make the final connection.

NOTES

1. Ron Kermani, "The Art Heist That Failed: But not for lack of imagination," *Times-Union*, Albany, NY, January 4, 1981, 1.
2. Ibid.
3. Ibid.
4. Ibid.
5. Ibid.
6. Ibid.
7. Ron Kermani, "Botched theft helps nab bank job suspect: Police link missing Boston money with Glens Falls museum art heist attempt," *Times-Union*, Albany, NY, March 8, 1981, 1.
8. Ibid.
9. Ibid.
10. Ibid.
11. Ibid.

Chapter 9
Planning the Heist

Son of his high school guidance counselor from the upscale town of Swampscott, Massachusetts, north of Boston in an area known as the North Shore, Brian Michael McDevitt swiftly and quietly escaped his local surroundings in December 1979. Without notifying his family or acquaintances, he headed for a tropical island to escape what would be the first of several felonies, the theft of one hundred thousand dollars from a Boston bank safety-deposit box. However, there has been some uncertainty about his getaway location, with the possibility that it may have been Jamaica. He needed distance and some time to unwind and plan his next course. While one might consider $100,000 to be chump change, in today's currency, its value would have been well over $500,000. It wasn't a bad haul for a first-time crime.

Now Brian had a new opportunity to reinvent himself, to ditch his political cronies and forget about all those petty little people from Swampscott. This would be his opportunity to escape the lowly Irish McDevitt clan and assume a new, much-more-respectable family name. With a sizeable bankroll in his pocket, why not adopt the name of one of America's leading affluent families, the Vanderbilts, of Dutch origin? This rather handsome young man with a distinguished Boston accent—and an obvious sociopath of the first order—would now become an heir of Cornelius Vanderbilt, one of America's noted robber barons who built his wealthy empire in shipping and railroads. And so Brian became Mr. Paul Sterling Vanderbilt. As he later told the South Glens Falls, New York, police in his sworn statement: "Before I got to Glens Falls, I was pretending to be Paul Sterling Vanderbilt, who is a real person. I was doing this to avoid trouble with Massachusetts authorities regarding a particular legal affair."[1]

Just what the "new" Paul was doing on a tropical island is anyone's guess. Was he chasing women, scoping out more banks or basking in the sun on one of the island beaches? The warm climate was certainly a welcome getaway from frigid Boston winters, and the vacation-land atmosphere must have suited him well. With sufficient money in his pocket, he most likely sought

out a high-class environment in which to surround himself and no doubt began to improve his wardrobe. I've wondered if his destination was just a random choice for his quick escape or if he was advised by someone in the Boston underworld that the island might be a good place to make new contacts for future deals. Was this his opportunity to steep himself in literature pertaining to art theft—the kind of wild stories that he unfolded in Glens Falls in hopes of teasing out of me the museum vulnerabilities and/or security concerns I had as director of The Hyde Collection? He seemed nearly obsessed with the concept of cat burglars breaking into the mansions of unsuspecting art collectors and making off with treasures of untold value, then selling them to the underworld, where they would eventually end up being purchased by rich Japanese businessmen who would display their newfound treasures in private inner sanctums, never to be seen again by the public.

Was Brian spending his brand-new freedom researching his next escapade—lying on the beach reading popular novels about art crime? I remember him waxing on about an article he had read in *Penthouse* magazine about the art crime world. He was intrigued by thieves cutting holes in windows for entry into museums, disarming electronic security systems, and cutting paintings out of their frames. Perhaps he was inspired by a January 8, 1979, *New York Times* article titled, "Art-Work Thefts Seen Pointing to Cross-Country Gangs." The story reports an ever-increasing growth in the art theft business, noting that in America alone, there was a 35 to 40 percent annual increase during the last few years. Pranay Gupte, the author, writes, "Law enforcement officials say that sophisticated gangs, sometimes with inside help and often under contract, travel across the country to steal for fences—people who deal in stolen goods—or organized-crime figures. In an overwhelming majority of cases, the stolen art is never recovered."[2] He went on in his article to note, "Federal officials . . . said that many small museums and private galleries have inadequate security systems. Last summer, for instance, the Historical Society Museum in Fort Worth, TX, was virtually stripped of paintings, rugs and furniture by thieves who used trucks to cart away their haul."[3] I also often wondered if perhaps McDevitt might have been inspired by movies that featured heists. Certainly the 1968 version of *The Thomas Crown Affair* comes to mind. Filmed in Boston and featuring the suave Steve McQueen and the gorgeous Faye Dunaway, it had all the intrigue and turn-of-event features that would have very much appealed to him. I'm sure if he saw the movie, he would have likened himself to the cunning and slick protagonist played by Steve McQueen. However, that movie was about a bank heist, unlike its 1999 remake with Pierce Brosnan that featured a heist in an art museum. But perhaps the earlier movie could have been the inspiration for his little incident at the New England Merchants National Bank.

Just how many months McDevitt stayed in the tropics is uncertain, as is where he might have landed when he returned to the States. I rather doubt he came back to Boston given his earlier five-figure bank withdrawal. My sense is that he landed in New York City and started his new life in the Big Apple. And then what attracted him to the foothills of the Adirondacks? No doubt it must have been his desire to keep a low profile. But his decision must have been more deliberate. After conducting a bit of research, he must have garnered that a Vanderbilt would be an acceptable character as a visitor to the lower Adirondack region, particularly close to Saratoga Springs. Saratoga, the summer watering place for the rich and famous, is where the late Marylou Whitney, then-wife of Cornelius Vanderbilt "Sonny" Whitney, spent her summers. Her Saratoga estate, Cady Hill, was the scene of many highbrow social events, where she was the philanthropic queen for many successful fundraising events throughout the season. Saratoga is best known for its famed horse-racing track and its annual Travers Stakes race. The Whitney family had a long history of Thoroughbred horse racing, which is what attracted them to the area. In July and August, Saratoga is abuzz with the rich and famous and a plethora of sycophants hoping to cash in by being in proximity to the Whitneys.

McDevitt must have assumed he could fit in rather easily in that part of the world, but he also must have realized that while he would have to distance himself from the Whitneys and their social strata in Saratoga, he would be able to pull off his charade in the surrounding communities. Yet he made no reference to that fact in his sworn statement after he was arrested on December 23, 1980, following his attempted Hyde heist. He stated, "I came to the Glens Falls area in May 1980 as I was just passing through. The weather was so bad I decided to stay a while. I stayed at the Queensbury Hotel." No doubt he was somewhat rattled, with fingerprint ink still fresh on his fingers, when he made that statement, because the museum has proof that he visited The Hyde on Tuesday, April 29, 1980. He signed the guest log that day as, *"Paul Vanderbilt, NY, NY,"* and he was with a guest, *"Kami Hawkins, Glens Falls."* Most likely he arrived in the area earlier in April with enough time to have become acquainted with some of the locals. McDevitt probably met Kami at her place of work, Wings Tavern, which was one of Glens Falls's favorite pubs at the time. Later on, she became so taken with his boyish good looks, supposed pedigree, and silver tongue that she invited him to live with her and her mother.

As he said in his sworn statement, McDevitt first stayed at the Queensbury Hotel. Its ambience seemed to suit him quite well. Opened in 1926, the aging, 140-room hotel, with several later additions to accommodate the required amenities of remaining relevant, was a bit tattered around the edges, yet it still had an air of respectability. A stately ballroom, several nicely decorated

meeting spaces, dining facilities, a small pub, a quaint little flower shop called Irene's, and a friendly barbershop made the newly minted Mr. Vanderbilt feel reasonably at home. And indeed, the hotel employees were smitten to have someone of such high social standing residing in their midst.

The larger question as to why he chose the Glens Falls region for his landing after his winter in the tropics is just how aware he was of The Hyde Collection. Had he planned this heist well before he drove into town in his rented Bentley? As noted earlier, The Hyde is not an especially well-known museum. Nevertheless, it is not entirely hidden in the Adirondacks either, and it was and is listed in many publications featuring important national and international museums and art collections. So, it's possible that he knew about it before he came to Glens Falls and was eager to visit The Hyde not long after he arrived to assess the potential of a future shopping spree. Therefore, this was either a strictly predetermined effort, or it was a serendipitous discovery that eventually inspired him to expand his light-fingered efforts from bank vault to art museum. If nothing else, he was unquestionably mindful that his one-hundred-thousand-dollar Boston takeout wouldn't last forever, and he needed to ensure some future financial independence.

It wasn't long before the assistant manager of the Queensbury Hotel, Michael Brian Morey, struck up a friendship with McDevitt. While Michael was ten years his senior, they seemed to get along quite well and soon began socializing. Morey had been a local kid who graduated from high school in Warrensburg, New York, sixteen miles north of Glens Falls. He was well respected by his peers and teachers. The *Albany Times-Union* reported that his school coach described him as "a good, decent boy, well-honored, well-liked."[4] After high school, Morey enrolled in Adirondack Community College, and in 1969, he enlisted in the Army and saw some action in Vietnam. Following his military service, he enrolled in Paul Smiths College, Saranac Lake, New York, in their hotel management program, which led him to St. Petersburg, Florida's junior college, where he received an associate degree in hotel management in 1975. With a new degree in his pocket and a pleasant and congenial personality, he soon found employment at the Queensbury Hotel. Morey was someone who got along well with his fellow employees, and he quickly moved up the ranks to the assistant manager position. One of his hotel supervisors said of him, "People would come to me and say, 'what a future that man's got,' he was an organizer and a leader."[5] Michael had been married but was divorced by the time he was working at the Queensbury. He had a five-year-old son and was having to pay child support, which very much strained his financial circumstances. Without a doubt, he succumbed, as did so many in the little hamlet of Glens Falls, to McDevitt's sociopathic, phony charm. His New England accent and the Vanderbilt lineage were very enticing. It was, indeed, incredibly easy to be taken in by him. And for Morey,

having a rich new acquaintance who was doling out twenty-dollar tips to all who served him, it must have been intoxicating to have such an upscale friend.

In an interview I had with Morey, he described McDevitt as looking rather sophisticated in the Queensbury Hotel lobby, sitting in one of the comfortable wing-back chairs near the gigantic fireplace eating Godiva chocolates. He costumed himself appropriately as a writer, wearing a Harvard sweatshirt over a crisply pressed Brooks Brothers shirt, and sliding down his nose, horn-rimmed glasses. He was either reading or writing, and as Morey observed, he always seemed to be casing the place. In the 1970s and 1980s, the hotel was the social hub of Glens Falls, with a constant stream of business and social activities providing McDevitt numerous opportunities to engage with the locals.

With plenty of cash in his pockets, McDevitt set about to ingratiate himself in the region. In addition to Kami, he began dating a young lady by the name of Barbara Bolan, who lived on Grant Street in Glens Falls. She, too, must have been smitten by his pedigree, and before long, she introduced him to her parents, who owned a pleasant small vacation manor on the banks of Lake George known as West Meadow Estate. No doubt they, too, were besotted by his charm and were willing to rent their Lake George residence to him from June until mid-October—legal details were handled by their lawyer. In his statement to the police, McDevitt bragged that at the West Meadow Estate, he was "doing writing, some photography and generally I was melting into the community and becoming a regular summer resident." Summers around the shores of the thirty-two-mile-long Lake George are relaxed as tour boats guide visitors to and fro, and water skiers glide through the dark, deep waters. There's lots of entertaining among the residents surrounding the lake, and most likely McDevitt charmed his way into socializing with the nearby neighbors. Driving his Bentley through Lake George Village, bustling with sweaty summer visitors, must have seriously boosted his ego—this smart-assed twenty-year-old kid from Swampscott, Massachusetts, was living high on the hog.

Summer weather can be absolutely wonderful in Upstate New York, with many long 80-degree days warming the waters of Lake George to almost bath temperature. However, by late September, temperatures begin to drop rapidly, and the locals start closing up their camps and estates for the long winter ahead. By mid-October, at the end of his lease, Brian McDevitt departed from the West Meadow Estate and drove back to Glens Falls for a return stay at the Queensbury Hotel. The employees must have been overjoyed once again to have the distinguished young Mr. Vanderbilt back in their midst cheerfully handing out his big tips. He played his Vanderbilt role to the hilt, insisting that he park his mint-condition, two-toned, black and silver-gray Bentley near

the curved entry of the hotel instead of the regular back parking lot reserved for guests. He drove the rented Bentley most of the time, but he occasionally hired a local kid to be his driver—"Giles"—in an attempt to make an impression on me. Manufactured by the British Rolls-Royce company, the car was an early 1960s model often mistaken by the locals as a Rolls instead of a Bentley. McDevitt placed a paper note in one of its windows saying, "DO NOT TOUCH." Glens Falls's city treasurer at the time, Francis X. O'Keefe, recalled, in a December 6, 1998, article written by David Blow in the *Post-Star*, an instant when he approached McDevitt's car near the hotel entrance and made the mistake of touching a bronze nameplate. He said that all of a sudden, the young Vanderbilt imposter came flying out of the hotel and yelled at him. "He ripped me up one side and down the other," O'Keefe said. "I wiped it [the nameplate] off with my handkerchief."[6] As Morey later recalled, it was a pretty special vehicle and really stood out in the rural Upstate New York hamlet, always drawing a lot of attention.

In Michael Morey's police statement following his arrest on December 24, 1980, he noted, "In the fall of 1980 he [McDevitt] checked back into the Queensbury Hotel and sat for many hours in the lobby, writing." Morey further stated, "It was at this time Vanderbilt approached me with a hypothetical prospective story about art and international theft. He talked for some time in a theoretical sense. I passed it off as a wealthy eccentric's writing style."[7] Like a spider enticing a fly to visit its web, young McDevitt was a cunning sociopath who was quite talented at spinning yarns and trapping his victims. Some were more vulnerable than others. In a small town like Glens Falls, people are rather easy to mislead in their eagerness for recognition and association with the privileged. And McDevitt keenly played to those tendencies. I remember hearing quite often about the handsome young Mr. Vanderbilt parading around town in his Bentley and the excitement about having "a Vanderbilt" in our midst: "Just what do you think he's doing here?" "Do you think he's going to settle here in the region?" "Wouldn't it be wonderful if we could get some of that Vanderbilt family money for the museum?" There was all manner of speculation. Yet not everyone fell for his charade. Leo Turley, Queensbury Hotel manager, noted that there were many Glens Falls citizens who suspected McDevitt of being an imposter simply by the fact that he used cash to pay for everything and he way over-tipped. He noted in Blow's *Post-Star* article, "I wouldn't let him run up a bill . . . I knew he was a phony. We didn't know if he was a counterfeiter or what, but we new [sic] he was a phony. 'What, [a] Vanderbilt doesn't have a credit card?'"

Once McDevitt settled back into the quaint Queensbury Hotel, Michael Brian Morey became one of his victims. Following McDevitt's initial subtle conversations about international art theft, in which he cleverly planted some hints, he made a more concerted effort to trap him. In Morey's words, "He

approached me a couple of days after, and it seemed more and more that it wasn't a hypothetical skit. He said he realized my financial problems being divorced, with a five-year-old son and having a huge debt service. He . . . [asked if] I would be interested in making money from the sale of art taken from other social circles. Those circles meant wealthy families like the Vanderbilts of Europe. He mentioned how the super-rich steal art from each other all the time for their art collections. Paul kept on stressing that this was a hypothetical plot for a story he was writing. He said take The Hyde Museum, for example, nestled in the small town of Glens Falls with few security precautions. He elaborated on a visit he made there with Kami [Hawkins] and their lack of security that he observed. [This would have been on April 29.] I thought it was a pretty far-fetched story. He presented me with a proposal for ripping off The Hyde—we talked of this for the next few days."

These conversations must have preceded McDevitt's first "official" visit to The Hyde Collection on Halloween Day, 1980. It was my first encounter with him, and from the very beginning, I had an uneasy feeling about him— his youth and his unconcealed eagerness. In McDevitt's own words from his police statement, he said, "One day I visited The Hyde, and I was concerned about the condition of the museum and later decided I could help them with a fund-raising proposal. Met Fisher at an art show they were having." McDevitt's sworn police statement was not entirely straightforward. While he may have been somewhat intimidated having just been arrested, my sense is that he was still attempting to untangle himself from his charade and either did not remember some facts, or in true sociopath mode, could not help himself from creating new ones. We indeed met on the 31st, when, at the time, I was frantically attempting to complete the installation of a temporary exhibition that was to open to the public the next day. He was invited to the opening, when I would be able to have more time to talk to him, and he, indeed, attended. Interestingly, he was inconsistent when signing the museum's visitor log. On the 31st he signed, *Paul Vanderbilt, Cady Hill House, Saratoga*, and the next day, at the exhibition opening, he signed, *Paul Vanderbilt, New York, NY.* I remember the museum volunteers being all a-twitter about seeing Cady Hill House on the log, which indicated he was staying with Marylou Whitney. Unfortunately, it wasn't until after his attempted heist that we discovered the inconsistency. It did give us pause nevertheless, because everyone knew he had been staying at the Queensbury Hotel, so why would he have used Whitney's address? And had we thought to check the log after the exhibit opening, it would have been even more baffling.

Throughout all our exchanges, there was never a discussion of a specific "fund-raising proposal." At various times, he pretended to be seeking funding from his acquaintances and the Vanderbilt family to help the museum. Also, he never indicated to the police that he was attempting to rent the

Cunningham House or that he wanted to be a trustee of the museum. Another interesting discovery made after the attempted heist was that on October 31st, the day McDevitt had his initial meeting with me, his accomplice, Michael Morey, visited the museum as well. They did not arrive together, but in the visitor log was the signature, *"Michael B. Morey, Queensbury Hotel."* In Morey's police statement, he said, "He [McDevitt] asked me to go to The Hyde and look at it since I have never been there. I took a tour of it in the fall. A few days later he reminded me that I was committed and my conversations with him and my presence at the museum constituted potential conspiracy. He also mentioned love for my son, and it would be a shame if anything happened to him." McDevitt now had poor Morey entrapped in his web and appeared to be using guilt and threats to motivate him. Nevertheless, I think Morey must have been to some extent intrigued with McDevitt's scheme, with the possibility of getting his hands on some quick cash to cover his debts. Otherwise, this would have been the perfect opportunity for him to have contacted the police.

As I look back to what is remarkable about Brian McDevitt, I see that part is just how well he did his homework. While he occasionally stepped on his tongue in his youthful zeal to impress me, he certainly had schooled himself on a range of noted art world personalities to name-drop, Brooke Astor being one of them. For a twenty-year-old guy, he was on a fast-track learning curve in preparation for a life of crime. He was, indeed, a con man extraordinaire!

Morey, in his police statement, said, "He [McDevitt] checked out of the hotel . . . and said he was staying in Lake George [Village] at a home used by a friend who wrote for the *Wall St. Journal*. I could not call him—no phone." Presumably, at this time he moved in with the girl he'd been dating. In McDevitt's sworn statement, he said, "I met a girl, Kami Hawkins, who worked at Wings Tavern, dated . . . until she asked me to move in with her sometime in November. I moved in with her and her mother [Ruth Hawkins] at 9 East Notre Dame St. in Glens Falls. I was still pretending to be Paul Vanderbilt, a wealthy subject from NYC." Sadly, he played poor Kami for a fool as well, making her think that he was in love with her and apparently even proposed marriage to her.

During that time, McDevitt rented a Mercury Zephyr from the local auto dealership, Den Wilhelm. When I later checked with Mrs. Wilhelm, she told me he'd passed himself off as the new curator of The Hyde. Also, a few days later, McDevitt went to Glens Falls' Office of City Planning to view building plans of the Hyde and Cunningham structures. My suspicion grew more pronounced, and I got in touch with the local police chief a second time out of fear that McDevitt was up to no good.

Following these disturbing events, McDevitt, in an attempt to flatter me, presented the museum with a so-called gift of three IBM Selectric typewriters,

which he'd rented from a New York City business firm. Suspecting foul play, I brought in an IBM representative, who removed McDevitt's presentation labels to reveal their true identity. My skepticism about his typewriter gifts was even more pronounced when only a few days after receiving them, CBS's *60 Minutes* aired a segment about stolen IBM Selectric typewriters. Dr. Day, the museum's board chair, freaked out and called the police that evening, which prompted them to become a little more aggressive in conducting their investigation. They apparently began nosing around the community, and word got back to McDevitt through Michael Morey. In McDevitt's sworn statement he said, "I asked what the museum needed, and Fisher said they needed new typewriters. I got them two [he forgot there were three] new typewriters from IBM in Albany [they were from a Manhattan rental firm], which I leased. I heard that an investigation proceeded about me, and that it was started by Dr. Day. I was angry that I was treated this way, and I went and removed the typewriters from The Hyde. It was right around this time that I started toying with the idea that a theft could occur at The Hyde."

McDevitt retrieved the typewriters on the day before Thanksgiving, November 26. His plans for a heist were starting to take shape. He notes in his testimony, "I contacted Morey. . . . I was proposing my idea about the theft, and I was trying to find out if he was interested. I could tell he was because he told me about the investigation [the police investigation prompted by Dr. Day], and I told him I attempted to obtain blueprints of the Cunningham building. Sometime after I removed the typewriters, my plan of the theft of the museum seemed more feasible. The more serious aspects of planning began."

Michael Morey's police statement picks up on the narrative: "There were numerous conversations the next few days. And he [McDevitt] gave instructions as to what I should do. . . . We met at Potter's Diner in Warrensburg and went over a draft of the project. At this time, the project for The Hyde was named SHIP. Code for Paul was ONE, and code for me was TWO. The first phase: fly a Concorde after SHIP from NYC to London (but noted customs problems) and so opted to fly directly from NYC to Zurich. We researched (the project) by reading numerous books on art theft as *Thinking Like a Thief*." One of McDevitt's demands to Morey was for him to investigate the security upgrade that was taking place in the Queensbury Hotel's vault. It was being executed by the same Glens Falls security firm, Mahoney Notifier, which had installed and monitored The Hyde security system.

Morey stated that in the first week of December, McDevitt told him he had to make an emergency trip to Palm Beach, Florida, because one of his wealthy relatives had just died of a heart attack, and McDevitt needed to be present because he was in line for a "large inheritance from his estate." That was just a ruse because he went to Palm Beach to set up arrangements with

an underworld Mafia type who would take The Hyde's stolen art works off their hands and give them hopefully a sizable amount of cash for their efforts. "When he [McDevitt] returned, he said the European plans were off, and he met with Mr. Griffin in Palm Beach, he operates a prestigious art shop. He approached Griffin and found out it was a front for trafficking priceless pieces of art to Underworld figures and very rich art collectors. Since a conservative estimate of approx $50 million." Further on in his statement, he described the financial plans in more detail: "We would then be given $15 million to be split evenly and charter a plane to Los Angeles, where we would meet with financial experts who would invest the money so it would not be detected. The fee for the consultants would be $250,000, for each [of us] $7.5 million." This was obvious wishful thinking on Morey's part, because it's general knowledge that they would have been lucky to have received 10 percent of the stolen arts' market value. McDevitt must have detected that Morey was getting cold feet about his plans because Morey stated, "Paul said that if I did not go through with this, members of my family and son would be done away with or taken care of. He said, did I understand that, and I said I did." Morey was trapped into believing that he had to proceed with McDevitt's dastardly plans.

In McDevitt's testimony, he notes, "Michael was in on it at this point, and we were both going to try to work to bring this off. During the next couple of weeks in December 1980, I tried to look at the various methods that we could get into the museum, whether to go through the perimeter alarm system or to go in during normal hours." McDevitt's testimony never revealed his Palm Beach trip. Morey next described in some detail how he attempted to glean information about The Hyde's security: "I asked Virginia, Mahoney's [Notifier, The Hyde's security provider] secretary, to lunch. [And eventually] Had dinner with her at the Grist Mill Restaurant and back to my home and had a long conversation. After she had quite a lot to drink, I asked her leading questions that would draw parallels that would give me indication of The Hyde security system as compared to the hotel system. She informed me in a roundabout way The Hyde did not have a panic button. Through subsequent lunches with her and a visit one week prior to The Hyde with my son, answers were given to the following: Hyde perimeter security system set up with tape windows and doors, a fire alarm system, and motion detection devices in each room, which all turned on at the time museum is closed by a person in charge. It was our understanding that detection and perimeter alarms were wired to Glens Falls police dept." Morey's visit to the museum for his final walk-through with his son Christian was on December 16, five days before project SHIP was enacted.

In the meantime, while all this plotting and planning was taking place behind the scenes, the museum staff and I were in the midst of Christmas

holiday activities. I was beginning to put Paul Sterling Vanderbilt out of my mind, assuming he'd finally realized we were on to him and that hopefully he'd packed up his belongings and headed back to New York or wherever he'd come from. You can imagine my shock to see his face on the evening of December 13, when he and his girlfriend, Kami, sauntered into the museum courtyard to attend the holiday L'Ensemble concert. I have often wondered what his motivations were. I don't think he was brought there by Kami. I believe he just wanted me to see his face one more time before he cleaned out the place, a kind of arrogant show of his middle finger, knowing that in a few days I'd be standing in that museum minus most of its works of art.

Now that McDevitt and Morey had determined the status of the museum's security systems, their plans started to take shape. McDevitt's testimony picks up the narrative: "I began compiling a profile on the working members of The Hyde, such as where they lived, about their families. I began looking at the scheduling procedures and when would be the best time to do the theft. I began to divide up the various stages of how it was to be done. I drew up equipment lists, such as vehicles that would be needed. . . . The planning became more precise and was broken down into minutes. Michael was working with me on the planning. For equipment, about a week before the theft was to take place, we started obtaining the things necessary to pull this off."

Morey expounded in some detail in his testimony: "Paul went to NYC one week before S-day to procure supplies needed for the project. He bought 14 pair of Smith and Wesson and Bianche handcuffs, 2 containers of ether, 2 pr. surgical rubber gloves, 2 .38 caliber special pellet guns, internal cylinder removed so the weapons would appear as a .38 special, and two stopwatches to be hung around our necks. He had handkerchiefs and surgical tape for the mouth and eyes and a Bianche shoulder holster for me. Tear gas gun, hair dye, moustache, eyebrow pencil, bronzer for skin and numerous tools for dismantling the paintings. Two pair binoculars, one high-power scope, and walkie-talkies."

McDevitt's statement about assembling supplies for the heist differs somewhat from his accomplice: "I was financing most of this. I bought ether, handcuffs, [and] the tape while Mike got his own gun, which he bought at Morans. I bought a gun at Hermans Sporting Goods in Albany. The guns were BB guns and were handguns. Mike found out that if you unscrew the inside the barrel [they] looked bigger and so we did. I bought the ether in NYC, the tape I bought in Albany at a pharmacy. We both had tool kits that I bought at Sears which had the common tools in them. They were for various problems we would run into while removing the paintings from the walls of The Hyde Collection. We had stopwatches, which I bought at Hermans in Albany, and they were for timing the operation. Mike provided the binoculars for the surveillance, the flashlights, [and] the tear gas gun."

McDevitt's description of gathering supplies differs from Morey's in that both seem to have been involved in securing them. Morey makes it appear that McDevitt had purchased them all, as though he was still the innocent bystander. In Morey's police testimony, he made sure to suggest he was being forced into this action, as can be implied from the following: "Paul at this time looked me straight in the face in the hotel lobby and reconfirmed his earlier statement that Griffin wanted to impress on me that if you don't go through with this or pull out or double cross me or tell anybody names or ever tell that you turned us in your son will never see Christmas. He said that goes the same for your family. Griffin and certain luminaries play for keeps, he said. The police would not be able to protect you by giving you a new identity because his syndicate friends have found them before and taken care of them. At this point I had a helpless feeling and did say what any other father with a son 5 years old would. And I would do anything to protect him."

While neither McDevitt nor Morey ever mentioned in their police statements the reason for selecting Monday, December 22, three days before Christmas, to pull off the heist, it must have been deliberate, assuming that the museum's staff and volunteers would gradually be shifting into holiday mode. They must have also assumed that attendance would decline around this time of the year, given that people are generally too absorbed in shopping, decorating, and partying. Therefore, the customary distraction around the Christmas holiday most certainly was part of their strategy. They had been assessing the ebb and flow of The Hyde's staff activities for some time. Morey stated that on the two preceding Mondays, McDevitt "stayed across from SHIP surveilling it, noting times of departures." Morey also reported, "The night before Sunday, late in the evening Paul came out to my house and we tested [the] walkie-talkies by driving close to SHIP but they didn't work properly. The [McDevitt's] parting words were, 'don't fuck this up, my good friend. Remember your son.'"

They also wanted one more assurance that they had the correct information about the museum's security systems. Morey stated, "Dec. 21, Sunday, I went skiing with Virginia [from Mahoney Notifier] and she confirmed no panic button at The Hyde." They had rented two automobiles from Hertz to aid in pulling off the heist. McDevitt said of them, "Mike put the [Chevrolet} Caprice in the back of Native Textiles [A local manufacturer of ladies' intimate apparel located about three blocks east of the museum on Warren Street] the night before, and during this day [December 22], he put the [Ford] station wagon at Howard Johnson's on Aviation Road." This location, near Exit 19 of Interstate 87, would have afforded them quick access for their trip to Washington, DC, with the stolen art works.

On the day of SHIP, the plans unfolded early. McDevitt reported, "The operation then went into effect. . . . At 7:30 a.m. I arrived across the street

from The Hyde and started my surveillance. Mike was calling Fed[eral] Express to set up a time to meet a Federal van between 2:30 p.m. and 3:30 p.m. He had also rented a garage at 22 Saratoga Avenue, South Glens Falls, that was to be the pickup site to commandeer the van and its driver. He was to call [Federal Express] later to get a false pickup to cover the period of time the driver of the van, Mary, would be missing. . . . He then proceeded to the garage where he was [to] wait for the arrival of Fed. Express van. The plan was as follows: at the time of the arrival of Fed van, Morey was to be at the garage to meet the driver, which we knew was [a] female named Mary. The van was to be backed into the garage, so it faced the sliding doors away from the house [next door]. He was to pretend that he had a parcel. When she opened the door, he was to show her the BB gun and tell her not to scream and that she would not be hurt. He was supposed to put her in the van right away, handcuffing her [and] taping her feet. He was to tape her eyes and to assure her that he was going to use ether to put her out. He was to place her in the back of the van. He was to put some boxes from the garage in the truck. The boxes had tools in them plus they were made up so they could hold the stolen paintings in them and be sealed with tape. Also, inside the box[es] was precut tape to be used to bound anyone [in the museum] they encountered. Mike was to drive [from South Glens Falls, across the Hudson to Glens Falls] to Donohue's Meat Market on Maple Street, about a block away from the museum, park in back and wait for me to get there. The timing of my arrival was [to be] determined by my observation about the number of people that were left inside the museum."

Michael Morey described their plans once they arrived at The Hyde. He was "to pose as deliverymen and . . . come to the back door . . . [with] . . . clipboard and delivery slip attached to the parcel—a heavy one, which would require two or three people . . . to come and see what it was and [it] was address[ed] to Fred Fisher. The parameter alarm would not be on as of yet because there is no [automatic] set time for opening and closing. . . . It was the intention to have them congregate in one area. . . . Paul and I [would] set stop watches and [he] would enter after 2.5 minutes, after I had positioned all three facedown on the floor as they would probably recognize him from his visits [in the] past. Paul and I would handcuff them and ether them, with the exception of Fisher, [from] whom we would extract any information on alarms in different rooms which might be on. We then would tape eyes and mouths with precut strips in boxes [that we] were to bring in. Reinforced delivery tape was also available to tape up feet and legs. Paul was to take upstairs and I downstairs to remove the paintings, and 20 minutes was the maximum time allowed."

I have often wondered just what these two characters planned to do to extract information out of me: threaten me with their BB guns or get physical?

Undoubtedly, I would have been able to recognize McDevitt; even if I hadn't seen his face, I would have known his Boston-accented voice. We'd had way too many personal conversations for me not to be able to identify his voice. It was an obvious weakness in their plans unless one of those guns wasn't for BBs. Another flaw in their planning had to do with accumulating the paintings. While most of them would have been easy to remove from the walls I'm not sure they would have all fit in a couple of boxes unless they had detached all of the frames, which I'm not sure could have been accomplished within their twenty-minute window. So many of the Hyde's treasures are watercolors and drawings on paper and could have been easily damaged or destroyed. Several of the paintings are on panels, not canvas, and therefore could not have been cut out of their frames and rolled up. In fact, the most important treasure in the collection, Rembrandt's painting of Christ, which measures nearly four by three feet, was painted on canvas; however, when it was last conserved, it was affixed to a honeycombed aluminum panel. Therefore, they might have had to settle for less of a haul than they had originally planned.

If they would have been successful within their twenty-minute allotted time and filled their boxes with a trove of The Hyde's Old Masters, their plans were to load them into the Federal Express van and head to the Howard Johnson's near Interstate 87. There they would have unloaded the boxes from the truck into the rented Ford station wagon and hightailed it for Washington. As McDevitt expounded in his police testimony, "The purpose of this was for the theft of a major art collection which was valued at between 35 and 45 million [dollars]. Myself and Mike were to drive the paintings to Washington where we would have sold them for 10 percent of their value. At all stages of the planning, the safety of the individuals and their well-being was a premiere consideration in all aspects. Also, we received information about the alarm system of The Hyde Museum, [which] was obtained from Morey dating the personal assistant of Mr. Mahoney of the Mahoney Notifier Co. Her first name is Virginia, and she knew nothing of this operation, as the information was obtained by deceit by Morey. The information she provided was imperative to the successful operation of the theft." In his testimony, McDevitt did his best to throw Morey under the bus in order to share this sorry messy escapade with his accomplice, but he also wanted the police to know just how considerate he was not to inflict harm on any of their victims—except The Hyde itself.

Nevertheless, McDevitt's dream of a "successful operation of SHIP" didn't come to fruition. His best-laid plans all hinged on timing—the timing of the arrival of the Federal Express driver at the rented South Glens Falls garage. McDevitt spent much of the day parked near The Hyde observing the staff activities. It being Monday, the museum wasn't open to the public, so there were no volunteers. Michael Morey was home until the mid-afternoon. He

reports in his police statement, "I called Fed. Express and asked them to pick up a parcel at 22 Saratoga Ave. [South Glens Falls] from a rented garage under the name of Bill Johnson. I asked them to make a pickup between 2 p.m. and 3:45 p.m., and they said they would try. I asked if Mary would be working that day, as Mary . . . [had] . . . pick[ed] parcels for Paul Vanderbilt many times. To make sure she would be in Glens Falls, I made a second call a half hour later asking for a pickup at McDonald's in Lake George [Village], but they don't pick up in Lake George." When he learned this, he told the dispatch to stop at Howard Johnson's, that a McDonald's employee by the name of Dick Dowd would be there to take the package. Morey was crafting a ruse as he stated, "This would facilitate her picking up Bill Johnson first and Dowd after 5 p.m. to cover the time element . . . [of] . . . her van being used." Soon after Morey made his calls, he began preparing for his entry onto the stage: "I put on a dark hair moustache, heavy eyebrows, smoked a cigar, and wore sunglasses. I then took a cab to So. Glens Falls. . . . I stayed out front of 22 Saratoga from 3:45 p.m. to 5:08 waiting for the Federal Express van." This is puzzling because earlier in his testimony, Morey said he asked for a delivery between 2:00 and 3:45 p.m. And his late arrival caused the complete downfall of their elaborate plan.

For this part of the drama, I turn to twenty-five-year-old Mary Paula Elizabeth Winglosky, driver for Federal Express located in Albany. She had been an employee there for five years. In her police statement, she noted, "I received a radio dispatch call that I was to make a pickup at 22 Saratoga and caller stated that he was Bill Johnson. The caller also stated that I should back into the driveway . . . specified time, 2:00 p.m. to 3:45 p.m., and I got to the location at 3:07 p.m. At this time . . . [I] . . . received a call on my radio asking when I was going to be there. I was there. [The] caller told [the] dispatcher that he wasn't there and [it] would take him a half hour to get there. I made other deliveries, and at about 4:20 p.m., I received another call on the radio . . . [asking me] . . . when I could be at 22 Saratoga Ave. As I came south on Route 9 from Main onto Saratoga [Ave.], I noticed a white male—late 20s wearing a green, puffy Army jacket, knit ski cap, and neatly trimmed black moustache and blue jeans. He appeared to have been standing around in the cold for quite a while as he was shuffling around."[8] Morey must have been more than a bit chilly because the temperature swings that day was from 0 to minus15 degrees Fahrenheit!

Winglosky continues, "I pulled up in front of the house next door to 22 Saratoga, and as I stopped the car [van], the male went to the passenger side and opened the door. Subject said this was the place and, are you going to back into the drive? He said he'd go and open the garage door. (after signing one of the bills) I was standing on the passenger side when subject walked up behind me and just stood there for a minute and didn't say anything. I said, Is

there something you needed? The subject opened his coat and showed me a gun. I screamed when I saw the gun and [the] subject said I have a gun. All I could see was the barrel. I noticed a car in the drive . . . facing the truck. Bill Johnson told me not to scream and I wouldn't get hurt. He seemed concerned about the car. I heard Johnson tell the person . . . [in] . . . the car he would be a minute and he would be leaving. He walked to the back of the truck, and he said get in the truck and he would drive. He changes his mind and said I was to drive and that he would tell me where to go." Undoubtedly by this time, Michael was more than rattled. It was after 5:00 p.m., and he must have been in contact with McDevitt because the planned meeting time was 4:00 p.m. behind Donohue's Market. In his testimony, McDevitt states, "The timing of my arrival was determined by my observation about the number of people that were left inside the museum. I determined that there would be only 1 to 4 people in the museum around 4 p.m. I determined that this was a good situation, and I drove to Donohue's Market. Michael wasn't there as planned."

The Federal Express van, driven by Ms. Winglosky, with a nervous Michael Morey in the passenger seat, went across the Hudson River Bridge, which was clogged with holiday traffic, and turned right onto Warren Street. Morey's statement picks up the narrative, "At 5:15, we went to [The] Hyde to check [if] they were still open and I saw the gate was still open, which indicated at least one person was there. I thought it would be Fisher. We [then] drove past The Hyde and pulled over by Native Textiles. No one else was around." Winglosky's police statement details what happened next: "At the back of Native Textiles, he told me to get out of the truck. He also stated that he was as nervous as I was. He told me to put my hands behind my back, and [he] put on the handcuffs. I told him they were too tight, and he said they had to be and he would loosen them later. He told me to sit on a box [presumably in the back of the van]. He then told me he was to give me ether and not to be afraid, it would not hurt me. I saw a brown bottle and . . . [on] . . . a white clean cloth . . . [he poured] . . . the solution from the bottle and held it up to my face. I kept backing away and telling him no. He said he would only put me to sleep for an hour. I told him he would hurt me because I was wearing contacts. He said not to worry." Morey described the incident thusly, "I handcuffed her and explained that I was going to give her ether. I gave her ether for about 15 seconds and she went under. I taped her eyes and mouth with surgical tape." Poor Mary was slumped on the floor in the back of her Federal Express van, and Michael must have been at his wits' end at what he was going to tell McDevitt about him being so late—it was about an hour and a half beyond the targeted time for SHIP.

Around 4:00 p.m., McDevitt, after determining that there were no more than four Hyde staff members in the museum, decided to drive to the designated meeting area behind Donohue's Meat Market. He waited there for quite

a while and no doubt was getting frantic. He said in his statement, "Michael wasn't there as planned. I drove around for a while and finally saw the Federal Express truck . . . up the street alongside Eden Park [Nursing Home, located directly across Warren Street from The Hyde]. I met him [Morey] on a side street. This was [now] an hour and forty-five minutes after the scheduled time to do the theft, and I informed him that we couldn't get in as everyone had left the museum. He then went, as did I, to behind Native Textiles. We discussed what to do with Mary at this time. I said to un-cuff her and then to call Federal [Express] and tell them where the van was. I drove off and left the . . . [Chevrolet Caprice] . . . in the parking lot of the Continental Insurance Co. [in the center of downtown Glens Falls], and I got into my Ford T-bird. I then went home." This was the first I'd heard that he was driving a T-bird.

Mary Winglosky picked up the story from here: "I started to come to and my face felt funny, and I then realized that we were moving in the truck and that at one point he backed up the truck. I heard Johnson [Morey] and some man [McDevitt] talking. The man told Mr. Johnson that it was too late. The man asked what happened and what the problem was. Johnson said that Mary had gotten tied up and she was running late. I heard Johnson ask the man where was Fisher. The man said Fisher was gone because it was too late. [We] drove around, and then he took the tape off my mouth [and took] off the handcuffs. Drove for a while [more], and [he] asked me if I was okay. I asked him if he would turn up the heat. [I] was placed in the passenger seat. He kept [the] tape on my eyes. . . . [When we] stopped at a light . . . he said he would take the tape off my eyes. He also said don't look at me. [Johnson] said he wouldn't harm anyone and that he wasn't that kind of person. He said couldn't I tell that by the way he was treating me. I said, What did you need from me. He said that if I helped him he would make it worth my while. . . . He said he would give me $25,000 for it [the van]. I said I didn't want the money. He said that he could put it in a Swiss account so it would be there whenever I wanted it. He then said that he was going to rob from the rich to give to the poor. He said he had two children and he wanted to help some who didn't have anything and this would make it possible to do this. He also mentioned something about his church and that this would help them. He mentioned that the people down south would appreciate this more than the people that have it. I said what you really need is my truck. He said yes. He said what he did with [the] handcuffs and ether was for my protection. He said that if I would go along with his plan, he could take me to a big beautiful house or he could rent a hotel room. He said at the house he would call [the] police and tell them where I was. Johnson kept saying he [was] doing this because of his son and that if he didn't do this his son wouldn't see Christmas." Morey, in an obvious state of confused, incoherent panic, drove the van to the parking lot of the Sheraton Motel, not far from the Howard Johnson's.

"At the Sheraton, [I went] to the bathroom. I saw some blonde hair coming out of [Morey's] ski cap. At some time he said he didn't like to use violence and that it wasn't his gun, that they provided him with it and that's why he insisted it wasn't loaded. He said he didn't like putting on all the clothes. He went into a story about he was forced into this by the Mafia. He told me that I shouldn't go to [the] police, that the Mob would find me." Morey then drove the Federal Express van to the Howard Johnson's parking lot, where he had stashed the Ford station wagon. Mary continues, "[I then] received [a] call to pick up [a package] at TV Data. After [another conversation with Morey], he said, you are a nice girl. Mary, everybody likes you, and he shook my hand. [As he left], he said, don't look at me or my car." When he was leaving, Morey told Winglosky that he would call her the following day.

"At 8:00 p.m., I . . . [called the] . . . Dispatcher . . . [and told him] . . . I slid into a ditch and that I was pulled out and I would be back on the road. I waited five minutes and I left. On my second stop, I made a call to the dispatcher and I broke down crying. I told Andy I wanted to come back in. I thought about whether I should report this or not, and I decided I had to. [I] got back to Federal [Express] at 9:40 p.m.

"Johnson [Morey] was . . . soft-spoken, and he spoke very articulately. I didn't think anything of it at the time, [but] I thought this was some kind of [a] nut who was going to rob me. He asked if there were any alarm[s] in the truck. At this time, I had a mental image of a subject I know to be Paul Vanderbilt. I then started listening to see if I could detect anything to confirm my suspicion it was him. I smelled a strong cologne [on Vanderbilt], which I didn't remember smelling when I was abducted. The dark moustache did not go with the blonde hair. I was putting together the things [that] the subject [Morey] was saying about robbing the rich and possibly ruining his family name. This also made me think of Vanderbilt, who I have delivered packages to before. I delivered [them] to East Acres Estate [she must have meant the West Meadow Estate] at Lake George and pickups for him at 9 East Notre Dame Street in Glens Falls and . . . [a] . . . girl lives there [who] helps Paul. In the past, he [Vanderbilt] had asked me unusual questions about being a courier and if . . . [I] . . . had to wear . . . [a] . . . picture ID and radio procedures."

This obviously had to be a harrowing experience for Mary Winglosky. All in all, she handled herself incredibly well during the ordeal and was amazingly sharp in putting pieces of the puzzle together in identifying a possible association with Paul Sterling Vanderbilt. They apparently had gotten to know each other somewhat through his bogus earlier shipments in an effort to glean the schedules and routines of Federal Express in the Glens Falls area. Michael Morey, on the other hand, was obviously way out of his league in attempting to be the rough-riding accomplice to McDevitt. His rambling conversations with Mary reveal there was obviously no "plan B," and while

McDevitt went on his merry way home, Morey had to figure out how to get out of this mess gracefully without making Mary overly suspicious. In his police statement, he said, "During the conversation, I continually mentioned my son's safety and threat to his life. I wished she could cooperate with me because if I failed, my son wouldn't see Christmas." I think he was genuinely frightened for his son's well-being. McDevitt had truly spooked him, but in the early planning stages of this endeavor, he could have gone to the police. No doubt he was terribly conflicted—the safety of his son over greed for what could have been a sizeable amount of cash.

Morey said in his statement that as he got ready to depart, he went to the back of the Federal Express van and retrieved the boxes of heist equipment and loaded them in the waiting station wagon. He then said, "At this time, Mary had tape back on her eyes. I left and told her in three minutes to take the tape off." He must have sped out of the parking lot in a total state of hysteria wondering how in the hell was this all going to play out. At the end of his police statement, he remarked, "The next day I heard Paul had been arrested, and I destroyed by fire all relevant paperwork on the planning of the crime. I took all associated equipment and clothing and threw it along the Great Sacandaga Lake, [about twenty-five miles west of Glens Falls], then I returned both vehicles to the rental agencies. I thought Paul was going to have someone get me. I [now] know that Paul Vanderbilt is actually one Brian McDevitt, as police informed me upon my arrest."

Michael Brian Morey was arrested on Christmas Eve at eight in the morning in his basement apartment, on John Clendon Road, in Queensbury, an adjoining community to Glens Falls. The arresting officer was South Glens Falls police chief Richard Noonan, whom the *Times-Union* reporter Ronald Kermani described as, "a husky officer with an intense stare."[9] Morey was brought to the South Glens Falls police department for processing. This would be the bleakest Christmas holiday he would ever experience. He made his voluntary sworn and signed statement, which was witnessed by Sergeant Kevin Judd and Chief Noonan at 10:30 p.m. Christmas Eve, and he spent the next three days in jail. There was no attorney present. Morey was initially charged, as was McDevitt, with second-degree kidnapping. Both were arraigned on Friday, December 26, by South Glens Falls justice Edward Pratt. By that time, they had attorneys. Morey was represented by Glens Falls attorney William Canale, and Brian McDevitt's attorney was Terrance Shanley of Troy, New York. As directed by their attorneys, they both pled innocent to the charges. Bail was set at fifty thousand dollars for McDevitt and ten thousand dollars for his accomplice. McDevitt had no means of paying his bail and therefore was remanded to the Saratoga County Jail in Ballston Spa. Morey, on the other hand, was able to come up with his bail thanks to his dad and was released. In a telephone interview, he told me he remembers lots

of news reporters with cameras in the courtroom. "There I was, handcuffed, standing in front of the judge with my parents in attendance—it was not my finest hour."

Brian Michael McDevitt was the first to be arrested by Police Chief Noonan in the early afternoon of December 23. His arrest was based on the information given to the police by Mary Winglosky that morning—as she correctly linked the Hyde incident, recognizing McDevitt's Boston-accented voice during her earlier exchanges, with a Paul Vanderbilt. Mary's police statement noted that the two men were talking about a guy named Fisher, and because of my previous dealings with the local and state police regarding McDevitt's suspicious activities at The Hyde, they no doubt began amassing all of the pieces of this bizarre puzzle. Luckily, she had remembered delivering packages to Vanderbilt's Glens Falls residence, 9 East Notre Dame Street. And it was there that Chief Noonan knocked on the front door at around 2:00 p.m. *Times-Union* reporter Ronald Kermani wrote, "McDevitt put on his coat, said goodbye to his fiancée, and rode with Chief Noonan to the two-room police station on Route 9 in South Glens Falls. He never returned to East Notre Dame Street, a residential section where McDevitt frequently parked his Bentley or his rented cars."[10] The police, however, did return to that little abode later in the day with a search warrant and rummaged through

"One suspect in art plot free on $10,000 bail."
The *Times-Union*, Albany, New York, December 27, 1980

McDevitt's belongings, where, among his papers, they were able to ascertain that Michael Morey was his accomplice. That information led them to arrest Morey the following morning. One can just imagine the horror and embarrassment that Kami Hawkins must have experienced as the police rummaged through McDevitt's possessions. His slick subterfuge had completely captured her heart into believing that he was her one and only. He had made quite a comfortable home for himself in that humble little house on East Notre Dame Street—though not quite a mansion fit for a Vanderbilt. Undoubtedly Kami's mother was likewise taken in by him and must have been devastated over her daughter's anguish.

NOTES

1. Brian McDevitt, Sworn Statement to Police, December 23, 1980, 3:40 p.m.
2. Pranay Gupte, "Artwork Thefts Seen Pointing to Cross-Country Gangs," *New York Times*, January 8, 1979, 8.
3. Ibid.
4. Ronald Kermani, "The Art Heist That Failed: But not for lack of imagination," *Times-Union*, Albany, NY, January 4, 1981, 1.
5. David Blow, "Queensbury Hotel," *Post-Star*, Glens Falls, NY, December 6, 1998, http://www.queensburyhotel.com/poststar.html.
6. Ibid.
7. Michael B. Morey, Voluntary Statement to Police, December 24, 1980.
8. Mary Paula Elizabeth Winglosky, Sworn and Signed Statement to Police, December 23, 1980.
9. Ronald Kermani, "Delayed truck traffic jam foil plot to steal Hyde art treasures," *Times-Union*, Albany, NY, January 6, 1981, 1.
10. Ibid.

Chapter 10

Facing the Law

While I was attempting to get back to my regular routine of managing the museum on a beggar's budget with too few staff—and no paid guards—following the events of the attempted heist, the two perpetrators were facing the legal music. Apparently, the police recognized that Michael Morey, while an obvious accomplice, was not the mastermind of the Hyde caper. He might have been treated somewhat kindlier because he was a local, but he was still put through the regular legal system and came out the other end a much-humbled individual. McDevitt, on the other hand, was taken more seriously, particularly when it was eventually revealed that he had committed a previous crime. As the March 8, 1981, *Albany Times-Union* headline purported: "Botched theft helps nab bank job suspect." Unable to come up with a fifty-thousand-dollar bail, he was moved to the Saratoga County Correctional Facility in Mount McGregor, not far from the humble little cottage where President Grant lived out his final years writing his memoirs before succumbing to throat cancer.

McDevitt was initially charged with second-degree kidnapping. On January 8, 1981, he was additionally arraigned on a fugitive charge by Malta, New York, justice Morgan Bloodgood in connection with the Boston bank heist. A month earlier, Boston police had issued an arrest warrant on a single count of grand larceny. At the arraignment, the slippery scam artist from Swampscott pled not guilty and was immediately led back to his cell on Mount McGregor. Ronald Kermani described McDevitt's jail experience in the March 8 *Times-Union* article noted above: "McDevitt tried to ignore his tiermates at the Saratoga County Jail. He read Rudyard Kipling and wrote to keep his mind off the petty thief in the cell on one side and the attempted murderer in the cell on the other side. Some mornings, McDevitt would smile ruefully at the bloody shaving job left by the sole dull razor blade passed to him at the end of the shaving line."[1] This was a dramatic change of venue for the pseudo-Vanderbilt who munched Godiva chocolates in the matronly Queensbury

Hotel lobby pretending to be a Harvard-educated freelance writer just a few months earlier.

Twelve days after McDevitt's second arraignment, he and Morey were hauled back into court for a preliminary hearing to establish a date for a grand jury. McDevitt's lawyer, Terrance Shanley, pleaded with Judge Edward Pratt to lower his bail to fifteen thousand dollars, but he was utterly unsuccessful. Undeniably, Judge Pratt took into consideration not only McDevitt's local attempted museum heist and kidnapping charges, but also his Boston bank theft. This guy was obviously working his way up the criminal ladder, and the judge felt he had to hold firm. In his appeal, Shanley referenced that John and Mary McDevitt, Brian's parents, had traveled to Saratoga from Swampscott to make an appeal on behalf of their youthful, misguided son. Further, he noted that McDevitt's fiancée, Kami Hawkins, of Glens Falls, was likewise there to support him as a misunderstood, naïve young man who could not have realized the impact of his actions. But to no avail. Most likely, the witness that firmly upheld the judge's determination was Federal Express driver Mary P. Winglosky of Watervliet, New York. This was her sole opportunity to testify about her harrowing experience on the night of December 22. Her public testimony affected both McDevitt and Morey—above all, Morey, who was directly involved in her kidnapping. Again, Ronald Kermani reported in an article in the *Albany Times-Union* that, "With her parents present, Winglosky, 25, of Leisureville Apartments, Watervliet, told Pratt and several spectators of her abduction by Morey. Morey allegedly handcuffed Winglosky, knocked her unconscious with a dose of ether, and taped her mouth and eyes shut. 'I was petrified. I couldn't believe it was happening,' Winglosky said about her abduction, adding, 'I thought it was the end of my life.'"[2]

Without a doubt, McDevitt's and Miss Hawkins's parents must have been horrified at Winglosky's testimony. How could anyone not be shocked by the brutal action of a couple of guys who were planning to remove a huge haul of art treasures from The Hyde Collection, which required the abuse of this innocent young lady? Her testimony certainly had its effect, and Judge Pratt, following the three-hour preliminary hearing, pronounced that the pair would be facing a grand jury on January 28, 1981. McDevitt's lawyer was also unsuccessful at closing the hearing to the press and the public. McDevitt's parents must have been considerably disappointed at Shanley's failed attempts. It surely had to be a dreadfully confusing experience for them as they tried to support him from an obvious situation that was plainly more serious than they had anticipated.

In expectation of a very sensational grand jury, McDevitt's lawyer, Terrance Shanley, made a motion to the County's Appellate Division for a change of venue based on the extensive, or, as he called it, "intense," publicity that had been generated from this high-profile caper fearing that "a fair

Pair to face grand jury in kidnap, art theft plot

By Ronald Kermani
Staff Writer

The case against two men accused of kidnaping a commercial courier driver at gunpoint last month and conspiring to rob the Hyde Collection in Glens Falls of valuable art will be presented to a Saratoga County grand jury, South Glens Falls Justice Edward Pratt ruled Tuesday.

Following a three-hour preliminary hearing during which defense attorneys unsuccessfully moved to close the hearing to the press and public, Pratt continued bail for defendants Michael Morey and Brian M. McDevitt.

A county grand jury is scheduled to hear the evidence against Morey, 30, of Glens Falls, and McDevitt, 20, of Swampscott, Mass., on Jan. 28.

Morey and McDevitt have been charged by police with kidnaping second-degree for allegedly forcing Federal Express driver Mary P. Winglosky to drive at gunpoint to Glens Falls, where McDevitt and Morey had planned to enter the Hyde Collection, overpower employees, and abscond with millions of dollars worth of valuable art, police said.

The defendants have pleaded innocent to the felony charges. Morey is free on $10,000 bail and McDevitt is in the Saratoga County Jail in lieu of $50,000 bail.

Although Troy attorney Terrence Shanley said McDevitt's fiance, Kami Hawkins, lives in Glens Falls, and his parents had traveled from the Boston suburb of Swampscott to attend Tuesday's hearing, Pratt refused to lower McDevitt's bail to $15,000 as requested by Shanley.

Pratt also denied motions made by Shanley and William Canale of Glens Falls, Morey's counsel, to dismiss the charges because of what they claimed was insufficient evidence.

With her parents present, Winglosky, 25, of the Leisureville Apartments, Watervliet, told Pratt and several spectators of her abduction by Morey.

Morey allegedly handcuffed Winglosky, knocked her unconscious with a dose of ether, and taped her mouth and eyes shut.

"I was petrified. I couldn't believe it was happening," Winglosky said about her abduction, adding "I thought it was the end of my life."

The heist was foiled when the courier van was delayed in traffic and the museum closed shortly after 5 p.m. Dec. 22 without incident.

Morey allegedly remained with Winglosky in the van until about 8 p.m., and told her that the Mafia would find her if she informed police of the kidnaping and robbery attempt, she testified Tuesday.

Staff photo by Paul D. Kniskern Sr.

WITNESS TESTIFIES — Federal Express courier driver Mary P. Winglosky of Watervliet enters the South Glens Falls Justice Court Tuesday to testify at a preliminary hearing for two men charged with kidnaping her and conspiring to rob the Hyde Collection in Glens Falls last month.

"Pair to face grand jury in kidnap, art theft plot."
Ronald Kermani, Albany *Times-Union*, January 21, 1981, staff photo by Paul D. Kinskern Sr.

and impartial trial cannot be had." Shanley was particularly referring to the exceptional coverage by the Albany *Times-Union*, chiefly the widespread three-part series written by Ronald Kermani. The Appellate Division denied his appeal.

The grand jury went off as scheduled, following the Appellate Court decision. And after the wishful strategy of McDevitt's and Morey's lawyers, the jury indicted the two on second-degree kidnapping and two counts of second-degree robbery. The trial ended on February 2, 1981. Sentencing was not handed out at the time but deferred to a later sentence hearing. Morey went home after the trial, a much-disgraced individual, but woeful McDevitt was sent back to the slammer because he was still unable to come up with the fifty-thousand-dollar bail. His experience in the Saratoga County jail was becoming significantly more unpleasant—certainly not in keeping with a rich Vanderbilt, or in reality, even a middle-class Swampscott kid—and he most likely used his restricted telephone privileges to plead with his dad for some relief. On February 18, there was a hearing in Judge Robert Doran's court to free innocent Brian McDevitt from his exorbitant bail. His dad, John, returned

to Saratoga County and was present in the courtroom prepared to offer a twenty-thousand-dollar certificate of deposit and his Swampscott house as security for the bail. Good old dad was there to save his son's ass from the fate of a not-too-comfortable existence in jail with a range of hardened convicts. Again, Ronald Kermani reported, "District Attorney David Wait requested an adjournment, saying he needed time to inspect the bond and certificate. Wait added he believed McDevitt would be released on bail Monday [the 23rd] if no problems were found with the certificate."

Wait's optimism when he spoke to the *Times-Union* reporter did not reflect his personal opinion. On Thursday, February 27, when Saratoga County court judge Loren N. Brown presided over the bail hearing, District Attorney Wait did not hold back. He argued aggressively against granting McDevitt his freedom, stating he and Morey were on "quite an odyssey." But to no avail. Judge Brown, undoubtedly finding sympathy for McDevitt's poor father, who had scraped together what little assets he and his wife had been able to assemble over their married life, overlooked the district attorney's objections and granted their pathetic son, Brian, his freedom. I have often wondered what the conversation was like in the car as the McDevitt family drove back to Swampscott. However, having experienced the wily sycophantic charade of their son, he most likely assuaged their distress by promising that he would be a changed man going forward.

Back in the Boston area, Brian must have kept a low profile. While he might have obtained his freedom from the Saratoga County jail, he was no doubt on house arrest in the McDevitt abode. With the gossip of his New England Merchants National Bank theft, as well as the attempted Hyde heist ricocheting through his neighborhood, coupled with the pervasive animosity of most of McDevitt's high school chums, he probably hid in his bedroom reading a lot of books over the next few months while waiting for his dreadful jail sentence hearing.

In June, prompted by the lawyers of the two perpetrators of the failed Hyde heist, another hearing was held in an attempt to reduce the earlier grand jury's second-degree robbery indictments that were handed down to McDevitt and Morey. Saratoga County court judge Loren Brown presided, and District Attorney David Wait argued vociferously against any further leniency. The decision was delayed until late October, at which time Judge Brown ruled that, indeed, he would dismiss the charges based on the fact that the grand jury testimony was "devoid of any evidence that (the pair) had the requisite intent to deprive (The Federal Express Co.) of its property (the van) either permanently or for an extended period of time."[3] Shockingly, the perpetrators' intent on relieving The Hyde Collection of a large portion of its holdings was not considered by him to be of second-degree severity. I assume had they entered the museum and been successful at restraining staff and attempting

to commit the heist, whether successful or not, the judge's decision would have been broadly different. Nevertheless, this ruling infuriated Wait, who immediately requested another grand jury, but he was rebuffed by Judge Brown, who prohibited him from going forward. After the hearing, Wait told the press that he intended to appeal Brown's ruling to the State Supreme Court "within the next couple of weeks." But unfortunately, Wait was not successful.

McDevitt must have had a severe case of cabin fever, being holed up at his parents' home awaiting the inevitable, because it wasn't until Tuesday, January 12, 1982, back in upstate New York, that he began his first full day of a two-year jail term in the Saratoga County Jail. Judge Loren Brown sentenced him based on the kidnapping of Mary Winglosky, the Federal Express Driver and for attempting to rob The Hyde of its works of art. These acts constituted a first-degree unlawful imprisonment charge and a third-degree attempted grand larceny count. In a January 13, 1982, *Times-Union* article titled, "Scam artist begins two-year jail term," Ron Kermani wrote, "Taking into account the amount of time McDevitt served in jail before being released on bail and possible 'good time' accrued in jail, McDevitt must serve about 14 months of his 24-month sentence, said his attorney, Terry Shanley of Troy. But after his Saratoga County jail term is complete, McDevitt is wanted by Massachusetts police for allegedly stealing $100,000 from a prominent Boston attorney's bank account. . . . Massachusetts police said McDevitt has agreed to surrender when his Saratoga County term is completed."[4]

In the same newspaper article, Kermani reported, "[Michael] Morey pleaded guilty to a reduced charge of attempted second-degree robbery in November. He was sentenced by Judge Brown to 60 days in jail and placed on five years' probation. He finished his jail term in mid-December and said Tuesday [January 12] he is starting a local business that will export building products to 'Third World' companies." Morey actually had to go back to square one. In an interview with me, he noted that things were pretty tough. "I couldn't get work, Leo Turley [Queensbury Hotel Manager] wouldn't hire me, I couldn't get unemployment and I couldn't leave the area because of my son." Nevertheless, the guy had a resilient streak and the tenacity to not let the adversity of his situation take him down. It certainly couldn't have been easy given the small, fish-bowl community in which he lived. He took an interest in the variety and quality of granite in the Adirondack region and discovered that he could single-handedly start his own business. Initially he was extracting stone by hand and selling it to local builders. Since his father had exhausted his savings for Michael's ten-thousand-dollar bail, Morey had to turn to his brother for financial assistance in this initial endeavor. He loaned him a truck, some tools, and five dollars a day. While many individuals would have succumbed to this adversity, Morey turned his misfortune into

success. It took him some time, but he was resolute. He became captivated by the possibilities of quarrying granite in the lower Adirondack region and sought help and information from professionals in the field. Soon his family and friends were impressed by his enthusiasm and his "can do" attitude. By 1986, he was opening new quarries featuring a type of granite he called "Corinthian." His expanded business required an ever-growing staff and capital, and he eventually titled his company Champlain Stone Ltd. It has become phenomenally successful. No doubt had he not found himself at rock bottom (pardon the pun), given the nonsense of his actions with McDevitt, he might still have been managing hotels. His company's promotional material spells that out with much fanfare: "Today, Champlain Stone Ltd. employs more than 100 people and supplies eight distinct stone products to dealers in the United States, Canada, and Europe. Our high-quality natural stone is recognized throughout the industry for its rich color and texture and is specified for residential, commercial, institutional and public projects alike."[5]

Brian Michael McDevitt, the pretty-boy Vanderbilt wannabe, did not fare as well. He just couldn't keep his slippery hands free from crime, even if he promised his poor family that he would turn a new leaf. He popped back into my life years later, after I assumed his name would never cross my path again.

NOTES

1. Ronald Kermani, "Botched theft helps nab bank job suspect: Police link missing Boston money with Glens Falls museum art heist attempt," *Times-Union*, Albany, NY, March 8, 1981, 1.

2. Ronald Kermani, "Pair to face grand jury in Kidnap art theft plot," *Times-Union*, Albany, NY, January 21, 1981, 4.

3. Ronald Kermani, "DA wants charges refiled in art caper," *Times-Union*, Albany, NY, October 29, 1981, 38.

4. Ronald Kermani, "Scam artist begins two-year jail term," *Times-Union*, Albany, NY, January 13, 1982, 32.

5. Champlain Stone Ltd., August 30, 2024, "Our Company," http//www.champlainstone.com.

Chapter 11
Revitalizing The Hyde

As I look back at the remaining years—I directed The Hyde up until February 1990—and the ever-growing success we experienced, I must bestow upon McDevitt's attempted heist some actual credit. The museum received a tremendous amount of press, both sensationalist as well as beneficial. The local newspaper, the *Post-Star*, hadn't been particularly enthusiastic about The Hyde, but that changed following the late December event. In their Tuesday, December 30, 1980, editorial, titled "Support the Hyde," the writer, most likely Don Metivier, gave the museum a huge boost:

> The elaborate plan to attempt a major art theft from the Hyde Museum that was foiled last week by holiday traffic, should clearly demonstrate the enormous value of the collection. The fact the collection is housed in Glens Falls is also of tremendous value to the community. We have many things to attract people to Glens Falls, but one of the most overlooked is the art treasures of the Hyde. As the city begins to market itself as a center for conventions and meetings, the art collection should be one of its selling points. It represents one of the finest private museum collections in the world and demonstrates the unique balance of activities available in the Glens Falls area. If we are to make use of this local treasure, we must also support it. Recently efforts by the Hyde to obtain funds from the city were rebuffed and like all of us, the trustees find their costs rising. There have been warnings from the museum that if it is not able to obtain funds to operate in Glens Falls there are other enlightened areas which would be pleased to welcome its famed art collection with open museum doors. No matter if the collection left Glens Falls in the back of a stolen van or in the heavily guarded truck of another museum, it would still be a tragedy. We urge support of this local treasure to insure neither ever happens.[1]

Obviously, money didn't just pour from the sky following this praiseworthy editorial, but the events surrounding the attempted heist were of such high visibility that there was, indeed, a new sense of respect for the institution, the likes of which I had not experienced previously. The board of trustees

in particular had a rude awakening in that some of the community wags began embarrassing them about the museum's vulnerabilities, particularly their relying on volunteer ladies to protect the museum's valuable collections during public hours. Moreover, the fact that the art collection had become so very visible and thought of as a possible commodity for the underworld was an appalling experience for them. Particularly for Hyde family board members, it was a shock to think that Aunt Charlotte's treasures were of such international importance and that individuals in their community were alarmed that it could all be lost. The museum was no longer their personal possession and/or responsibility; because of its great value and susceptibility, it required some much broader consideration going forward. This was a dramatic shift for the board, and they slowly began to evolve into a much more responsive group.

McDevitt's folly gave me the leverage I needed to insist on making some important professional operational modifications. Obviously, there were budgetary restraints that required changes to be made in an orderly fashion, year by year as the income increased. However, fundraising became somewhat easier because there was a new community awareness of the museum's needs. State and national granting agencies were likewise more prone to favor The Hyde as we progressed down a new path of putting our house in order and raising operational standards. It was like placing bricks in a foundation wall. One brick of improvement made way for yet another, and brick by brick we made some very significant achievements.

Top of my list of needed changes, besides the obvious security procedure upgrades, was to complete the work on the museum's catalog so that it could get published. I practically became apoplectic following the attempted heist in sensing the need to make the art world more aware of The Hyde's treasures. The anonymity of the art collection, hidden in the foothills of the Adirondacks, made me fear for its safety. If some punk kid could get away with stealing it and getting it into the hands of the mafia underworld, where works could be sold and not recognized as museum objects, the loss could be permanent. The Louvre's *Mona Lisa* could never be sold in the open market, but a nearly unknown or unrecognized painting could easily be marketed without identification. The collection desperately needed to be documented in book form and placed in the research libraries of universities, auction houses, and museums. My panic drove me to speed this project along and no doubt blinded me in assuming that one curator—a generalist art historian—could be able to undertake the immense amount of research required for this project. Jim Kettlewell was forced to assemble, as much as possible, all the provenance, literature, and exhibition history on 112 of the major objects in the collection. In essay form, he often concluded facts where information was sketchy at best and made observations that were not always the most accurate.

Nevertheless, the project came to fruition, and the soft cover catalog went on sale on December 15, 1981—seven days short of the one-year anniversary of the attempted heist. Funding for the catalog came from a variety of sources, both local and national, including the National Endowment for the Arts, the New York State Council on the Arts, the Chase Manhattan Bank, and the Gannett Foundation. This was a high point for the institution in receiving funding from such noted sources. We sent gratis catalogs to national and international research libraries as insurance against any future loss, as well as for opportunities to further academic study on collection objects. It sold well to museum visitors, especially local individuals and museum members, and warts and all, it was a milestone for the institution. For the first time, there was a cohesive visual and verbal overview of the collection, including a brief history of the Hydes and their marvelous art-collecting avocation. Only later did I become aware of its occasional scholarly flaws. I'll never forget one morning not long after sales began, when an anonymous individual, obviously schooled in French, left a copy of the catalog near the front door of Hyde House, like an abandoned baby in a basket, with red pencil marks highlighting mistakes made to various French passages—what an embarrassment.

In the fall of 1981, I was able to convince the board that it was time to undertake a strategic planning process. It was a new concept for them, and it took a bit of persuasion. I brought in an independent professional consultant who was very adept at holding hands and gingerly moving the process along without intimidating members of the board. For the first time for the institution, there was a healthy assessment of its strengths and weakness, and from that an agreed-upon range of accomplishments to be undertaken over the next four years. For me, it was a very important moment when an outside voice—a museum professional—helped the trustees understand that what I had been promoting over the last couple of years were standard best-practice requirements for the museum field, and not just Fred's pipe dreams. Much of the emphasis of the planning study was the museum's physical plant and its inadequacy in its role of serving the public. Indeed, it had been a private home designed for the specific purpose of living with and collecting art but not as a fully functioning museum—particularly one in the late twentieth century. I'm sure Charlotte Hyde was convinced the house would be perfectly suitable as her museum, and it was initially, when only small groups of people toured the place on a very limited open schedule between the hours of 2:00 to 5:00 p.m. five days a week. However, since I had arrived and was able to pump some activities into the place, it was beginning to reveal its limitations. Attendance had more than doubled, from around 6,500 annually at the beginning of my tenure to over thirteen thousand. Furthermore, financial support from the local community had increased by nearly 35 percent. This was a genuine demonstration that with amplified activities and visibility (and obviously

some post-heist impact), the institution could generate increased operating funds. In fact, this allowed the Hyde Trust to evolve from a private foundation to a public (501-c-3) charity, thereby making public support much more appealing as well as being able to more successfully garner grant funding from government, corporate, and private foundation sources.

The finalized strategic plan laid out a series of goals that addressed the continued internal professionalizing of our operations, seeking additional funding sources, staging more public activities—exhibits, concerts, children's educational programs—and assessing the possibilities of future physical growth. The trustees were certainly not ready to dive into any expansion planning at this time, nor should they have, because we needed more years under our belt to be able to make such a significant decision. What surprised me, however, was that they were not totally dismissive of an eventual expanded facility. While I realized that going forward it would not be easy to continue growing our public activities within the cramped confines of Hyde House and its unattached two-car-garage-exhibit-gallery, I likewise had reservations. Small, special cultural institutions like The Hyde, which are such delicate establishments, can so easily be destroyed by ambitious overreach—we will build it, and they will come. That doesn't always happen. Our meager endowment would not support a much larger operation, and we surely didn't have a long enough track record to justify immediate growth.

Following our long-range planning, the staff knuckled down, attempting to check off the long list of strategic goals. We seemed to be making headway in gradually growing our audience and sustaining improved visibility. For me personally, 1982 was a momentous and emotional year. In April, Becky and I adopted siblings, Bill and Beth (nearly three and five), who abruptly filled our former quiet Coolidge Avenue abode with the exuberant cacophony of two boisterous little people. It was a huge transition for this forty-two-year-old male and his thirty-eight-year-old wife. No nine-month gestation periods for us to leisurely readjust our lives. Social Services had introduced the kids to us earlier in the year, and the day after Easter we were driving them from near the northern border of New York State to our home in Glens Falls. We had no choice but to instantly dive into parenthood with all its highs and lows. The kids readjusted quickly, and I must say, our partner in taking on this responsibility was our dog, Nutmeg. For the first time in her life, she had competition but also a new responsibility in protecting them, and most importantly, she was a significant factor in the bonding process. It was an exhilarating year for Becky and me; having a family definitely helped center us personally, as well as within the community, in many new and important ways. However, my hectic schedule at the museum put the largest burden of child care on Becky's shoulders. In retrospect, I wish I would have spent more time with them when they were little.

In the early spring of 1983, I was fortunate enough to have been accepted into the mid-level museum professional program known then as the Museum's Collaborative, a six-day intensive course in the principles of management for cultural institutions conducted by faculty from Columbia University and the Harvard University Graduate School of Business. It was held in the former Averill Harriman Estate, Arden House, nestled in the Ramapo Mountains, which had been given by the Harrimans to Columbia University for use as a conference center. The rigorous program was attended by museum professionals from around the country, including one of my local colleagues, Joseph Cutshall-King, director of Glens Falls's Chapman Historical Museum. While the course work was tremendously invigorating and beneficial, what was most important for me was the follow-up project. We were made to focus on one particular issue that we were grappling with in our individual institutions and apply what we had learned in class by preparing an all-inclusive practicum. We were given a couple of months to complete this task back at our institutions, and then we had to return to Arden House for a long weekend of presentations of our practicum with feedback from faculty and attendees.

This was the perfect opportunity for me to investigate comprehensively the feasibility and impact of any future growth of The Hyde so that, as director, I could have the personal conviction of my decision-making. Further, such a document would be absolutely crucial in assisting the trustees in making a commitment of this magnitude. The year 1983 was the twentieth-anniversary year of the museum being a public institution; therefore, it seemed most appropriate to be addressing its future at this time. The basic premise of my practicum was stated thusly: *Should The Hyde remain localized in concept and appeal, and continue to operate in its current physical plant, or should a building campaign be launched to enlarge the museum allowing for increased activities in an attempt to increase attendance and a broader base of support?* The report examined the museum's strengths and weaknesses, its demographic statistics, the major macro-environmental trends of the times, the museum's opportunities and threats, the tourism trends of the Lake George/Saratoga Springs regions, competitor regional arts and cultural institutions, and finally an assessment of the genre of museum that The Hyde represents (which I classified as a "Gardner-generic or an art collector's personal museum"). I examined six possible scenarios, from closing the museum altogether and giving the collection to Harvard, as Mrs. Hyde had ordered in her trust should the community be unable to support it, to abandoning Hyde House altogether and engaging in an expansive building campaign, perhaps in a new location, that would thrust the institution into a league of art museums comparable to several large upstate museums mostly associated with universities—as well as four options between these two extremes. I evaluated the impact of each scenario and settled on what I felt to be the

most commonsense solution. Clearly Hyde House, with its glorious small Old Masters collection, was an historical gem that needed to be preserved intact as Mrs. Hyde had left it. But equally important in my mind was the range of art-related activities we were offering to the public, which were providing the institution with sustaining public support, visibility, and attendance. And in going forward, it was apparent that the constant rearrangement and movement of art works and antique furniture, required to provide space for activities in Hyde House, posed a serious ongoing threat to the collection. In order to protect the house and its prized collection, it seemed imperative that the museum should engage in a moderate physical plant expansion that would allow extended programming—an adequately sized gallery for exhibits, educational spaces, a small auditorium, space for visitor orientation, and all the essential back-of-the-house necessities. Taking the time to investigate in detail The Hyde's many options was tremendously beneficial to me. It was the ideal opportunity to solidify my thinking and feel confident about the museum's potential. The report recommended that we begin our planning by refining and expanding the museum's mission to better articulate the services we were to provide. After I presented my practicum at Museum's Collaborative, and received helpful and supportive recommendations, I tightened it up and eventually gave copies to the board when we began to plan seriously for The Hyde's future.

I should pause here and report that because of our increased financial support, we were able to grow our staff accordingly, with a head of security and a couple of guards, two certified maintenance staff, a secretarial assistant, and a bookkeeper. The place was beginning to operate much more efficiently as well as appearing better kept. During much of 1983 and 1984, the staff was devoted to strengthening the museum's professional standing. The goal was to engage in the formal process of accreditation by the American Association of Museums (currently known as the American Alliance of Museums), and, indeed, there was much to achieve in getting prepared for the intense self-study and rigorous on-site visit. To our great delight, in 1985 the Association granted the museum accreditation status—one of less than five hundred accredited museums in America at that time. It was a momentous step for the small upstate art museum, infusing additional pride for the board, staff, and community. Not much later, the New York State Council on the Arts designated The Hyde Collection as one of fifty primary arts institutions in the state (with big-sister organizations like The Metropolitan Museum of Art, the New York City Ballet, The Frick Collection, The Metropolitan Opera, the Everson Museum in Syracuse, etc.). It was mostly symbolic, but it also meant that annual grant funding could possibly be more reliable. For all of The Hyde's stakeholders, it was so very rewarding to recognize that the institution was now being respected, both regionally and nationally.

With the successful accreditation wind at our sails, the board and staff next engaged in a second, follow-up strategic planning activity in the spring of 1985. This time a small committee of board members was chosen for the undertaking, which they titled the "Building Expansion Feasibility Committee." What a dramatic attitude adjustment from the rather entrenched board of trustees I had inherited in 1978. Undoubtedly with state and national recognition, as well as the near-loss of the collection in 1980, there was an enhanced appreciation of the significance of their charge. The museum could no longer just be considered an insular little community asset. The world beyond Glens Falls was now watching. We brought back Dr. Robert Matthai, who took us through our first long-range planning session, which was a fortuitous move in that he had the confidence of the board and superb planning skills. He took us through an all-embracing thoughtful and productive process. What evolved was the concept of linking the Hyde and Cunningham structures together with a new educational wing in the center. Both houses would retain their unique characteristics in that they were to be linked by low-profile walkways that would visually preserve their independence. Cunningham House would become the administrative wing, allowing for the new education wing to be solely devoted to museum functions. Hyde House would be preserved as the historic showplace for the Hydes' magnificent collection—a perfect solution for safeguarding the unique home that Louis and Charlotte Hyde felt was suitable in style and scale for their art-collecting avocation. And further, given their inspiration from Isabella Stuart Gardner's Boston Museum, Fenway Court, it was critical to preserve it for that association as well.

The momentum for change was picking up. The planning session ended with a forty-page report, laying out seven recommendations for achieving our goal. The board was now fully invested in the concept but questioned its financial feasibility. The estimated cost for new construction and the restoration of Hyde House was approximately three million dollars, and the board wanted to increase the endowment by an additional two million. In the spring of 1986, we hired a fundraising firm to conduct a feasibility study in the greater Glens Falls community, which fortunately predicted that a five-million-dollar goal was most likely achievable. The next step was finding an architect for the project. I was adamant that we needed to expand our search well beyond the region and seek an architect of note. It was important to me to engage an architect who was nationally recognized for designing museum structures, for their knowledge of specific museum requirements, and also for the visibility they would bring to the project. But it was also a bow to Mr. Hyde, who was known for attracting foremost architects to have designed several Glens Falls structures, including his own home. This was an exhilarating process in which we eventually narrowed our choices to three national firms of note. Our final selection, after I.M. Pei backed out because the scale

of our project was unfortunately too small, was the firm of Edward Larrabee Barnes. Barnes's portfolio of museum projects and his philosophy of museum architecture were a great fit. He was a no-nonsense kind of architect, who had designed a wide range of museum structures throughout the country, including the Dallas Museum of Art, the Walker Art Center, Minneapolis, and the Chicago Botanic Gardens; he was exceedingly well schooled on our specific needs. I have to admit that I was on the fence concerning the design. One side of me wanted the magnetism of a flashy unique building that would create a buzz all its own, while the other side wanted a structure that would not visibly distract from the two flanking historical buildings. Ed Barnes convinced me that we needed to honor the past, and he sensitively designed a low-profile building using flat simple planes with a stucco exterior that would harmonize but not compete with the existing stucco structures.

When the plans were complete and construction costs pretty much determined, the board seriously addressed the fund-raising effort. We hired a staff development officer and engaged the firm who conducted the feasibility study to assist us with the capital campaign. I was astonished by the enthusiasm of the community. The board's capital campaign committee, which included several local distinguished non-trustees, was exceedingly successful. Internally, the board, particularly Hyde family members, pledged nearly a third of the goal before the campaign went public in October 1986. Once it was announced there was a steady growth of pledges. When we were tottering over the three-million-dollar range and seemingly to be reaching a bit of a stasis, the museum was given an absolutely fabulous gift. Charles R. Wood, the owner of the nearby amusement park, The Great Escape, and a new member of the board, offered to stage a major evening gala fundraiser at his theme park. But more than a gala, it was to be a nationally advertised antique auto auction at which Mr. Wood gave The Hyde one of his prize possessions, Greta Garbo's 1933 sleek black Dusenberg, which was to be the featured auction item of the evening. Charley, who had a heart of gold, had accumulated quite a bit of wealth from his amusement park enterprise and was a major philanthropist in the lower Adirondack region. He, too, was a collector, but he had what I call a crow's eye—he was attracted to alluring sparkly objects, some good and some not so good, to feather his nests. Nevertheless, he had amassed an amazing number of antique automobiles, as well as houses filled with a mélange of valuable and mundane objects. He was a strong-willed individual who required quite a bit of hand-holding. In most instances, his stance was "my way or the highway," so having him as a new member of the board was an obvious mixed blessing.

Charley's fundraiser for The Hyde was a welcomed contribution, even though there was a bit of speculation among many of us about what it would be like to conduct a formal black-tie gala in an open-air amusement park. He

took full charge, as was his style, and on the evening of August 26, 1987, the incredible "Over the Rainbow" gala commenced. It was an unbelievable sight to witness beautiful ladies dressed in their fineries and men in their tuxedos screaming and hollering on amusement park rides. Charley went all out for the big event, including an appropriate-for-the-event, sit-down meal staged on the park's family picnic tables. After the meal, the high point of the evening commenced, the big auction. It was performed by one of the leading firms in the antique auto business of the time, Dean Kruse of Auburn, Indiana. In fact, it was the little colorful Indiana town of Auburn where Greta Garbo's flashy roadster was manufactured. The auction began with several fancy cars hammered in at extraordinary prices, creating an animated buzz among the attendees in anticipation of the grand finale. Kruse emphatically played up the event, recounting the history of Garbo's stunning car in vivid detail. Then the bidding began. There were only a few bidders in the crowd, no doubt planted there by Charley, but the phones began to go wild, and within a few minutes, the winning bid was hammered in at $1.4 million—all profit for Hyde. It was purchased by the late Houston, Texas, shopping center magnate Jerry Moore. What an awesome night it was. In one fell swoop, the capital campaign was moving to completion. The committee went on to raise $6.8 million, which would be close to $14 million in today's dollar. This was a tremendous victory for the museum and its board of trustees. It gave them a new sense of ownership that was both gratifying and complicated as time went on.

The gala was undoubtedly something I thought I would never witness in little Glens Falls, let alone for The Hyde Collection. My ongoing "Saratoga envy" state of mind was finally shattered, because the honorary chairwoman for the imposing event was none other than Marylou Whitney. She obviously owed Charley Wood for all he had done for her over the years in support of her many Saratoga charities. I'll always remember the sight of Marylou and her husband, Sonny, in all their fineries, high up in the air in one of Charley's thrill rides holding on for dear life. But Marylou was having the time of her life; in a way, she was as much of a carney as was Charley. I finally had to concede that The Hyde had at last made it socially. It wasn't at Saratoga's famed racetrack or its opulent Gideon Putman Hotel or even at one of its festive tented polo field events—it was at an amusement park. Perhaps more in keeping with blue collar Glens Falls, but by God, it was exceedingly profitable, no doubt more so than an accumulation of several years' worth of Marylou's Saratoga highfalutin galas. Press for the event was widespread—from the *New York Times* to *USA Today*—the sale of Greta's Dusenberg to benefit The Hyde was big news.

Edward Larrabee Barnes's final plans for the expansion were approved by the board. It was truthfully a common sense design solution, not overpowering, yet not diminutive either. The total space of the three intersecting structures

was thirty thousand square feet: fourteen thousand for the two existing structures and sixteen thousand for the new building. Moreover, it was designed in such a way that, when future needs arose, expansion of the facility could be made without compromising its integrity. Groundbreaking for the Education Wing was on March 16, 1988; we were able to operate the museum until September, when it was officially closed to the public for fourteen months. Not only was there a large structure emerging from the excavated cavern between Hyde and Cunningham houses, but we were also facing a complete restoration program for Hyde House. In order to accomplish this, we hired the noted architectural restoration firm of Mendel, Mesick, Cohen of Albany to oversee the delicate maneuvering required to completely modernize its mechanical, electrical, and plumbing infrastructure while protecting its historical integrity. Obviously, the building was emptied, and all the fine and decorative arts had to be stored off-site in a safe, climate-controlled facility. Our administrative functions were moved to Cunningham House, where we could keep a close eye on the plethora of construction and restoration activities.

Once more the museum was given an unexpected golden opportunity for some much-needed visibility during our downtime. The IBM Corporation sponsored an exhibition of a large selection of The Hyde's works of art in their New York City corporate headquarters gallery on Madison Avenue and 56th, from June 20 through August 26, 1989. As a matter of coincidence, the IBM building is one of the many commercial structures designed by Edward Larrabee Barnes. In order that they look their best for a Big Apple audience, IBM also funded conservation treatments for a large number of the paintings. I will never forget the thrill of attending the exhibition opening. The museum was truly being given the attention it deeply deserved. It had come such a long way from the first day when I stepped inside that forlorn structure on Warren Street in Glens Falls. All I could think about was how fortunate we were that Brian Michael McDevitt had not been successful in his foolish efforts to divest the museum of its splendid treasures. Every one of the museum's thrilling evolutionary stages would not have been possible had he been victorious, and yet possibly because of his failed labors, the fear and notoriety he and his accomplice created might have been the very catalysts that set it all in motion. Yet I'm loath to give him any credit for our years of hard work in growing these many accomplishments.

On November 10, 1989, the grand reopening of The Hyde Collection arrived. On a cool but sunny morning, after several short speeches, Mrs. Hyde's elderly niece, Mrs. Polly Beeman—one of the loveliest and most gracious ladies I have ever had the honor of knowing—cut the ribbon at the front entrance of the museum's new Education Wing and the large crowd of enthusiastic community supporters swept into the spacious entrance of the revitalized institution. What a momentous day it was. Governor Mario Cuomo sent

his regards, noting, "This is a time of great pride for the museum directors and officials of Glens Falls whose efforts make this treasure of culture available to all. We join our voices to many others who say thank you for this source of great pleasure and inspiration."

The Hyde Collection as a public museum had made a huge transition. From its humble beginnings following the death of Mrs. Hyde, during numerous shaky times, and through many, many triumphant ones, the institution prevailed and flourished. Without doubt, its success lies in the hands of an amazing community of supporters. From a rather passive board at the beginning, who transformed itself entirely into a dynamic one; a small, but scrappy dedicated staff; a huge body of highly devoted volunteers, who stuck with the museum through thick and thin; Hyde family members, who stayed loyal and supportive of the institution during some very trying circumstances; and finally, the greater Glens Falls community, who initially in my association with the museum I assumed couldn't care less about The Hyde, rallied with enormous support, from its corporate and business leaders to hundreds of its individual citizens and members of the museum. That passionate support continues to this very day, allowing the museum to achieve ever new and exciting goals. One of its many accomplishments was the exhibition *Modern Nature: Georgia O'Keeffe and Lake George*, which opened June 15, 2013, in celebration of the Museum's fiftieth anniversary. Researched and assembled by Hyde's then-curator, Erin Coe, it was a landmark exhibition of O'Keeffe's early work in the Lake George region with paintings borrowed from major museums across the country. During those founding years of the museum, when all we had was an unattached two-car garage as a gallery for temporary exhibitions, I could only dream of such a splendid possibility.

NOTE

1. Editorial, "Support The Hyde," *Post-Star*, Glens Falls, NY, December 30, 1980, 4.

Chapter 12
McDevitt Again

To reopen our significantly expanded museum, it required that my small staff and I work nonstop for months on end, dealing with new challenges, and some disasters, one after the other. Granted, the staff grew a bit, but it was still pretty skimpy given the demands placed on us. This is in no way my complaining; I had led all the stakeholders on this evolutionary path, and I knew it was going to get tense as we zeroed in on our ever-increasing goals. As could be expected, engaging the small-town board in the high stakes of a multimillion-dollar fundraiser, especially as they became more and more successful and invested, would have a downside. Realizing they required more members to accomplish their task, the board brought on a few new trustees to bolster their labors ahead. All of it made sense and was necessary to reach the big goals we had set out for ourselves, but the dynamics between the board and me gradually began to change. The most noticeable new board member who triggered most of the tension was Charley Wood. Aggressive, overly sure of himself, and more worldly (in a P.T. Barnum–like fashion) than most of The Hyde's trustees, he almost immediately began to make enormous demands, which only grew in dimensions after his successful August fundraiser. I found myself walking on eggshells more and more as we headed toward the museum's reopening.

In the late spring of 1989, I serendipitously stumbled on an intriguing ad listed in the American Association of Museums' monthly newsletter, *AVISO*. It was for the director's position of the Hillwood Museum in Washington, DC. I had always been rather curious about the place since I'd been in grad school at George Washington University. Hillwood was the twenty-five-acre estate of the late Marjorie Merriweather Post, who died in 1973, while I was in DC. At the time there was fascinating press about her magnificent collection of Imperial Russian fine and decorative arts—touted as the largest hoard outside Russia. Mrs. Post had originally given her estate and collection (housed in her immense, brick Georgian-style mansion) to the Smithsonian. However, after her death, the nation's mega-museum conglomerate reneged

on their agreement and gave the estate back to the small foundation Mrs. Post had established to oversee her museum. It was a fledging institution not unlike The Hyde, and having spent the last eleven years bringing about huge institutional changes in Upstate New York, I pondered the possibility of doing the same farther south. Becky and I talked about it and initially thought the timing was not appropriate. After all, I was about to swing the doors open to a completely renewed institution, and it would be exceedingly important to hold a steady hand for a while to keep the ship afloat.

A month or so went by, and on a whim, I told my wife, "Just for the hell of it, I'm going to send in my résumé to Hillwood. It never hurts to keep my hat in the ring." I must say it's typical for nonprofit executive directors to always keep one eye on their charge and the other on alternative options. Boards of trustees can be terribly fickle, and one never knows when the ax will fall. It's just a good insurance measure to keep one's résumé polished and periodically distributed should disaster strike. This is particularly important when one is the major breadwinner, with a wife and two growing kids. So, on a lark, off went my résumé to DC, and given the pressure I was under, I thought no more about it.

One of our biggest challenges in opening the new Education Wing was finding an appropriate temporary exhibition to stage in our brand-new expansive gallery, which was designated the Charles R. Wood Gallery—the most prestigious space in the facility for a capital campaign–naming opportunity, and, indeed, Charley won the honor. Initially I had planned to have a special show featuring a wide spectrum of American artists who had created works of art in the Adirondacks. From the early-nineteenth-century Hudson River School painters to the present, there were so many notable artists who were inspired by the majestic mountains and lakes of the Adirondacks. We had preliminary talks with a noted art historian to research and curate the show, but the funding never materialized. Given our small staff and the hair-raising schedule we had, it was probably just as well. I'm not sure we could have pulled it off.

The bottom line for me was that the premier exhibition had to be a good, solid, well-researched show that would be suitable for launching the museum's new gallery. Preferably I would have wished for one that was curated and pulled together by us, but that became impossible, so I looked for an alternative, an exceptional traveling exhibition assembled by another museum. There were several traveling exhibit services available at the time, and we had the luxury of many exciting options. After much study, and based on the size of our new gallery as well as our finances, I chose the show *Masterworks on Paper from the Albright-Knox Gallery*, circulated by the Gallery Association of New York State. There were other reasons for the selection as well. The Gallery Association, known as GANYS, had always been an

amazingly supportive organization for The Hyde, and I loved the idea of them participating in this new venture. But even more important was the show itself. It featured works of art that reflected the philosophy and taste of the Hydes. Given their proclivity for artists' oil paint studies and works on paper in which one can sense the mind of the artist as they worked out their thoughts on canvas or paper, this show seemed to me to be right on target. There were drawings by Seurat, Picasso, Matisse, Leger, Malevich, Delaunay, Gorky, Miro, Hopper, Rivers, Motherwell, and many other notables. It resonated beautifully with the original collection.

Contracts for the show were signed in the late summer of 1989, and I turned my attention to the plethora of niggling details required for launching this new enterprise in November. Then in walked Charley Wood, who had yet another, better idea. "Fred, for the new exhibit in my gallery, I want you to show the work of my friend and favorite sculptor, Harry Jackson, and I'll pay for all the expenses!" What came immediately to mind was, *Who in the hell is Harry Jackson?* I had never heard of him, and my heart sank, as I could only guess what kind of a sculptor he must be given Charley's capricious taste. I tried to back him down: "But, Charley, I've already signed a contract for an exhibit." "Shit, Fred forget the contract, you can get out of it, no problem." He had photos of some of Jackson's work from his personal collection. The sculptor was a realist whose primary genre was the American Wild West, cowboys on horses, Native Americans, notable Western Hollywood actors such as John Wayne. He was definitely talented in a Frederick Remington sort of way—his sculptures were cast in bronze and often cold-painted in bright colors. I didn't back down, but Charley left me the pictures and biographical material on Jackson, saying the sculptor would be calling me to make arrangements for the exhibit.

My next move was to seek the advice of the new board chair, Roger Hague, a brusque, not-too-sophisticated character who absolutely had no sympathy for my conundrum, particularly given Charley's magnificent generosity. Roger had too much at stake in the community to ever cross swords with Charley Wood. A few days later, Jackson called me, and the conversation wasn't pleasant at all. I tried to explain that we were already committed to an opening exhibition, but like Charley, that didn't faze him; he became incredibly aggressive and at once accusatory about my not appreciating his work. Charley called the next day to make arrangements for a meeting with him and Jackson; he was flying the sculptor in from Cody, Wyoming. When that day arrived, I was steeled for the inevitable, that I might just have to back down given the political pickle I was in. I, too, was beholden to the amusement-park philanthropist for all he had given the museum.

Charley arrived with his paramour, Josie, and his rugged-looking Western guest. After we exchanged pleasantries, Harry Jackson went totally berserk.

He'd been waiting for this day and was not about to have some smart-ass East Coast portly museum director cast any aspersions on his beloved sculptures. His language was incredibly abusive, and he nearly went for my throat in a fit of rage. I'd not heard that many cuss words since my days in the navy. I could tell Charley and Josie were horrified, and luckily, they were able to extricate Jackson from the museum before he killed me.

Long story short, Jackson did get his exhibit, but not in the main Charles R. Wood gallery. Fortunately, the design of the new wing included a much smaller exhibit space, the Samuel Hoopes Gallery, where Charley's eight pieces of Harry Jackson sculptures from his personal collection were put on view with biographical information about the artist and a few photos of some of his other works. It was a compromise Charley welcomed given the embarrassment of Jackson's performance. It wasn't that Jackson didn't have talent. In fact, he had a fascinating history. His first incursion in the art world was his close association with the Abstract Expressionist painter Jackson Pollock. Harry was so taken with Pollock's work that he moved to New York and began painting in an abstract style and was recognized by art critics as someone with tremendous potential. It was only after a trip to Italy in the 1950s that Jackson veered back to realism, and for the remainder of his career, he created highly realistic sculptures. He died in 2011, and in his *New York Times* obituary, it was noted, "In a review of Mr. Jackson's cowboy art for the *New York Times* in 1980, Hilton Kramer called his career 'unlike any other in the recent history of American art.' His change of direction, Mr. Kramer wrote, 'has turned a well-known and highly praised but penurious young artist into one of the wealthiest 'unknown' artists in America—an artist unknown, that is, to the art world where his first reputation was made 30 years ago.'" The obit also noted that Jackson had been severely wounded in World War II and had "life-threatening epileptic seizures and severe mood disorders."[1] No doubt, he was a victim of PTSD. Indeed, I can personally vouch for his severe mood disorders.

At some point during the Harry Jackson escapade, I received a letter from the president of the board of Hillwood Museum, stating that I was on the short list of candidates for director and would I please come to DC for an interview. My first reaction was that it was impossible; I had too much on my plate. But the more Becky and I talked about it, particularly given the political tensions at work, it was decided that it probably wouldn't hurt to at least go through with an interview. On November 11, the day after The Hyde Collection's grand reopening, I was on an airplane headed for Washington, DC. The interview went well; I was very much taken with the board president, Ellen MacNeille Charles, granddaughter of Marjorie Post. She had a positive attitude with a burning desire to have her grandmother's museum become professional and accredited. The collection was magnificent; the landscaped

estate was beautiful; and best of all, the museum had a seventy-million-dollar endowment—the financial means to accomplish Mrs. Charles's wishes. I had lots to ponder when I returned home, and in early December, I returned to DC with Becky for a more serious discussion with Mrs. Charles and to view the director's residence on the grounds of the gated estate. If we were to make the transition, at least it would be a safe environment for the kids. But we had concerns about how they would adjust to a much-larger urban environment.

Back home in Glens Falls, I was in turmoil pondering my fate. The last twelve years had been so exhilarating, and we had accomplished so very much for the institution and its community. Yet deep down, I felt that maybe I had done all I could for The Hyde. Perhaps my strengths were best placed in transitioning institutions, leading them toward a professional standing. Without doubt, Hillwood in many ways was much like The Hyde. Its previous director had been a military officer with no museum experience, and the institution, its board, and its staff were floundering without a sense of its potential or place within the museum world. Yet giving up The Hyde when Glens Falls was just rediscovering it as a new and positive force within the community was a risk. Would I be perceived as a circus barker who had sold them all a bill of goods and was getting out of town before the tent collapsed? Moreover, I felt like a new mother who had just given birth to her first child, and now that it was beginning to walk, I was contemplating abandoning it. It was a tough professional, as well as personal, decision.

Again, Becky's practical wisdom surfaced, and together we agreed that this was probably the best time to part company with The Hyde. I had given it twelve years and was beginning to burn out. The institution needed new leadership to take it to the next plateau. At January's board meeting, I announced my decision to the shock of many of trustees, and yes, some of them were bitter that I'd gotten what I wanted but was leaving because I wasn't sure I could run it. Cecilia, bless her heart, prompted the board to give me a very nice sendoff. On a Sunday in late January, I was honored by a large contingency of Hyde supporters at the Queensbury Hotel. There were many well-wishers and tears. The mayors of Glens Falls and Queensbury presented me with testimonials, and a few board members had very nice remarks. It was a bittersweet occasion, but by that time, I was convinced I had made the right decision.

Because the kids were only halfway through the school year, we decided that Becky would stay in the region till June, and I would travel back and forth as often as I could. It was only an eight-hour drive. On February 5, 1990, I started my first day as the new executive director of Hillwood. What a shocking contrast from the little community museum in Glens Falls. The posh estate of Hillwood is nestled in the wealthy Forest Hills residential area of Northwest DC, off Connecticut Avenue, in walking proximity to the

Van Ness Metro Station. The south end of the property is adjacent to Rock Creek Park. This is by way of saying that it had nearly zero visibility, being so remotely located from the plethora of tourist attractions in the center of the city. Because of its robust endowment, supported by a private operating foundation, it didn't require a membership, and therefore it was a museum without a community except for its staff and the fifty or so paid guides.

The past leadership had been running it almost like a roadside attraction, which many on the board felt was just how it should be run. By the ruling of the Advisory Neighborhood Commission, the museum could have no more than two hundred visitors a day and children under twelve were not allowed. All visitors had to make reservations well in advance of their visit. The dozen trustees, who only met once a year in December, were all apportioned $100,000 annually from the endowment to donate to their pet charities. Operating the museum was pretty much secondary to them because of their perceived charge to give away money. In essence, they were trustees of the Marjorie Merriweather Foundation of the District of Columbia. They saw themselves as trustees of a grant-giving foundation that just happened to be burdened with a museum. Spending extra money in maintaining it was anathema to them—all except Ellen Charles, the new president of the board. She had recently assumed her position from her mother, Adelaide Riggs, the eldest daughter of Marjorie Post. Mrs. Riggs was a no-nonsense, rather formidable individual who had presided over the foundation since her mother's death in 1973.

My first year at Hillwood had the same ring to it as my first year at The Hyde. They were clearly very different institutions with many differing circumstances, yet both were floundering with boards that were uncertain of their charges and pretty unwilling to accept change. But at Hillwood, I had a board president with a strong determination to make a transformation, even to the dismay of her mother and other family members. The collection was obviously very different from The Hyde. I was no longer the caretaker of important Old Master paintings. Marjorie's great love was the decorative arts. But I'm not just talking about chairs and dishes; her passion was amassing objects of the finest craftsmanship, and when possible, objects previously owned by royalty. She was schooled in the 1920s by the famed art dealer Joseph Duveen in hopes, given her immense wealth, that she would purchase from him Old Master paintings. Instead, she sought pedigreed pieces of fine furnishings, tapestries, and aristocratic Sevres porcelain—mostly eighteenth-century French.

When her third husband, Joe Davies, accepted the position of ambassador to Russia, prior to the outbreak of World War II, Marjorie was smitten with the lure of the Romanoffs. And to her delight, the Soviets were selling off imperial trappings at bargain-basement prices. During her eighteen months'

stay in the USSR, she built the core of what would eventually become the largest assemblages of Imperial Russian objects outside Russia. Her final home, Hillwood, is chock-a-block full of the most fabulous objects—a mélange of some of the finest Russian and French decorative arts ever made: two Imperial Fabergé eggs, solid gold and silver Russian Orthodox liturgical objects, magnificent porcelain table settings, furniture made for Marie Antoinette, and splendid jewelry pieces—some historic and many made by foremost jewelers to adorn the fashionable Marjorie Merriweather Post. Needless to say, the two-story museum is a dazzling gigantic treasure chest. But more than merely a vanity statement, it houses a massive trove of Russia's heritage. In fact, the director of the Hermitage Museum in St. Petersburg, Mikhail Piotrovskii, fondly referred to Hillwood as his museum's western annex.

Arriving at Hillwood in early 1990, when Ronald Reagan's immortal words, "Mr. Gorbachev, tear down this wall," were still reverberating between the continents, and as the USSR was crumbling, was an opportune move. Russian culture was escaping its past Cold War association and finding new meaning within the context of Western civilization. I had countless big challenges ahead of me to upgrade and refocus Hillwood: to bring it in line with the museum world and to help the board and staff shift their allegiance from a grant-awarding foundation to a fully operational museum, the one Mrs. Post thought she had created by giving it to the Smithsonian. As she breathed her final breath, she was assured that Hillwood would be managed by one of the nation's leading museums. Somehow, when it was returned to the board, they were having way too much fun giving away money to be bothered about the mechanics of operating a museum. Sadly, it was an institution that didn't even have a mission statement.

Luckily my twelve years' experience in transforming The Hyde gave me assurance that change was possible, and I had learned through many hard knocks that it had to be done by taking small steps and building upon one accomplishment at a time. While the interior of Mrs. Post's mansion was sparkling and the collection was in fine condition, the infrastructure was in need of an upgrade. She had purchased the estate in 1955, and therefore, it had thirty-five-year-old, outdated HVAC, plumbing, and electrical systems, plus a leaking flat roof that needed replacement. Save for one elderly curator, Katrina Taylor, who was a student of America's first formal museum class at Harvard taught by Paul Sachs, the same class that Mrs. Hyde's first curator, Otto Wittmann, had attended, the rest of the staff were not museum professionals. The administration staff was primarily focused on foundation activities. There was one, not-too-qualified maintenance person for an estate with sixteen structures in various states of repair. Because of the elaborate thirteen acres of formal landscaped gardens and a large greenhouse complex with an immense rare orchid collection, there was a grounds staff of over a

dozen individuals who were gardening by rote. They were great folks, but none of them had formal horticultural experience. The small house staff, the folks who oversaw caring for the collection and maintaining the interiors, were led by Mrs. Post's elderly butler, Gus, a formidable Swede who was there to guard his former employer's reputation, whom he affectionately referred to as "Mother." Luckily, there was a security staff of about twenty individuals, none of whom had any formal security experience. The museum was guarded on a twenty-four-hour basis, and God only knows what was going on after hours. They were probably my most disorganized group of staff members, constantly picking on each other like temperamental adolescents—luckily, they were not armed. When the museum first opened, the trustees outsourced security to ADT to supply guards who were armed. There were many apocryphal Hillwood stories of late-night raccoon-hunting adventures on the wooded estate by the ADT guards. And finally, there were the paid guides. Fifty or so overly dedicated and extremely opinionated, mostly Washington socialites—many military and diplomatic wives—whose guide position at Hillwood was their first and only job experience. They were the tail that wagged the dog. Not that they weren't adept at tour-giving, but they thought of themselves as the reason the museum existed. Several of them had even applied for the executive director position, and when portly Fred Fisher reported for duty, they were less than willing to accept this Upstate New York clod from a museum they had never heard of who didn't even know one iota about Russian objects. Clearly Mrs. Charles had failed them bitterly, and they were not happy folks! That was my cast of characters.

Like my experience at The Hyde, it seemed that everywhere I turned, there was a fire to extinguish. It took a while to get the pulse of the place, and then it was a situation of prioritizing which fire was the hottest for me to extinguish. There were many physical plant issues to deal with, so one of my first hires was a seasoned maintenance staff to help me sort out the immediate needs. It was palpably clear that security issues were one of my hottest fires. Even though the museum was hidden in the residential woodlands of northwest Washington, DC, and surrounded by a high fence, I began to fear that it also could be an easy target, perhaps because of its seclusion. With its hoard of Russian diamond-studded golden treasures in nearly every display case, easily pilferable, I had visions of Russian mafia types landing on the lunar lawn in a helicopter and making way with a major haul. My earlier McDevitt experience was front-of-mind, and having learned what a couple of bumbling amateurs could have achieved, it didn't take much imagination to think what real professional thieves armed with serious weapons could accomplish. However, it was hard to get that across to my newly adopted staff. They surely must have thought I was kind of kooky. Nevertheless, the museum was really in a sad state when it came to security. There were no

cameras, no panic button, no video-tape recorder, no alarms on doors; security was basically a joke. We were relying solely on room motion and broken glass detectors, along with our guard staff, most of whom had absolutely no security training, who would have happily gift-wrapped objects threatened to be stolen had some thug held a gun to their head. No doubt I, too, would have gleefully tied the bow if such a thing would have happened to me.

Fortunately, my previous Hyde experience afforded me some valuable connections. In constructing the museum's new education wing, Edward Larrabee Barnes, who had a wide range of museum design experience, brought to the project superb contractors: mechanical engineers, lighting specialists, acoustics designers, and a top-notch security consultant, Joseph M Chapman, whom the *L.A. Times* tagged "the Michelangelo of Security." Joe, based in Connecticut and a former FBI spook, was one of the country's leading museum security gurus. As noted in the *Times* article, "He and his team of architects and engineers have designed security systems for the National Gallery of Art, the Museum of Modern Art, the National Archives, the Forbidden Museum in Beijing, the Egyptian Museum of Antiquities in Cairo, the National Palace Museum in Taiwan, some of the Smithsonian museums and the Baseball Hall of Fame in Cooperstown, N.Y."[2] He was the appropriate choice for the museum for me, given The Hyde's 1980 brush with an attempted heist. Joe was a real character. He had a deep knowledge of the field, given his previous FBI experience, and he could converse for hours about his copious attempts to thwart the underworld. For The Hyde, he was able to design an outstanding and cost-effective security system that fit the institution perfectly. I certainly left the Glens Falls Museum in a much more secure condition than it was when I arrived.

After consulting with Hillwood's board president, Mrs. Charles, I engaged Joe Chapman to design a much-needed security system for the museum beginning in the late winter of 1990. I remember his comments as I took him on his first tour of Hillwood: "God, Fred, this place is jammed packed with gold and diamonds, and with your inadequate safety measures, it's a thief's dream!" He rattled off all the necessary steps that needed to be taken, and I knew he was talking big bucks. The foundation certainly had the financial capability, but I knew I had to confer with Mrs. Charles to be sure she wanted to proceed, given that the board would not meet again until early December. In her typical determined attitude, she squared off her jaw and said, "Fred, that's why I brought you here, we need to get this place in working order, I'll deal with the board." This was after she had already given me the green light to increase salaries—which were embarrassingly paltry—and to engage in a few other physical plant upgrades. Joe proceeded with his charge. The planning stage was methodical in that he evaluated every detail of the mansion from a burglar's point of view. One of his first recommendations was

to create a suitable space within the mansion for the security staff. The inappropriate, closet-sized security control room needed to be enlarged to accommodate all the necessary monitoring equipment and staff. Luckily, it was located in the back of the mansion, next to a screened-in porch, which, other than its questionable architectural significance, could be easily repurposed. It was a busy time for me; Joe or a member of his staff made weekly visits to the museum as they progressed through the detailed planning stages.

And then, in late March, a catastrophic event occurred in Boston that shook my world again and bolstered my determination to proceed with Hillwood's security upgrade in a fast-paced manner. On Sunday, March 18, the media was buzzing with the horrendous story of an art heist at Boston's Isabella Stewart Gardner Museum. Thirteen works of art, including paintings that were slashed from their frames, were removed from the museum by two brazen suspects dressed in Boston police officer uniforms. The two individuals, who were successful at convincing the museum security staff to let them enter the Gardner, forced the two guards on duty into the museum's basement, handcuffed them, and bound and gagged them with duct tape. They then rummaged through the museum, selecting an odd assortment of Old Masters paintings: among them three Rembrandts, including one of his most important works, *The Storm on the Sea of Galilee*, four Degas drawings, a Manet, and most distressing, Vermeer's magnificent little gem, *The Concert*. They also grabbed two unusual objects: an ancient Chinese vessel called a ku, and a gilt bronze finial in the shape of an eagle, which was removed from a flagpole supporting a flag from Napoleon's Imperial Guard that had been in a flat glass display case that was wrenched open by the thieves. At the time, the purported value of the heist ranged from one hundred to two hundred million dollars, but it would eventually be upgraded to half a billion dollars. The dastardly deed occurred early on the morning of the 18th, while much of Boston was imbibing in the revelries of St. Paddy's Day—an obvious "distraction" strategy.

During that weekend, I was in Washington, living alone in Hillwood's director's residence adjacent to the service gatehouse along Linnean Avenue. It would be four months before Becky, the kids, and Nutmeg, the dog, would relocate to DC. I was literally bowled over when I first heard the story break on NPR's *Weekend Edition Sunday*, and I spent the remainder of the day following the news as snippets of details about the crime unfolded. What immediately came to mind was the astonishing similarity to The Hyde's near-heist: two individuals, handcuffs, duct tape, policemen as opposed to FedEx delivery men, holiday-time distractions, and two very similar museums. The only missing elements were pellet guns and ether. *God*, I thought, *was The Hyde's incident a practice run for an eventual successful heist of the Gardner?*

The following day, Monday, the 19th, Joe Chapman, having been obviously well aware of The Hyde's McDevitt caper, arrived early at Hillwood to continue his security evaluation, and as soon as he found me in the parking lot talking to some of the grounds crew, he blurted out, "Jesus Christ, Fisher, did you hear about the Gardner? It's got to be that goddamn McDevitt, don't you think?" We jabbered boisterously like two high school kids going over all the details and comparing them to The Hyde's episode. Joe finally said he was going to call one of his FBI contacts to give him the heads-up and immediately went to our administration building to use the phone. I felt justified, knowing that the similarity was frightfully astonishing. I even suggested to Joe, as he was walking away from me, that I would be happy to elaborate on my experiences should they wish. While it had been ten years since the McDevitt folly, having just heard the brutal Gardner story, all the lurid memories seemed to be streaming back as though it had happened the day before. Luckily, I had saved the press clippings and related information pertaining to the attempted heist and had brought them with me when I relocated to Hillwood. I surely thought the FBI would be extremely interested.

NOTES

1. Hilton Kramer, "Harry Jackson Artist Who Captured the West Dies at 87," *New York Times*, July 28, 2011, https://nytimes.com>design.
2. David Colker, "The Michelangelo of Security," *Los Angeles Times*, July 9, 1990, https://www.latimes.com>archives.

Chapter 13
Déjà Vu

For the next few days, every major newspaper in the country was screaming with Gardner-related headlines. On Thursday, March 22, the *Christian Science Monitor*'s story was titled, "Boston Theft: Museums Review Security Systems." That same day, the *New York Times* ran a couple of stories: "Masterpieces: Not Usually Vulnerable or Very Vulnerable Indeed," and a smaller story, "F.B.I. Releases Sketches of Art Thieves in Boston." That story revealed some interesting information, but without the sketches: "The F.B.I. said today that the guards had been able to get a good enough look at the two thieves to enable a police artist to sketch their likenesses. One of the men was described as about 5 feet 10 inches tall, weighing 150 pounds and in his early 30's. The other was said to be 6 feet tall, about 200 pounds, with dark hair."[1]

The article didn't include the sketches, but the first thief they described could have been McDevitt, who was twenty when he made his Hyde attempt; now it was ten years later, and the Boston thief's height and weight certainly was similar to McDevitt's. The *Times* article finished with this notation: "The F.B.I. is interviewing almost anyone with even a remote tie to the museum, including caterers and repairmen." Also mentioned in the article was that the auction houses, Sotheby's and Christie's, had underwritten a one-million-dollar reward in hopes that it would entice an important lead toward catching the thieves. The press was going crazy about the fact that the Gardner didn't have its collection insured. I, too, was rather surprised, because even its poor little Upstate New York stepsister had its collection insured. That was taken care of well before I arrived on the scene. Like most museums, we couldn't afford to insure the entirety of the collection, but we had a ten-million-dollar overall coverage, assuming that not all of the collection would be lost in any one incident. It truly wasn't that costly if we could have afforded it.

In a bit of a finger-wagging vein, the insurance company Huntington T. Block, the primary insurer for most American art museums, including The Hyde and Hillwood, sent out a memorandum to the museum community four days after the Gardner incident, stating the following:

We all agonize at what occurred at the Gardner Museum in Boston.

To characterize the perpetrators of this terrible crime as professionals is preposterous in our judgement. Anyone who would cut a canvas out of its frame is no professional. That's desecration, and it's despicable.

In the meantime, the press and the news commentators are engaged in a veritable feeding frenzy. They don't want to hear that America's museums are probably more secure than are the museums of any other country in the world. They don't want to hear that insurance rates for museums should remain stable even after a loss such as that suffered by the Gardner. They don't want to hear that there's a good chance that these pictures will be recovered.

Instead, they want us to tell them that no picture is safe on any museum wall, that Dr. No, the closet collector, does exist, and that the international drug cartel maintains an active market in stolen art.

With respect, we don't know where the Gardner Museum obtained the information that it would cost $3,000,000 to buy theft insurance. There must have been a misunderstanding somewhere. However, we certainly don't indict the Museum's trustees for not buying insurance. As we understand it, the Gardner bequest is very restrictive, and the trustees had to make a judgment call.

The point of this memorandum is that while the whole country seems to be pushing the panic button, we're not, and we hope you're not either![2]

Meanwhile in Boston, the wounded Gardner was going through hell. Their director, Anne Hawley, who had been on the job less than a year, was in total shock. On that Sunday morning, she had been home fixing brunch for friends when her head of security, Lyle Grindle, phoned with the dreadful news. When she arrived at the museum, the place was swarming with Boston police, including Detective Paul Crossen, as well as several of her staff members. Earlier that morning, the first staff members to arrive were unable to beckon the guards, who were still tied up in the basement. A supervisor with keys was summoned, and they were able to enter the museum. When they realized there had been foul play, they called 911, and soon sirens were audible as hordes of Boston's finest were climbing out of their squad cars and running for the museum. The police worked in teams, guns drawn, carefully scouring the Gardner, assuming the criminals might still be inside. It was quite a while before they discovered the poor, bound-up guards in the basement.

At that moment, the Isabella Stewart Gardner Museum lost its innocence. The bubble of privacy that generally encapsulates museum trustees, directors, and staff had burst, and they were attacked on all sides by the FBI, the Boston police, members of the press, art detectives, criminals, and all manner of kooks. Anne Hawley did her utmost to maintain composure and put the institution's best face forward as she confronted the hostile outside world. In fact, it took her twenty-three years to finally tell her story. In a 2013 interview with Emily Rooney, news anchor for WBGH Boston (and daughter of

Andy Rooney), Hawley recounted, "The theft was such a painful and horrible moment in the museum's life." She went on to say, "We . . . were being threatened from the outside by criminals who wanted attention from the FBI, and so they were threatening us, and [even] threatening putting bombs in the museum. We were evacuating the museum; staff members were under threat. No one knew really what kind of a cauldron we were in!"[3]

While I didn't experience such an atrocious disaster in Glens Falls, I can remember well how devastated I felt after The Hyde's failed heist—and I had a suspicion that such an event was possible given McDevitt's amateurish overtures the previous couple of months. In my case, after the event, while luckily our collection was still intact, I could no longer take its security for granted. It's utterly gut-wrenching to acknowledge that these internationally esteemed objects under your care are so vulnerable. I remember the nightmares I had weeks following my experience. Anne Hawley was living the nightmare, and it must have been absolutely horrific.

What transpired in the wake of the Isabella Stewart Gardner heist was total bedlam. In the months and years that followed, it seemed everyone became an art crime expert. Given the taint of underworld crime that has long existed in Boston with some prominent mob personalities, experts and so-called experts began pointing fingers at who they thought were the suspects. Could it have been David Turner, William Youngworth, Myles Connor, Bobby Donati, Whitey Bulger, or any number of other seedy characters? Particularly some of them had previously committed art-related crimes. The more notorious they were, the more likely they were to have conducted the heist. As the reward money climbed to five million dollars, the speculation grew more frantic. Art crime experts, many of them arrogant beyond belief, began crawling out of the woodwork, each with their own theories, some plausible and others totally off the wall. And then there was the Boston bureau of the FBI, which was notoriously corrupt and laced with scandal; they handled the Gardner's heist like a bad scene from the Keystone Cops. The national bureau of the FBI didn't fare much better. Unfortunately, art thefts don't seem to carry much gravity given the competition with drug lords and big criminal syndicates. Art, after all, is in the possession of the effete and the mega-wealthy, and it just doesn't garner that much concern, even though in America, art crime is a multibillion-dollar "industry," if I might call it that, and it grows larger every year as the value of art continues to ascend to the stratosphere.

Given this background, the Gardner was engulfed in an environment of desperation, suspicion, fear, and hope. Every new, optimistic lead was played out and then overshadowed by the next breathless new lead. While most of the so-called experts tripped themselves up with new theories about who did it, the real concern of the museum was: Where in the hell are the paintings? Are they being kept together? Have they been scattered, one by one, all over

the world? Are they all in Boston? Are they in Philadelphia? Are they being held by the Irish underworld? Are they in Asia? Are they in the Near East? The questions were never-ending. But to their credit, the board and staff of the Gardner have never given up hope. After the heist, the empty picture frames of the lost paintings were rehung as sad symbols of their tragic loss and as placeholders should they ever be found. What's certain is the art can never be replaced by different paintings by the same artist. Because of Mrs. Gardner's eccentric trust, the collection can never change—ever. No new art can ever be purchased. The house and its contents must remain static forever, like a prehistoric insect trapped in a globule of amber. No doubt it was for that reason alone that the trustees elected not to insure the collection.

The dreadful heist did cause an indirect benefit to the Gardner. Having experienced what is touted as one of the world's costliest heists, the institution was immediately thrust into the limelight. All its high points, as well as its warts, were exposed for everyone to see. The press went wild, exploring every facet of the museum's operation. Why did the museum not have professional security staff? Why weren't the guards armed? Why didn't the museum have better electronic surveillance equipment? The list of damaging questions went on. Unfortunately, the museum had an inadequate endowment. And like The Hyde, because of its static nature, the museum had a limited appeal when it came to fundraising. Its director, Anne Hawley, was, in fact, chosen to address that problem. Her hiring was somewhat controversial in that she was not from the museum field, but she had previously led the Massachusetts Council on the Arts and Humanities. Since the heist, she has pushed the boundaries of Isabella Gardner's trust as far as she could and has taken large strides in increasing funding for operations. In fact, on January 19, 2012, the museum opened an elegant new wing designed by the renowned Italian-born architect, Renzo Piano. It is connected to the adjacent historic structure with a glass walkway. The museum was able to raise a staggering $180 million for this undertaking, which, like all big transitional changes, caused much controversy and required some legal maneuvering to comply with Gardner's quirky trust. For the very same reasons I faced in Glens Falls, which we succeeded in accomplishing twenty-three years earlier, the Gardner's new wing facilitates all the required public activities and amenities—galleries, auditorium, café, and sales shop—that couldn't be properly undertaken within the historic structure, particularly one like the Gardner, which has such calcified restrictions.

Hawley was successful in beefing up all aspects of her museum's operation. One in particular is its security. In 1990, at the time of the heist, the museum had about forty guards, most of whom were not professionally trained; in fact, the two night guards who faced the intruders were full-time musicians. They have even been suspected of being accomplices of the

crime. The Gardner, like many American museums, was unable to pay livable wages, and therefore, it was the victim of its financial standing. In 2005, following the retirement of their head of security, Lyle Grindle, Hawley hired Anthony Amore. He was the assistant federal security director with the Transportation Security Administration before joining the Gardner. In addition to overseeing the security operations of the museum, which is now a much more professional, larger, and better paid crew, he has taken an active role in the ongoing investigation of the heist. It must be said that in the wake of the heist, knowing that it couldn't rely solely on the antics of the local police and the FBI, the museum scraped together enough funds to hire private investigators. Amore now plays that role in-house and continues to coordinate the various leads that constantly cross his desk.

Back at Hillwood, following the dastardly March 18th Boston heist and Joe Chapman's call to the FBI informing them of the similarities to The Hyde's failed heist, I kept waiting for some kind of response. Every Monday, when Joe or one of his assistants arrived from Connecticut to work on our security upgrade, my first question was, "Have you heard from the FBI?" But it was to no avail. There seemed to be nonstop accounts in the media featuring sensationalized stories and bizarre speculation about the latest Gardner heist suspect, causing me much consternation and frustration. Stories explored possible involvement of notorious Boston gangsters and questions about the likelihood of an inside job associated with the Gardner's two night guards. Why wasn't someone making connections with The Hyde's 1980 caper?

On May 9, 1990, I flew to Chicago to attend the annual meeting of the American Association of Museums. The three-day conference was, as usual, jam-packed with a large number of museum-related topics, not all of which interested me but, typical of such conferences, gave me plenty of opportunities to network with friends and museum colleagues. On the last day of the conference, I noticed in the AAM program booklet a special session on museum security. Given that there wasn't a conflict with another session more pertinent, I decided to attend. Lo and behold, the whole session was devoted to the Gardner Heist, and every chair in the partitioned meeting room was filled with eager attendees. I'm not sure if it was the head of security, Lyle Grindle, or one of his assistants, but a Gardner representative gave an hour-long presentation citing the horrendous details of the heist and its aftermath. It wasn't a well-structured talk, and there seemed to be an unfortunate egotistical tone in his delivery, as though he was rather enjoying being in the spotlight retelling the gruesome details. Toward the end of his presentation, he held up a page of mug drawings an FBI artist had made from descriptions given them by the two museum guards. This was my first opportunity to see the drawings. He then distributed Xerox copies to those of us in the audience, suggesting that should we recognize one or both of them, the museum would

be interested. Following his presentation, a large number of attendees stayed on to ask questions, including me. This seemed to be the perfect opportunity to find out if the Gardner was aware of McDevitt, and if so, was he being pursued as a possible suspect? Given the sizable number of people gathered around the speaker, it took some time for me to finally get to the front of the line. After I introduced myself, I briefly described my experience at The Hyde and the amazing similarities between the two incidents and the fact that McDevitt was from Swampscott, Massachusetts. I could tell he wasn't too interested and was looking away as though he wanted to talk to someone else. When I said that one of the mug-shot drawings showed some resemblance to McDevitt, he laughed nervously and said that you really can't rely on sketchy drawings to make an explicit identity, then walked away as though he was totally bored with my observation. He didn't ask questions, nor did he seem one iota interested—his arrogance was overwhelming. I stood there thinking, *What an asshole; if that's how things are being handled at the Gardner, they will probably never find the suspect.* He treated me as though I had extremely bad breath or was standing there with my fly open. The guy only wanted to be heard; he was much too full of himself. What else could be done? Joe Chapman had talked to the FBI, and now I had tried to have a one-on-one with a Gardner security representative, and no one seemed to give a damn. Or, at least, that is how it seemed.

I got on with my life given the massive number of projects that were being undertaken at Hillwood. Whatever was going to happen at the Gardner would happen; at least I had done my due diligence in attempting to inform them about my suspicions. As the months went by, there continued to be occasional sensationalized media stories concerning the Gardner heist. A spokesman for the FBI said such-and-such, followed by the head of security at the Gardner, who countered with this-and-that. It became a game of continuing speculation, which, most of the time, centered on big-name Boston gang types spicing their hyperbolic stories with underworld intrigue and mayhem.

Then, in late May 1992, I received a phone call from William Honan of the *New York Times* informing me that he was doing a story on the Gardner heist and what he called the latest suspect, "A guy by the name of Brian Michael McDevitt, does that name ring a bell?" "Oh hell, indeed it does." Honan indicated that McDevitt had now come under the microscope as a potential suspect. Honan had apparently conducted quite a bit of research about the 1980 Hyde attempted heist, and straightaway he began asking me pointed questions. He had even interviewed McDevitt for his article and informed me that McDevitt had moved to LA and supposedly was working in Hollywood as a screenwriter. As we discussed the various details of the Gardner case, he expressed his dismay about the seeming lack of interest in and confusion about McDevitt by the FBI. We talked for a good forty-five minutes, and after

our conversation, I sat back in my desk chair feeling vindicated, that for the first time someone else, someone completely unbiased, was finally placing some credence on the similarities of these two incidents.

Honan's *Times* article, entitled, "After 2 years, Boston Art Theft Remains an Unsolved Mystery," was published on June 2. He opened with, "More than two years after the biggest and most brazen art theft in history—in which a dozen masterpieces worth an estimated $150 million to $200 million were stolen from the Isabella Stewart Gardner Museum in Boston—the works are still missing, and no arrests have been made. Officials of the Federal Bureau of Investigation, which has had as many as 40 agents at a time trying to solve the case, will speak only guardedly about its continuing inquiry, although it is now known that the F.B.I. has at least one intriguing suspect."[4] Further on in his lengthy article, under the subtitle, "Leads Suggested But Not Followed," Honan cast a critical swipe at the investigation:

> At the F.B.I., there are signs of confusion and conflict over the Gardner investigation. Although a number of museum officials and art professionals are known to have told the bureau about the similarities between the Gardner and the Hyde attempt, Mr. Cassano [supervisor of the violent crime squad of the F.B.I.'s Boston division] said he was unaware of the Hyde case when a reporter questioned him about it early last month. He referred the reporter to Margaret Dennedy in the bureau's office for Brooklyn and Queens. Ms. Dennedy, a supervisory special agent, said she had never heard of the Hyde case, either, and that it was Mr. Cassano's responsibility.
>
> Although the Bureau has interviewed more than 300 people, including former guards and even caterers who delivered canapes for parties at the Gardner, Federal investigators have not pursued some obvious sources.
>
> Mr. Fisher has not been interviewed, even though he has sent two messages about his suspicions to the bureau. Nor has Kevin Judd, the police chief of South Glens Falls, who took the confessions of Mr. McDevitt and Mr. Morey after the attempt to rob the Hyde.
>
> Roy Prout, a detective in the Suffolk County District Attorney's office in Boston, also said he had not been contacted by the F.B.I. about a possible link with the Gardner case. Detective Prout took Mr. McDevitt's confession after Mr. McDevitt's was arrested for stealing more than $100,000 in cash and bonds from a safe deposit box in the New England Merchants National Bank in Boston in 1979. He served three months of a 15-month sentence in the Middlesex County House of Correction in Billerica, Mass., for that theft.[5]

Honan's article revealed some interesting background information about McDevitt as to some of his activities over the intervening years since my last encounter with him. Apparently after his brief imprisonment for the Boston bank theft, he remained in the Boston region, and in the mid-1980s, he

enrolled in the University of Massachusetts-Boston's College of Management program where he had been an honors student. Following his graduation, he maintained a connection to the university, where he was enthusiastically involved with the alumni association during the years 1988 and 1989, and then he suddenly disappeared without notice. But old habits die hard, because Honan noted that at the time of the Gardner heist, McDevitt "was on a year's probation under a 30-day suspended sentence for felony larceny at Filene's department store in Peabody, MA. That was his third conviction for larceny in the Boston area since 1988. In each case, he was fined and given a suspended sentence, customary for nonviolent criminals because of jail crowding in Suffolk County, which includes the city of Boston."[6] McDevitt obviously had a difficult time keeping himself clean. He was very much a Jekyll-and-Hyde (pardon the pun) character. While I'm not pretending to be a psychiatrist, he appears to be someone with a split personality, or perhaps one could say he was just a con man extraordinaire. In Mr. Honan's article, he notes that he talked to the chancellor of U-Mass about McDevitt, who "praised him for his public spirit in matters like raising money to set up 100 different national flags at the university to reflect the students' diversity."[7] This harkens back to McDevitt's high school years, when his principal likewise gave him high marks for his civic-mindedness. He has a penchant for striving to look like Mr. Goodie-Two-Shoes while all the time scheming behind others' backs—a pattern that started early in life. Honan noted that everyone he interviewed who had known McDevitt described him as "keenly intelligent, exceptionally articulate and invariably well groomed."

I had the distinct fortune to become acquainted with Stephanie Rabinowitz, McDevitt's girlfriend at the time. She met him in early July 1989 at a Boston restaurant by the name of Play It Again Sam's. He was introduced to her by a mutual friend (probably, Nat Segaloff) as a screenwriter for the television comedy-drama *The Wonder Years*—another one of his charades. The slick con man swiftly captured her heart, and they almost immediately became romantic friends. At the time, McDevitt was living in a small attic-apartment in Boston's prestigious Beacon Hill region. Stephanie described it as clean and well-appointed, as though he was financially quite successful. It wasn't too long in their relationship before he took her on a weeklong trip to Negril, Jamaica, where he seemed to be in very familiar territory among some rather shady con man–type acquaintances. This supports the speculation that McDevitt might have fled to Jamaica instead of Bermuda following his 1979 Boston bank heist. Their friendship blossomed, and they enjoyed each other's company, attending parties and going to the movies. He was a consummate con artist and was able to ingratiate himself with Stephanie's parents as well. She brought him to their art-filled Connecticut home a few times, including for the celebration of her father's fiftieth birthday. Her dad

was tremendously taken by the luminous Mr. McDevitt and was thrilled with his daughter's new beau. Stephanie had kept a diary since she was nine years old, and she shared with me many of the entries pertaining to her relationship with Brian. This includes the one on December 16, 1989: "Brian then had the urge to go to Faneuil Hall to get a X-mass tree. I picked one out for him. We then went back to his place and decorated it. It came out nice." However, their relationship was not always pleasant, and Stephanie began to sense Brian's shifty alter-personality. She noted thus in her March 5, 1990, diary entry regarding an issue that he obviously hadn't informed her about: "Later when I brought it up he said 'you couldn't make it anyway.' Fuck him—How does he know what I could or could not do—He pissed me off all right. We saw *Dr. Zhivago*. Brian made another scene at the theater by placing his coat on the front seat and lying, saying they weren't his—He's such a trouble maker! That also pissed me off."

Honan's *New York Times* article also noted that McDevitt was living in a small attic-apartment on Boston's Beacon Hill at the time of the heist and that he almost immediately pulled up stakes, leaving no forwarding address and moving to LA. He told Honan he moved to be with a woman he became acquainted with and to "reinvent myself." Two of his Beacon Hill neighbors witnessed him packing for the move and selling some of his excess furnishings.

His girlfriend, Stephanie, offers some fascinating background information that provides damning evidence that McDevitt was very possibly involved with the Gardner heist. She noted that on Thursday, March 15, three days before the heist, he contrived a fight to distance himself from her and made an excuse that he was going to New York City that weekend to attend the Writer's Guild Awards ceremony—which had actually taken place a month earlier. In her diary entry for the fifteenth, she wrote, "Brian called—He seemed a little cold . . . we talked—or should I say—he talked—most of it was about himself. He says he's going w/ or w/out me to California. [Apparently his plans were already in place for leaving Boston] I personally think he doesn't really give a flying fuck about me." Later on in the entry, she noted that after his call, she called him back, pleading with him that she wanted to see him before he left for the weekend. "At first he said he wouldn't be able to go out tonight—Then he said he'd like to see me, but it couldn't be till later and it wouldn't be for long—He then said I couldn't stay over—I said I wasn't planning on it—He was so rude to me . . . He's so mean—He said a lot of mean things to me." In the same entry, Stephanie noted that Brian told her someone was coming by early that evening to see his apartment, obviously pertaining to his hasty departure for LA. On Sunday, March 18, she wrote in her diary, "Brian called—He sounded cheery . . . He asked if I missed him—I said—'well, I haven't seen you for weeks . . .'" One can easily surmise that

his "cheery" disposition might have been related to his success at pulling off the Gardner heist.

McDevitt claimed to William Honan that he had an alibi during the night of the robbery, that he told the FBI he was with a woman that evening. I would later learn that he really had no alibi. In fact, Stephanie Rabinowitz relates some fascinating facts about his supposed alibi. She, too, moved to LA after McDevitt fled there and got a position as production assistant on the animated TV series *The Ren & Stimpy Show*. In her June 2, 1992, diary entry, she wrote, "Brian came by for lunch. The Gardner Museum theft in Beantown came out again in the newspaper—An article all about how Brian is the suspect—He wanted me to lie and tell the F.B.I. I was w/ him that night—I couldn't do it—I want nothing to do with it—He got really upset and mad with me—Tough! I don't want to be involved—I don't want to be married ... [someday] ... and have kids and have the F.B.I. or any shit from this to haunt me—So Brian's screwed and I'm sorry for him but I'm not going to be stupid and put myself on the line—Fuck that."

Finally, Honan reported in the *New York Times* article that "Mr. McDevitt, who garrulously discussed the case by telephone last Friday and yesterday, dismissed the similarities between the Hyde and the Gardner robberies as 'pure coincidence,' and spoke scornfully of the lack of professionalism of the Gardner robbers, who damaged paintings by cutting them from their frames. Asked about the sworn statement of Mr. Morey, his accomplice in the Glens Falls case, that they intended to cut some paintings from their frames [at The Hyde], Mr. McDevitt explained in detail how a painting can be cut from its frame without being damaged, in contrast to the method used by the Gardner robbers."[8]

Not long after my conversation with the *New York Times*, I got a call from Helen Kennedy of the *Boston Herald* who also interviewed me for a story. Her article was published on June 3, and it had some interesting discrepancies from the *Times* article. The discrepancies completely demonstrate the confusion and ineptness of the Boston FBI. For example, their spokesman, William J. McMullin, said they had already investigated similarities between the Gardner and The Hyde. "We are aware of the details of the museum robbery in Glen [sic] Falls, N.Y. We have been aware of that theft for some time." Earlier in her article, Kennedy noted that, "Though the F.B.I. has interviewed hundreds of people in connection with the Gardner heist, Fisher . . . said he was not one of them. 'I've never been contacted by the F.B.I., he said.'"[9]

One fact in Kennedy's article that I had not heard before was that McDevitt had grown a beard. His lawyer, Thomas Beatrice, was quoted as saying, "The alleged perpetrators at the Gardner were clean shaven. McDevitt had worn a beard for some time prior to [the] robbery at the Gardner—six or seven years I believe. He's just recently taken it off." That's an interesting comment that

was occasionally raised by Beatrice, but never McDevitt himself. Stephanie Rabinowitz, his girlfriend, said it was very possible that he had shaved his beard for the robbery. She hadn't seen him before the heist, and it was quite some time after it when she saw him again.

The McDevitt story was slowly gaining traction as various other newspapers across the country reported on this new rogue to be added to the growing list of Gardner heist suspects. A couple of days following the *New York Times* story, I got a call from Cecilia Esposito at The Hyde. Ceil had been appointed executive director of the museum after I had resigned. She told me that CNN was about to travel to Glens Falls to conduct an interview for a story they were doing about McDevitt related to the failed heist at the Gardner. We both agreed that the similarities of the two cases certainly warranted a serious investigation, and we chuckled that just maybe this time the slimy weasel McDevitt might get to spend a few more years behind bars. A day after I talked to Ceil, I received a call from a CNN reporter requesting that I do an interview for the story. On the afternoon of Tuesday, May 9, I took the DC Metro to CNN's Washington headquarters and sat in front of a camera for a twenty-minute barrage of questions. The CNN McDevitt story aired later that week. No doubt in sunny LA, McDevitt must have been in seventh heaven. He was now gaining national attention; while not the kind of attention most of us would want, I'm rather sure he was lapping it up, thinking of ways to leverage his newfound fame for even bigger and better options.

Over the next few weeks, there were a few additional McDevitt stories in the media, but typical of the Gardner case, they were soon drowned out by yet another new suspect with a bigger résumé of noteworthy crimes. While the media had been seemingly thorough in their various investigations of McDevitt, interviewing a wide range of people associated with him in one way or another, I'm not sure whether the FBI was really taking him all that seriously. The Bureau had yet to contact me, so I was beginning to assume they had bigger fish to fry.

Becky and the kids and I took a two-week vacation in Maine over the Fourth of July. And then, in late July, I took a ten-day excursion to Russia— my first, landing in Estonia and taking a bus to St. Petersburg. The year 1992 was an interesting time to visit the former USSR; there was lots of tension in the air, but it was a fabulous experience, particularly for me given Hillwood's sizable Russian collection. The Gardner heist had been shoved to the back of my mind with all my travel and work activities, and then, out of the blue, I received a call from the FBI requesting a meeting with me at Hillwood.

On August 25, Jim Lillard arrived at the museum, and I escorted him up to my second-floor office in Hillwood's administration building and closed the door. Lillard was a rather lanky guy, with a straight-as-an-arrow posture and the personality of a wet dishrag. He didn't seem to know much about why he

was there or what questions to ask. I tried to inform him as best I could, but it was clearly apparent that someone from the Boston bureau had called the DC headquarters to request a due-diligence interview, just to put the case to bed. I don't think the interview took much longer than twenty minutes. Obviously, I couldn't add any real new slant to the story, but hopefully I helped to fill in the details. The situation was becoming clear; there was an amazing similarity between the two cases—one unsuccessful and the other successful—but unless McDevitt confessed to the crime or they could pin him to it through some serious circumstantial evidence, he would just remain yet another suspect. The FBI also interviewed Stephanie Rabinowitz, his girlfriend, when she was in LA and later when she moved to Washington State. She told me they met with her three times and that she even gave them scans of her diary entries—the ones she gave me—but as she noted, "They seem to think he had nothing to do with it, and like, whatever, I just told them what I knew . . ."

NOTES

1. William H. Honan, "Masterpieces: Not Usually Vunerable or Very Vunerable Indeed," *New York Times*, March 22, 1990, C17.
2. Huntington T. Block, March 22, 1990, "Memorandum to our Museum Customers," Washington, DC.
3. Emily Rooney, "Isabella Stewart Theft: Boston's WBGH News, Emily Reports Anne Hawley's first public comments about threats after the theft and interviews FBI Investigator Geoff Kelly about why suspect(s) not named and speculates about the paintings," WBGH Boston, December 5, 2013.
4. William H. Honan, "After Two Years, Boston Art Theft Remains an Unsolved Mystery," *New York Times*, June 2, 1992, C13.
5. Ibid.
6. Ibid.
7. Ibid.
8. Ibid.
9. Helen Kennedy, and Samson Mulugeta, "New Clues in $200M Gardner Museum Art Heist: '80 heist 'similar' to Gardner theft," *Boston Herald*, June 3, 1992, 7.

Chapter 14

"To Catch a Thief"

I received another call from Cecilia Esposito at The Hyde in mid-November 1992, saying that another film crew was heading for Glens Falls. This time it was CBS who was planning to do a segment on Brian McDevitt for their popular Sunday evening program *60 Minutes*. There hadn't been much in the media about him for quite some time, so I was fascinated to see what new slant they would be taking. Unfortunately, it aired on the Sunday following Thanksgiving, when my family and I were driving back from Indiana, having spent the holiday with Becky's family. From all of the accounts I heard about the program from friends and acquaintances, I knew I had to see it. However, in those archaic days before Google, YouTube, and podcasts, the only way to view rebroadcasts was to send for videocassette recordings, which I did not long after the show aired. What a strange, almost eerie, feeling it was to confront Brian Michael McDevitt, alias Paul Sterling Vanderbilt, on my TV screen. Now thirty-two years old with a bit of a fuller face, he was that same con artist who had tried his best to win my approval in Glens Falls. Hearing his New England–accented voice was an immediate trip back to the fall of 1980. It was a weird, but in some crazy way, mesmerizing experience.

The title of the segment was "To Catch a Thief," and it was narrated by the late Morley Safer. His opening remarks were, "To catch a thief, not the movie but the real thing."[1] Safer went on to set up the story by describing the Gardner heist and the frustrating attempt in identifying various burglar prospects, ". . . except for one slightly slippery suspect." And the next face to appear on the screen was McDevitt's, who said, "They were definitely professional thieves. They knew what they were doing." Safer narrates, "Brian McDevitt says he's an expert on this kind of heist because he was once part of an international ring that stole to order." McDevitt follows, "This is clearly an operation that somebody paid for. They wanted, I think, those two specific paintings [Vermeer's *The Concert*, and Rembrandt's *The Storm on the Sea of Galilee*], and the only way you can get those paintings for your collection is that you pay somebody to go in and steal them. That's

what I used to do." Safer, playing along, quizzed McDevitt, "What's your best professional guess about the location of the Gardner paintings now, as we speak?" "I believe they are in Japan." "All of them?" "All of them." Safer was truly stroking McDevitt's ego by calling him "professional," and McDevitt, all puffed up, took the bait with his willingness to respond to him, "I believe they are in Japan." When Safer later questioned McDevitt about what he would have done with the paintings had he been successful at The Hyde, McDevitt responded, "Paintings would have been transferred to Japan. And that's where they were going, was to Tokyo."

The segment shifted to the 1980 events at The Hyde Collection, which Safer referred to as a "mini-Gardner." He described the resemblance of both museums and the heist similarities of both, questioning whether the Gardner heist was a "successful copycat of the botched Hyde caper." Safer then interviewed Saratoga County district attorney David Wait, who described McDevitt and Morey as "the gang who couldn't shoot straight." Wait went on to reveal how eager McDevitt was when he was apprehended, as though he was energized to tell his story: "I'm sure they [the police who took his statement] just sat there and just kept typing as fast as they could until he just stopped talking. So, it wasn't a probing interrogation type of thing he just kept right on talking. Maybe he wanted to sound clever." I found this to be an interesting insight to McDevitt's motives. Yet when one considers all his collective criminal activities, I tend to think his art heist motives were genuine. On the other hand, Safer proclaimed, "With his lawyer Tom Beatrice present he [McDevitt] spoke to us, just why we're not sure. But he is hoping to sell a screenplay he claims to be writing about his life story which he calls, 'Masterpiece.'"

Morley Safer then turned to McDevitt and zeroed in on the big question: "Brian, your name has been linked to the Gardner heist, which was the biggest art theft certainly in the history of this country, maybe in history." "Correct." "Did you do it?" "No, I did not." "You understand the suspicions." "Correct, I mean yes, I do. I think the FBI would have been remiss if they had not interviewed me." "And you don't have an alibi for the morning of March 18th?" Brian, sitting next to his lawyer, responded, "It was unfortunate, there were also four hundred thousand other people who were home alone in the city of Boston that night." With this response, McDevitt instantly blew a hole in earlier testimonies about an alibi. He initially had said he was with a woman that evening, and he told Stephanie Rabinowitz that he was in New York to attend the Writer's Guild Awards ceremony. Later on, his lawyer said that Brian couldn't be considered a suspect because he was sporting a beard at the time and the two Gardner robbers were clean-shaven save for their fake moustaches. And then there is the diary entry of his girlfriend, Stephanie, which documents McDevitt's unsuccessful appeal to use her as an

alibi. With all these contradictions, it seemed to me that his guilt was all the more obvious!

The *60 Minutes* report was remarkably thorough. Safer even interviewed Boston detective Roy Prout, who was hot on McDevitt's tail following his bank safety-deposit box robbery in the fall of 1979. When asked what he had discovered about McDevitt, Prout responded, "Well, it was apparent throughout my investigation that most people seem to feel they were deceived by him and that he was not quite what he appeared to be. Some people that I spoke with described him as a phony." Safer next revealed a new fact, or a fantasy, resulting from McDevitt's escape from Boston following the bank heist, "McDevitt now claims that in fleeing Detective Prout, he ended up in Brazil [not Bermuda or Jamaica] and fell in with an art theft ring." Responding to this, McDevitt said, "And then it was like living a James Bond film or *It Takes a Thief.* I mean, dropping into skylights . . . the money, the cars, the women." To this, Safer editorialized, "He may see himself as a high-society, second-story man, in fact he's a garden-variety con man." Safer followed by asking McDevitt, "How easy was it for a guy like you, who speaks pretty well, looks pretty well, dresses pretty well, to be a con man, easy?" To which he responded, "Easy, very easy. No question about that. That's when I was nineteen, twenty, twenty-one. That was over a decade ago."

For the *60 Minutes* program, McDevitt was interviewed in Hollywood, where he said he went to reinvent himself. He claimed the FBI grilled him exhaustively in Boston and, in fact, had a permanent stakeout in Hollywood watching his every move. Being the typically clever con man, he was successful in joining the Writers Guild of America, who was so wowed by his line of BS that they put him in charge of their grants program. Morley Safer interviewed a fledging writer at the time by the name of Ben Pollock who got suckered in by McDevitt to form a screenwriting company. But as Safer said, "Old habits die hard." He interviewed Pollock, who said, "He [McDevitt] came up and told me that he was this writer from the *New Yorker* and that he'd won the Hemmingway Award and the O'Henry Award, he had written *Hope and Glory*, the film, and that he had ghostwritten *Soap Dish*, and that he'd done several television shows." But apparently Pollock became suspicious, and after doing some personal investigating, realized that McDevitt's résumé was, as Safer described, "pure fiction." What transpired between Pollock and McDevitt harkens back to how McDevitt treated Michael Morey in coercing him not to back out of The Hyde heist. Pollock told Safer, "McDevitt told me basically, 'Don't tell anybody what you found out about me. You do not want to make me unhappy. I'm not the kind of person you want to get mad.' Which is frightening. It was an implied threat." Safer asked, "One you thought was a serious one?" "Yeah, absolutely, I mean he's a guy who I thought was Robert Kennedy, all of a sudden now he's Jeffrey Dahmer!"

The program concluded with Safer asking McDevitt, "If we hooked you up to a lie detector right now, Brian, how do you think you'd fare?" "I'd pass beyond the shadow of a doubt." "Did the FBI ever suggest that in the course of their investigation?" And with that question, McDevitt turned to his lawyer. Tom Beatrice responded, "They suggested it, we discussed it and we decided not to take it. Just based on the fact that it is considered unreliable, we just couldn't take that chance." Safer's ending remarks best describe the conundrum: "The FBI continues to press McDevitt but clearly has nothing solid to pin on him. As for McDevitt himself, you never know when, if ever, to believe anything he says. You get the distinct feeling that he wants you to believe he did steal the paintings. Con men are a strange breed."

NOTE

1. *60 Minutes*, Season 25, Episode 11, "To Catch a Thief," directed by Jeffrey Fager, featuring Morley Safer and Brian McDevitt, aired November 29, 1992.

Chapter 15

Hollywood Reinvention

McDevitt's lawyer, Tom Beatrice, stated in an interview for the June 3, 1992, *Boston Globe* article that "He [McDevitt] was born and raised here in this city [Swampscott]. He made a decision to relocate [to Hollywood] based on his own lifestyle. It had nothing to do with the Gardner."[1] McDevitt's relocation across the continent to Hollywood, almost immediately after the Gardner heist, was hyped by him as a move to "reinvent" himself. It's indeed an appropriate expression for the Swampscott con man, because his was a life of a continual succession of reinventions. Never one to settle down and accept the reality and conditions of the world around him, he scripted his life as though he was fashioning a screenplay. Clearly escaping his pedestrian Irish heritage, he sought life in the fast lane, and when he couldn't afford it, he turned to crime to fatten his pockets. Hollywood, the land of artifice, therefore seemed to be a suitable next landing place for him. He had acquired a colorful, real-life résumé and was now ready to put it to use. But, once again, he resorted to his default position of deception. This time, however, he didn't pretend to be a Vanderbilt or use any other alias; he assumed that being three thousand miles west of Glens Falls or Boston would lay some distance from his past. So once again, he created a new McDevitt—a brilliant writer. It wasn't altogether new. He arrived in Glens Falls as a rich professional freelance writer, but now he added new laurels to his crown. His latest résumé was grander and better than ever. The June 3, 1992, *Boston Globe* article on McDevitt reported he "told business associates that he was a distinguished writer, with stories published in *The New Yorker, Harper's Magazine, The Guardian* and he had won the prestigious O'Henry and Ernest Hemingway Foundation awards."[2]

How McDevitt funded his escape to the West Coast is uncertain. Morley Safer commented in his *60 Minutes* program, "McDevitt is vague about how he makes a living, but he now lives in the Hollywood Hills." This fact has never been made clear. His girlfriend, Stephanie, remarked that, "He told me he was producing and writing, and I have no idea how he was supporting

himself." Given his track record, however, his modus operandi was to make a dramatic career change following a big heist. He funded his ostentatious Bentley lifestyle in the Adirondacks with the money he stole from a Boston safety-deposit box. And if he would have been successful at pulling off his attempted heist of art works from The Hyde Collection, he was planning on a new life from the laundered money he was to receive from his underworld connections. So, how did he finance his Hollywood transfer? Could it have been with laundered money from the Gardner heist? The fact that he fled Boston soon after the Gardner catastrophe gives one pause. His anticipated earnings from The Hyde heist were to be approximately seven million dollars (or at least, that's what he hoped he would make); one wonders what was promised to the two Gardner burglars who made off with a haul worth half a billion dollars. And if one of them was McDevitt, where did he deposit his newly earned pot of gold? Surely the FBI agents who conducted an investigation on McDevitt related to the heist must have thoroughly examined his history and financial status. But given the muddled confusion they've made of the entire Gardner investigation thus far, it makes one speculate.

According to Stephanie Rabinowitz, McDevitt lived rather well in Hollywood, living in a hilltop bungalow above Mulholland Drive, but she never knew how he was earning a living. By the time they were both in LA, they were no longer dating; however, Brian kept contacting her and occasionally taking her to lunch and various activities. In a diary entry on September 16, 1991, she wrote, "Brian really wants things to work out w/ us—He keeps talking how he wants to be loved and have someone share things w/ and it would be fun to live w/ me and he'd be more serious—I don't think I love him anymore . . ." In that same entry, she notes, "Brian and Jeff [I presume from later findings it was Jeff Bydalek] came by at 10 AM to pick me up for breakfast—Brian had shaved his beard and mustache off—He looked good—He was happy to see me—Very—Nice breakfast—Then we went back to his place and hung out—Nice place on the hill—His friend Ben [I presume it was Ben Pollack] came over and we had a barba-que!"

Once McDevitt landed in Hollywood, it didn't take him long to meander through the maze of screenwriter types. His good looks, sharp attire, and inventive silver tongue worked magic within the ego-driven viper pit of competing screenwriters. Having an ego the size of Mount Fuji himself, he was quite successful in selling all within hearing distance the fact that he was an East Coast superstar with accolades a mile long. And it's incredible that it took so long before anyone in Hollywood picked up the phone to check his references. Yet, I must admit it took me a while to investigate McDevitt's Vanderbilt ruse with a real Vanderbilt.

To make himself official, he straightaway joined the Writers Guild of America, West. And within a few months, McDevitt had so wowed Guild

officials that they elected him chairman of the Grants and Foundations Committee—the guy really should have been seeking an acting career. That committee appears to be no longer viable, but when McDevitt was in charge, it was a research committee that, luckily for the Guild, as reported in the *L.A. Times*, "did not directly deal with guild assets or money."[3] This undoubtedly wasn't a full-time, paid position because he was creatively involved with numerous schemes. Like a proverbial magnet, McDevitt was almost immediately attracted to a rather dubious character by the name Jeffrey Bydalek. Calling himself a "serial entrepreneur," Bydalek was from the Chicago area and bragged that he was a self-made millionaire—truly someone who would have been very attractive to the likes of McDevitt. The two soon formed a screenwriting company by the name of Inkwell Productions. Unfortunately for McDevitt, in October 1991 Bydalek was arrested by the FBI and charged with an alleged grand larceny scheme that he was involved with in Illinois. By early 1992, Inkwell Productions had folded. McDevitt had also sought the friendship of the young screenwriter Benjamin Pollack, whom, it was reported in the *60 Minutes* program, likewise formed a screenwriting association with him. However, Pollack was smart enough to sense that he was being conned and started checking McDevitt's references. Bingo, nothing panned out. I clearly know how Pollack must have felt, for I, too, had had that same enlightening experience in Glens Falls when a Vanderbilt family member informed me that she had never heard of a Paul Sterling Vanderbilt. It was when Pollack accused McDevitt of fabricating his résumé that he was threatened by him, telling Morley Safer that McDevitt was instantly transformed from a Robert Kennedy to a Jeffrey Dahmer. Pollack was interviewed, as was I, for the 2018 ten-episode podcast series about the Gardner Heist titled *Last Seen*, produced by WBUR and the *Boston Globe*. Pollack said that when he confronted McDevitt about what he had discovered, McDevitt "was cool as a cucumber. He told me how it was going to go, and he threatened me. 'If you tell anybody what you discovered, you know, I'm going to do you in.' And then he was sort of straight up to my face."[4] After confronting McDevitt, Pollack reported that he received thirty to forty threatening phone calls daily from McDevitt, over a five-week period. Pollack eventually was able to get the police involved, and McDevitt faced criminal charges for harassing Ben Pollack.

And then there was another individual in Hollywood who similarly suspected something suspicious about McDevitt. A freelance investigative reporter by the name of Peter A. Lake began questioning his validity when he got wind of the Inkwell Productions' demise following Bydalek's arrest by the FBI. Lake began examining McDevitt's credentials and discovered they were all fiction. As he told an *L.A. Times* reporter, "nothing he has said or written was true; it was one lie after another."[5] Unfortunately, Lake

was unsuccessful in convincing screenwriter officials that McDevitt was a phony, and he voiced his concerns on the Writers Electronic Bulletin Board, which has been described as an electronic "watering hole" for writers. This ultimately evolved into a pissing contest between him and McDevitt. The *Times* article went on to report, "Subsequently, Lake began sending McDevitt private electronic messages designed to smoke out information. 'I was speaking to some law enforcement people and your name came up,' he wrote McDevitt at one point. 'They were bluffs because I didn't know what was in his past,' said Lake, who concedes that the [McDevitt] messages had a menacing tone. From McDevitt's alarmed reaction, Lake determined he was hiding something. Alerting guild executive director Brian Walton and other union officials, Lake said he told them, 'This guy is a walking time bomb. He's going to embarrass us some day.'"[6] But apparently the fuss he was raising on the internet bulletin board was not well received by Guild officials, and Lake was rebuked by them. It seems there were specific rules guiding its use, particularly in issuing disparaging comments about the professional abilities of other writers or in violating members' privacy.

There began to be a small storm brewing about the dubious Brian McDevitt within the screenwriters' community, and he must have felt a black cloud of suspicion slowly building over his head. His subterfuge was beginning to dissolve, and he started to panic and fight back. Then the June 2, 1992, *New York Times* story broke about him being a Gardner heist suspect, and it reverberated across the continent and made a huge impact in Hollywood. The June 12 *L.A. Times* article, titled "The Case of the Mysterious Screenwriter: Movies: Brian McDevitt's past was suspect to some members of the Writers Guild. A new inquiry reveals an unexpected plot twist," opened with the following: "It was news to send screenwriters all over town scrambling to their computer keyboards: Brian McDevitt, a member of the Writers Guild of America and the chairman of one of its committees, had been questioned in connection with one of the largest art thefts in history. McDevitt's name was far from unknown to users of the union's computer bulletin board, a communications system linking 1,200 guild members. For months he had come under fire from a group of screen writers who had questioned his credentials. So strident were the attacks that the union leadership had ordered the screenwriters to desist."[7] The *L.A. Times* article really must have spooked McDevitt, because he met with his former girlfriend, Stephanie, for lunch that day and pleaded with her to create an alibi that she was with him the night of the Gardner heist in case someone from the FBI would interview her. However, the 2018 WBUR/*Boston Globe* podcast noted that McDevitt had also "received a summons to a grand jury back in Boston." Indeed, this would have been even a greater reason for his anxious need for an alibi!

Once the news broke, the panicky McDevitt immediately contacted his East Coast lawyer, Tom Beatrice, to help defend him. Beatrice told the *L.A. Times* that "his client is being harassed by 'malicious and unstable people' who have a vendetta against him because of his past. . . .' [He is] definitely not the chief suspect' in the Gardner theft." Clearly Beatrice was relying on McDevitt's telling of the story and didn't comprehend the entire mess his client had made in Hollywood. The *Times* writer, Terry Prestin, further reported, "Adding to doubts about McDevitt's credibility, Beatrice said earlier this week that a script written by his client from the Evelyn Waugh classic '*The Loved One*' was 'well received' by the Sundance Institute in Utah. But Michelle Satter, director of the institute's feature film program, said that although McDevitt was invited to enter a screenplay based on a synopsis he submitted, the script was not forwarded to the committee that determines who will be invited to the institute." McDevitt couldn't acknowledge the truth if it was handed to him on a silver platter. He just kept on creating new tales in an attempt to justify his so-called brilliant writing ambition. And he definitely wasn't going to give up easily, announcing on the electronic bulletin board soon after the revelation of his past became public that he surely did not intend to resign from his committee chairmanship. Nevertheless, a month after the *L.A. Times* broke the McDevitt story, they ran another one titled, "Writers Guild Official Ousted for False Resume." It noted that, "The guild had given McDevitt an opportunity to submit proof that his work history was as he had stated, but he did not supply the information."[8] No doubt, once the word got out about his sleazy past, some Guild officials must have been quite embarrassed for having defended him so strenuously. But the die was cast, and he had gotten caught in the web of his own making. The June 12 *L.A. Times* article ended with this jocular observation: "Meanwhile, screenwriters are speculating about what could have prompted McDevitt to reinvent himself as a screenwriter. 'We write about criminals. We don't usually consort with them,' said screenwriter Terry Curtis Fox [whose genre is crime-related stories]. 'What I find amusing about all this is that McDevitt thinks becoming a member of the Writers Guild has some kind of a cachet." Another telling remark about McDevitt's Hollywood nosedive was quoted in the June 3 edition of the *Boston Globe*: "Joseph Straczynski, a producer and writer for the television show 'Murder She Wrote,' said yesterday that watching McDevitt's Hollywood ascension is like 'watching a car crash in slow motion. A lot of us are absolutely befuddled.'"[9]

No one in Hollywood could ever refute the fact that at least McDevitt was brazen. He was no delicate flower. The June 3 *Boston Globe* story about him articulates that fact well: "In Hollywood, some of those who know McDevitt say he moves throughout the underworld of screenwriters with a collected confidence, claims to be represented by the best agents, and gets into the most

desirable clubs by walking past the line and just appearing at the door." This brings to mind a story about him. In December 2010, Jim Arnold, a Hollywood screenwriter and author, wrote a personal story about Brian McDevitt in his blog, Jimbolaya:

> I met Brian in 1991, when I worked at Paramount and was tasked with helping put on a 50th Anniversary Celebration for the movie *Citizen Kane*. I got a call from him out of the blue. He said he was a staff writer on [the TV series] "The Wonder Years" [which is what he told his girlfriend Stephanie when he first met her in Boston in 1989] and 'was his name on a list or where would his tickets be sent?'
> What?
> Not wanting to piss off an important writer, I put his name on a list and told him if we had any extra tickets, I would call him back. I thought, at the time, as an aspiring writer, it would be good for me to have a writer acquaintance who had an actual writing job and connections.
> I never checked his credential [sic.]. Brian was the type of person who could sell you a sack of shit and not only have you believing that it was full of gold bullion but that it smelled like lilacs, too.
> Of course, we did have a couple of extra tickets and Brian and his girlfriend made it to the CK party. After that, we developed a friendship. It evolved to the point where he was going to help me develop and hone my movie script; I would help him get a pitch meeting with Paramount brass who I interacted with (in my lowly way) every day (his script was about a Russian art theft…).
> We would go to lunch; he would regale me with tales of WGA [Writers Guild of America] politics—he was involved somehow with them in administrating an early internet chatting protocol called a BBS.
> He even gave me a script he said he'd written—it was a screenplay for Evelyn Waugh's *The Loved One*, which was odd, since it had already been made into a movie in 1965 with Waugh, Terry Southern and Christopher Isherwood as credited writers.
> Then, one day all hell broke loose with the revelation in the trades that he had faked his WGA credentials and all his credits and was really just this Boston conman. He had apparently irritated the wrong person at the WGA, someone who actually had the interest and capacity to really check on his background. His crimes, lies, and the prison time, etc., all came tumbling out.
> I remember calling his girlfriend that morning and telling her I just wanted to know 'why.' I never heard from Brian again and I think he left Hollywood pretty much immediately.
> What I do know is that was the last time I ever trusted *anyone* in Hollywood, which is a valuable lesson to learn, even if it came a little later than it should have.
> Yet—he was an absolutely delightful person. Pathological liar, maybe, but an engaging, smiling, articulate Irishman. . . . Wherever you are Brian, I wish you well.[10]

Jim Arnold's mention of McDevitt showing him a script of a screenplay for Evelyn Waugh's *The Loved One* recalls yet another of McDevitt's attempts to deceive. Arnold expressed to me that he was pretty sure McDevitt had just slapped his name on the original movie script co-written by Waugh, Southern, and Isherwood and pretended it was his own original work. A similar incident happened to Doug McIntyre, the noted talk show host on LA's KABC's *McIntyre in the Morning*. In the early 1990s, when he was a young Hollywood screenwriter, he had written a biopic screenplay entitled *Ride the Wind*, an intriguing story about the Wright Brothers. Following the customary procedure of searching for a producer, he distributed copies of the screenplay to various film directors. At some point, he got a call from one of his colleagues informing him that a guy by the name of Brian McDevitt was shopping McIntyre's script as his own on the Writer's Guild's electronic bulletin board. McDevitt merely changed the front matter of the script and presented it as his unique work—no issue of plagiarism there! He must have discovered McIntyre's manuscript in some movie director's office and grabbed it when no one was looking. The guy had absolutely no scruples and apparently no talent when it came to writing, even though he was purported to have been working on various art theft–related screenplays. No doubt he must have been searching high and low for such manuscripts already composed by other writers.

After the revelation of his felonious past hit the papers, and the screenwriter crowd went into an uproar about having a criminal in their midst, his splendid Hollywood writer's career came to a flaming crash. The ABC *60 Minutes* program that aired in late November 1992 was filmed while he was still on the West Coast, which must have been in early June of that year—just as the feces was hitting the fan.

However, one of the most revealing incidents connecting him directly to the Gardner heist occurred when he had a surprise meeting with his former girlfriend, Stephanie Rabinowitz, on Saturday July 25, 1992. It was at the "funeral party" for the *Ren & Stimpy Show*, which had recently gone off the air. It was held at Kelbo's Hawaiian Restaurant in West LA for all the cast and crew involved with the show. Stephanie, who had worked on the show, was shocked to see him because he had no affiliation with it. She said, "I remember walking up the stairs and was surprised to see him standing there. I was also shocked that he was there because WHO and HOW would he have known about this party? He gave me a hug hello and whispered in my ear that he was leaving Los Angeles very soon and would be moving to an island and would live out the rest of his life there. He really wanted me to come with him and he would take care of me for the rest of my life. He wouldn't take no for an answer . . . he said even though he had [another] girlfriend, he loved me very much and kept asking me to go with him. I asked him how he was going

to take care of me. . . . He whispered in my ear that he was paid [she couldn't remember exactly how much money he received, but she thinks it was about $300,000] by a man [who she also couldn't remember] to get these [Gardner] paintings for him. He was hired, and he pretty much confessed it all to me." In interviewing Stephanie several times, she claims that he was adamant about his request for her to go with him, and he claimed he was going to an island off South America and that he had plenty of money to last for the rest of his life. But she said, "As tempting as it sounded, I couldn't do it." She said he became immediately furious with her and stormed out of the restaurant, and it was the last time she ever saw him.

It had been almost two months since the *L.A. Times* had revealed his real identity, and obviously the pressure was building; he had to go underground. True, he had lots of press in 1980 following the attempted heist at The Hyde. But most of that was confined to Upstate New York. Even his Boston bank heist was a regional press event. However, he was now becoming more of a nationally known petty criminal with the possibility of hitting it big-time should the FBI decisively nail him to the Gardner case. Stephanie went on with her life, eventually moving to Washington State. On August 14, 1996, she met up with the person who had originally introduced her to McDevitt (most likely Nat Segaloff). In her diary, she wrote, "He said Brian McDevitt has been living on a small island off of Brazil for the past 7 [it would have actually been four] years. He's planning on moving back to the U.S.—Wow! It should be interesting if I should see him again! I hope I'll be O.K.!"

The information that McDevitt was living on an island off the coast of Brazil brings up an interesting fact. During the CBS *60 Minutes* segment, "To Catch a Thief," the detective, Roy Prout, who had investigated his first big crime, the 1979 theft of one hundred thousand dollars from a Boston bank, said that McDevitt "ended up in Brazil and fell in with an art theft ring." Could he have returned to his old crime stomping grounds to hide from his growing fame as a key suspect in the Gardner heist? There are certainly noted organized crime networks in Brazil, and one of its islands, Ilha Grande, was known as one of Brazil's most notorious criminal breeding grounds, given that the island housed a large penal colony that closed in 1994. However, there are many wonderful, lush islands off the coast of Brazil that could have afforded McDevitt a fabulous hiding place from the prying eyes of the FBI.

NOTES

1. Brian McGrory, "Gardner art theft suspect is study in intrigue," *Boston Globe*, June 3, 1992, 25.
2. Ibid.
3. Terry Pristin, "The Case of the Mysterious Screenwriter: Movies: Brian McDevitt's past was suspect to some members of the Writers Guild. A new inquiry reveals an unexpected plot twist," *Los Angeles Times*, June 12, 1992, 1.
4. "Flimflammer," *Last Seen*, produced by Kelly Horan, WBUR, Boston, September 17, 2018, https://www.wbur.org>podcasts.
5. Pristin, June 12, 1992.
6. Ibid.
7. Ibid.
8. "WEST HOLLYWOOD: Writers Guild Official Ousted for False Resume," *Los Angeles Times*, July 15, 1992, http://articles.latimes.com/print/1992-07-15/local/me-3906_1_guild-west-writers.
9. McGrory, June 3, 1992.
10. Jim Arnold, "Ronni Chasen, Lourdes Kelly, Brian McDevitt and my tenuous connection to the Gardner Heist speculation," Jimbolaya (blog), December 3, 2010, http://jimarnoldblog.com.

Chapter 16
Circumstantial, Or . . .

Once McDevitt fled Hollywood, the press lost track of him. Yet stories about his association with the Gardner heist continued to percolate, particularly every March following the robbery with the usual anniversary stories updating readers on the status of the investigation. On the fifth anniversary of the heist, the *New York Times* ran an extensive article titled "Five Years and $300 Million—A special report: The Maddening Mysteries of the Greatest Art Theft Ever." In it, Ralph Blumenthal did an exhaustive summary regarding the frustrating search for a suspect. He reviewed the list of some of the more prominent possibilities—Miles Connor, Joseph Murray, members of the Irish Republican Army—and toward the end of the article, he focused on "one of the most enigmatic figures in the case . . . Brian M. McDevitt." Blumenthal interviewed Brian's lawyer, Tom Beatrice, who said he wasn't sure where McDevitt was at the time but assumed he was still in California working on a couple of screenplays, "one on a jewel theft, the other on an art theft from a private collection."[1] Beatrice acknowledged that his client, even though he denied involvement in the heist, was probably still under suspicion. One wonders if Beatrice was aware that McDevitt had fled to Brazil. FBI lead investigator on the Gardner case, Dan Falzon, concurred, assuring the reporter, "the issues with McDevitt have never been resolved [so the FBI] will continue to consider him." Blumenthal further explained that Beatrice had even attempted to contact McDevitt for him in order to seek comments for the *Times* article, but he never returned his call.

The British paper *The Independent* ran a lengthy story written by the rather witty character Thomas McShane in April 2007, resulting from his book *Loot*, published a year earlier. McShane had worked for the FBI for thirty-six years, most of which were devoted to art crime. He famously worked undercover, masquerading as shady art dealers in an attempt to lure unsuspecting criminals. He had an exceedingly successful career, having recovered, as he tells it, nine hundred million dollars' worth of stolen art. The *Independent* article was an edited extract of the last chapter of his book, titled "No

Boston Tea Party at IsAbatha's." McShane was one of the first FBI officials on the crime scene at the Gardner, being summoned there the day following the robbery. He gives a detailed account of the events as they played out during the couple of years he stayed on the case. He even went underground, posing as one of his sly art dealers, Thomas Russell, "international man of money and action," and constantly hit brick walls in following all his leads. As he noted, "As time passed, the lid on what happened at the Gardner Museum closed tighter than a Scotsman's wallet." Nevertheless, he finished his essay, claiming that he had narrowed his suspects to two options. The first was the Irish Republican Army, or the Ulster Volunteer Force, both known for a strategy of using stolen significant works of art as collateral in funding their various terrorist activities. And finally, Brian Michael McDevitt, because of the amazing circumstantial evidence, but he said unfortunately, "we had nothing that enabled us to hold him."[2]

The following year, on March 16, 2008, the *Boston Herald* ran an article entitled "Meet the Suspects: Brian M. McDevitt." It was one of several articles the paper ran featuring a serial rogues' gallery of potential thieves. The article was illustrated with a photograph of the handsome, bearded McDevitt, with his alluring innocent gaze that had successfully conned so many people. While the article followed the standard story of his Hyde adventure, it did pose one new startling fact: "The enigmatic McDevitt, who always denied robbing the Gardner, was convicted of five felonies in all, including a Boston safety-deposit theft of $160,000 in cash and bonds. *He died on May 27, 2004, of apparent kidney failure*"[3] (italics, my emphasis). Wow, I didn't see that coming. I quickly Googled "Michael Brian McDevitt Obit," and what do you know, there it was in the *Boston Globe*—one of the briefest obituaries I've ever read: "Loving son of . . ."[4] Those poor parents and siblings. There was no mention of his colorful past, just that there was to be a private memorial service. I'll get back to this subject later. The *Boston Herald* article ended with a quote from one of McDevitt's high school classmates, Jeffrey Earp: "He always projected himself in a high way. He seemed to be on the path to great things. Then, surprise, he was in the news."[5]

Then, in 2009, Ulric Boser published an exceptionally well-researched book, *The Gardner Heist: The True Story of the World's Largest Unsolved Art Theft*. Boser spent several years tracking down various leads and even put his life in danger over some of them. The inspirational personality that gave him the impetus to pursue his book was yet another colorful character in the art theft world, Harold Smith. Smith was a well-known insurance investigator specializing in stolen art. Working for the distinguished insurance company Lloyds of London, as well as other insurance companies, his fifty-year career covered some major cases, including the Gardner heist, which was at the very end of his colorful life. He was even the featured personality in a

documentary film about the heist, titled *Stolen*. Smith died shortly after filming the piece, leaving some of his unfinished leads for Boser to follow. In his 260-page book, Boser reviews the entire list of known suspects, including McDevitt, who, he concluded with the hunch of FBI agent Dan Falzon, was a "long shot, [but] the agent could never be sure."[6] While spending whole chapters on some of the more notorious suspects, Boser gave McDevitt rather short shrift. He pretty much followed the general line of thinking that the guy was relatively unknown and probably the victim of circumstantial evidence. In fact, it appears that much of the investigation surrounding McDevitt ends this way. I'm just not sure if anyone seriously examined the various witness statements of The Hyde's attempted heist perpetrators, including that of the Federal Express driver. If it was done, the question is, did they critically match that information with the known facts of the Gardner case? I have not written this book to make an absolute claim that McDevitt is, without a doubt, the most credible suspect. I haven't been privy to inside investigation facts, because the FBI and Gardner officials are holding all the search evidence close to their chest and are not willing to discuss it with anyone. And among the several interviews they conducted related to McDevitt, I'm surprised they did not take Stephanie Rabinowitz's experiences with him more seriously. She seems convinced that Brian pulled off the Gardner heist. However, she did admit to me that he was very open and trusting with her, but in light of the pervasive doubt, "I don't know what's true and what's not true anymore."

I, too, was acquainted with him in Upstate New York, and being someone who was in McDevitt's crosshairs, it would be interesting to do a close comparison of the two events side by side, as well as to compare known facts about McDevitt and Michael Morey as they relate to the evolving Gardner event. So, for a little fun, let's dive into the thick of it: The first to apparently witness the two Gardner suspects in the early morning of March 18 were three young high school seniors who were no doubt a bit tipsy from attending a St. Patrick's Day party in a frat house not far from the IsAbatha Stewart Gardner Museum. As they passed by a small gray hatchback automobile, they noticed two men dressed in police uniforms sitting in the car. One of them was wearing gold-framed glasses, and both had eight-point police caps on their heads. Being underage, inebriated drinkers, they scurried away quickly, hoping they would not be caught. Following the heist, when Boston's media went into full-throttle hyperventilation, one of them reported the sighting to investigating officials and was interviewed by them. While there were similarities in the description of the so-called police officers in the car with the description of the two heist perpetrators by the Gardner guards, there apparently wasn't enough information to be of much help. The next person to actually observe firsthand the two robbers was Ray Abath (student at the Berklee College of Music), one of the two museum security guards on

duty that eventful night. Abath caught view of two police officers at the back door in the control room video monitor. They knocked on the door and told him they were responding to a call, that there had been a disturbance at the museum. Against museum standing orders to never, ever let anyone into the museum without getting approval, Abath let them inside at 1:24 a.m. Newly uncovered information finds that Abath had let someone into the museum the previous night, which gave rise to more suspicion about his possible association with the heist. The thieves, on the night of the robbery, were both dressed in what seemed to be authentic Boston police officer uniforms, with badges affixed to their hats and coats. They appeared not to be armed—at least no guns were visible—and one of them had a police-type radio that sputtered with occasional garbled voices. Both were wearing obvious fake mustaches. One of them was slimmer than the other, about five-foot-ten and about thirty years old. He was wearing gold-rimmed glasses. His partner, likewise, around thirty, was heavier, about 180 to 200 pounds and around six feet tall. According to Stephanie Rabinowitz, McDevitt's former girlfriend, in the noticeably imprecise FBI sketches made from descriptions given them by the Gardner guards, the heavier robber somewhat resembles McDevitt's appearance. She has a background in graphic arts, and using Photoshop she made some interesting comparisons. But, indeed, it's a long shot to proclaim identity based on a drawing alone.

For The Hyde attempted heist, we have an abundant number of details from McDevitt and Michael Morey's sworn statements. One fact must be made crystal clear. Neither individual was wearing a Federal Express uniform. In all the media hype following McDevitt's association with the Gardner heist, he and his accomplice were said to be wearing FedEx uniforms, a similar strategy used by the Gardner thieves, except theirs were police outfits. It's plainly not a fact. However, it's not that McDevitt didn't try. In a conversation I had with Michael Morey, he stated that McDevitt had attempted to purchase a couple of FedEx uniforms in New York City, but he was unsuccessful and became somewhat concerned that he might possibly have alerted the authorities.

In her witness statement to the police, Mary Winglosky, the FedEx driver, reported that McDevitt "had asked me [before the attempted heist, when he was sending specious parcels by FedEx in order to gain information] unusual questions about being a courier and if we had to wear picture IDs and [about our] radio procedures." They had planned to have only Michael Morey act as if he were the FedEx delivery person, who was to deliver a huge heavy parcel with my name on it to the front door of The Hyde. McDevitt was to stay out of sight in the delivery van until Morey was inside the museum, and brandishing his weapon, he was to force us to congregate in the museum's courtyard and lie on the floor facedown. They had planned an elaborately timed scheme so

that McDevitt would enter the museum two and a half minutes later, and they would restrain us and start their assault on the art collection. It was therefore unnecessary for McDevitt himself to appear as a FedEx employee. Finally, they seemed unconcerned about not having Morey in uniform because on the day of their attempted heist, it was fifteen below zero. He was wearing dark-blue jeans and was bundled up in a green puffy army jacket, and on his head, he was wearing a blue knit stocking cap. One would assume that because of the severe weather, the FedEx employee would have worn a heavy coat over his uniform. If their plan had actually worked and the staff was still in the museum, I'm pretty sure we would have fallen for their pretense and allowed Morey inside due to the frigid weather, particularly since a FedEx truck was parked outside the museum. Like the Gardner thieves, Morey was wearing a fake moustache. He had also tinted his skin with a bronzer and was wearing a dark wig.

Once the two police-uniformed thieves were inside Boston's Gardner Museum, they asked Abath, the security guard, if he was alone. He responded that the only other guard on duty was making his rounds and was told by the thieves to call him back to the security control room. While they were waiting, the thief wearing glasses said to Abath that he looked familiar and was sure there was an arrest warrant out on him. "Show us some identification," he said. Abath left his post, behind the desk installed with a panic button, and approached the two thieves. Once the second guard, Randy Hestand, arrived, the taller thief immediately shoved him against the wall and handcuffed him with his hands behind his back. The bespectacled thief grabbed Abath and did the same. When they were rendered helpless, one of the thieves said, "Gentlemen, this is a robbery. Don't give us any problems, and you won't get hurt." The thieves next retrieved from their bulky coats rolls of silver duct tape and applied layer after layer over their mouths and eyes. They were then taken to the museum's basement, and with more handcuffs, they were made to lie on the floor and were restrained; Helman was attached to a workbench and Abath to some steam pipes. The thieves seized both guards' billfolds, and one of them said in a threatening tone, "We know where you live. Do as I say, and no harm will come to you. Don't tell them anything, and in about a year, you will get a reward." Leaving the guards prone and immobile, they headed back upstairs to begin their reprehensible rampage.

The Hyde Collection's potential thieves had similar plans, though perhaps a bit more severe and seemingly more complex. In Morey's sworn police statement, he said that once McDevitt entered the museum's courtyard, they were to handcuff all of us and keep us on the floor facedown so that we wouldn't see McDevitt, whom we would probably recognize due to his previous association with me and the staff. They were then to etherize all except me so that they could "extract [from me] any information on alarms

in different rooms which might be on." They were then to use precut strips of duct tape, which were in boxes that McDevitt was to bring from the FedEx truck when he entered the museum, to tape eyes and mouths. Morey also noted that they planned to use reinforced delivery tape to bind up our feet and legs. I assume that once they had extracted information from me, I, too, would have been taped and etherized.

After the Gardner thieves finished restraining the two museum guards and made it upstairs to the ground floor, which took all of twenty-four minutes from the time they entered the museum, they then headed for the gallery rooms on the second floor. The museum had a motion-detection system installed throughout the building, and it monitored their movements during the entire escapade. They first entered the Dutch Room together and were startled when an internal motion-sensor alarm went off for a brief moment. At some point, one of them backtracked out of the room and headed for the Short Gallery. The thief in the Dutch Room removed two of Rembrandt's paintings from the wall, *The Storm on the Sea of Galilee* and *A Lady and Gentleman in Black*. He ripped them from their frames and with a knife or a box cutter slashed the canvas paintings from their stretchers, leaving chips of paint scattered all over the floor. Displayed on a table near the entrance of the Dutch Room were two paintings back-to-back, Vermeer's masterpiece work on a wooden panel, *The Concert*, and Govaert Flinck's *Landscape with an Obelisk*. These also were removed from their frames, as well as another small Rembrandt self-portrait on an opposite wall. Before fleeing the room, the thief spent considerable effort extracting from its exhibit moorings a Chinese ancient bronze vessel known as a ku, which had been displayed on a table not far from where the Vermeer and Flinck paintings were on view. In the Short Gallery, the other thief began removing five framed sketches on paper by the artist Degas, far less valuable than the treasures confiscated from the Dutch Room. The other thief joined him in the Short Gallery, and before leaving, one of them became enamored with a Napoleonic Imperial Guard battle flag topped with a gilded bronze eagle finial that was encased in a glass display case that was screwed onto the wall. He had to climb onto a French cabinet to get at it, and when he had difficulty removing all the screws to retrieve the entire flag, he settled on only grabbing the finial. They both went back down the stairs to the ground floor and headed for a small gallery known as the Blue Room, where they removed their last treasure: a portrait painting by Manet called *Chez Tortoni*. It was a strange haul, very inconsistent, minor works that had relatively small value, and from the Dutch Room, their most important treasures, including the Vermeer, which was the most valuable painting taken.

With their haul assembled, they went back down to the basement to inspect the bound-up guards. In a pleasant tone, not in keeping with hardened criminals, one of them quizzed, "Are you comfortable? Handcuffs too tight?" Not

that the guys with their mouths duct-taped could have responded. Once back up on the ground floor, the thieves headed for the security control room, where they ripped out the cassettes in the video recorder and the printouts from the motion-detection equipment to take with them so that no one would be able to see their faces or follow their trail. Little did they know that the hard drive on the motion detector would later reveal their five-fingered shopping spree. After being in the museum a little over eighty minutes, they left separately, one at 2:41 and the other at 2:45 a.m. Did they cram their treasures in the small hatchback auto that they were spotted being in by the young revelers, or was there a different automobile waiting for them? It is unknown, but most likely they had an accomplice. Further, how did they manage to carry out their loot? Did they have expandable cloth bags stuffed in their coats to make it easier to remove the jumble of art works, or did they just clumsily carry the diverse number of objects in their arms, each one with a load?

McDevitt and Morey seemed to have been much more deliberate in their plans to rob The Hyde. We know they had been scheming for several weeks prior to the date of their attempted heist. In his police statement, McDevitt said they both had tool kits purchased at Sears, "which had the common tools in them. They were for various problems we would run into while removing the paintings from the walls of the Hyde." They also had plans for collecting and transporting the stolen paintings. They had several boxes in the FedEx van which "could hold the stolen paintings." The Glens Falls potential thieves were highly concerned about timing. Both had stopwatches, and once they entered the museum, they were planning on spending no more than twenty minutes inside. Morey notes in his statement, "Paul [McDevitt] was to take upstairs and I downstairs to remove the paintings and 20 minutes was the maximum time allowed." McDevitt said in his police statement, "The planning became more precise and was broken down into minutes." It appears that they were prepared to take paintings, frames and all, and would remove the frames during their trip to Washington, DC. Nevertheless, they also were prepared to cut some paintings out of their frames should that become necessary. For the most part, many of The Hyde's works of art are fairly small, and it appears that the two thieves-to-be were bound to abscond with as many of them as they could. One of their biggest challenges would have been taking The Hyde's Rembrandt, *Portrait of Christ*—the most important treasure in the collection. The large canvas is mounted on an aluminum, honeycombed panel, which would have made it a real challenge for them. They had also planted a getaway station wagon near Interstate 87 to abandon the FedEx truck with its etherized driver.

Some of the actions of the Gardner thieves align with the characteristics and interests of McDevitt. One of the curious happenings toward the end of their eighty-minute Gardner stopover was the concern for the comfort of the

bound-up guards in the museum's basement. Kelly Horan, one of the narrators of the 2018 WBUR/*Boston Globe* podcast, interviewed one of the guards, Randy Hestand. He said that he was 90 to 95 percent sure that one of the suspects was Brian McDevitt, whom, he said, had treated him in a "courteous matter—he'd readjusted his handcuffs, told him he'd make it worth his while if he cooperated, [and] apologized for having to do this." The very fact that they went back to check on them before they left, and one of the thieves even questioned their condition, resonates with a remark McDevitt made in his police statement: "At all stages of the planning, the safety of the individuals and their well-being was a premiere consideration in all aspects." Yet, while in the Jekyll side of his personality, McDevitt could be harsh and threatening. Once he had ensnared Morey as an assistant in his proposed Hyde caper, he'd threatened that his son would never see Christmas if Morey didn't comply with the plans. This kind of threat also happened during the Gardner heist, when one of the thieves, after taking the wallets of the two guards, said, "We know where you live, do as I say, and no harm will come to you."

One of the most perplexing facts of the Gardner heist, a subject so many people have pondered, is why one of the thieves made such a big effort to pry out of its glass display case the Napoleonic flag, and out of frustration, would take only its golden eagle finial. Why, with a museum filled with so many marvelous treasures worth a king's ransom, would someone waste time and effort prying off a flag finial worth only a couple hundred dollars? Tom McShane, in his book *Loot*, postulates, "An extremely interesting tid-bit in McDevitt's file was the fact that he was a flag aficionado. In the mid-1980s, while attending the University of Massachusetts, Boston, McDevitt spearheaded an effort to raise money, purchase, and display more than a hundred flags around the institution to reflect the diversity of its student body. That sure sounds like a guy who, in mid-robbery, would have taken the time to try and filch a Napoleonic flag and its capping finial."[7] The thief, McDevitt or whoever, probably most likely wanted a little personal souvenir of his efforts for his bookcase. He even might have taken the ancient Chinese ku as an exotic vase for his girlfriend to use as a container when he next presented her with a dozen red roses.

There is also McDevitt's strategy for staging a heist around a holiday. He wisely chose three days before Christmas to undertake his adventure in Glens Falls. With the distraction of holiday festivities an obvious likelihood, he was banking on museum staff being less cautious and more willing to allow his accomplice entry into the museum to deliver packages. This same strategy seemed to be applied in the Gardner's case, where the City of Boston is known to imbibe a bit heavily in celebration of St. Paddy's Day. While it's uncertain why the security guard, Ray Abath, allowed them entry into the museum, the thieves might have surmised that the guards would most

likely be less inhibited having partied heavily before working the midnight shift. To be sure, the thieves who succeeded in robbing the Gardner were no smarter or more creative than McDevitt and his cohort. Both based their plans on gaining entry into the museum by deception, fooling the staff into thinking they were providing a service—delivering packages versus protecting the museum. We're not talking about sophisticated cat burglars dropping in through the skylights over the lush courtyards of these two Italian Renaissance–styled palazzos. No, these were simple plans solely based on chance, and in McDevitt's case, he only failed (thank God) because of timing—the FedEx driver arriving later than planned and heavy traffic on the bridge over the Hudson River. McDevitt and Morey were called "the gang that couldn't shoot straight," but in reality, it wasn't a matter of their shooting skills, but of their unfortunate timing.

Another interesting trait of McDevitt's was his seeming willingness to talk at length about his escapades. When he was apprehended following his Hyde adventure, he apparently couldn't stop talking about it. On the November 1992 *60 Minutes* program about McDevitt's possible association with the Gardner case, Morley Safer interviewed Saratoga County's district attorney David Wait, who said: "I'm sure they [the police] just sat there and just kept typing as fast as they could until he [McDevitt] stopped talking . . . he just kept right on talking. Maybe he wanted to sound clever." It was like he was living his own story that he would later transcribe into a screenplay in Hollywood. And in Hollywood, when McDevitt was interviewed by Safer, he seemed almost beside himself to expound upon his past Glens Falls adventure. Considering himself a professional art thief, he said, "The only way you can get those paintings [the Gardner's works of art] for your collection is that you pay somebody to go steal them. That's what I used to do." Yet his apparent braggadocio stopped at the water's edge when it came time for him to take a lie detector test for the FBI. As his lawyer, Tom Beatrice, said, "We decided not to take it, just based on the fact that it is considered unreliable." Unreliable or not, certainly Beatrice was probably more concerned about his client, who had a severe case of diarrhea-of-the-mouth and had trouble suppressing his mountain-sized ego.

McDevitt's statement about his former career of stealing paintings for hire—"You pay somebody to go steal them"—is no doubt what happened at the Gardner. The two thugs—McDevitt or whoever—were paid by some underworld mafia-type to carry out the heinous deed. It didn't take a college degree but a huge degree of guts, and/or previous experience, to pull off such a crime. And, I might say, a hell of a lot of luck given the fact that had Abath used better judgment and not swung the back door of the Gardner open to welcome the two disguised thieves, the museum would still have those thirteen prized works of art. Moreover, given the fascinating evidence from

McDevitt's former girlfriend, Stephanie Rabinowitz, who recorded in her personal diaries all her experiences with him over four years, the evidence is pretty obvious. She was exposed to his various con-men acquaintances, she was with him on one occasion when she was sure he committed a minor theft from a Boston parking garage, and at one point during their relationship, he confided to her that he was involved in The Hyde's failed heist. But even more meaningful was his attempt to distance himself from her over the weekend of the robbery and most incriminating, his admission to her that he was involved in the Gardner's robbery and was paid enough money to live comfortably for the rest of his life. Yes, he was a slippery con man, and he had conned his way throughout his life, but her documented recollections are powerful evidence.

The word *circumstantial* seems to be the descriptor that has placed McDevitt in the category of lesser suspects of the IsAbatha Stewart Gardner museum's deplorable heist. All the activities described herein seem just to be circumstantial, with no "fingerprints," if I may use that term, to directly connect him with the crime. Granted, he's not one of the big-time Boston thugs to whom the FBI and Gardner officials have gravitated. It's, indeed, more realistic, or perhaps I should say, sensational, to place the blame on one of them. And there are plenty of fascinating underworld characters who have attempted to play into the fame of the robbery to fatten their so-called crime résumés. Further, there has been much serious research conducted by numerous authorities, including Stephen Kurkjian, whose 2015 book, *Master Thieves*,[8] pretty much pins the blame on the late Robert Gentile, who was up to his neck in mob activities. But again, much of his theory is based on con men admissions and circumstantial evidence. Nevertheless, there are others who don't completely dismiss McDevitt from the crime. In a response dated April 11, 2007, to the extensive blog *Art Held Hostage*, dedicated to the Gardner heist and written by the notorious British reformed criminal, Paul "Turbo" Hendry, a guy by the name of Frank McElroy wrote:

> I took McDevitt's deposition in jail in Boston in the early 1980s in connection with a safe-box theft from New England Merchant National Bank. I spoke to him, many of his con victims, and the police chief in Glens Falls, NY. He was a natural for the Gardner, and I suspect his death was faked. Most people don't remember that he was a big cog [here I think he's exaggerating a bit] in Boston for the Jerry Brown campaign for US president. He was a superb con and a local, from Swampscott, just north of Boston. The possible connections to the Winter Hill Mob are interesting, but none of the people in that group had McDevitt's talent. He could have been working for them I suppose. Wish I'd been at his funeral with a big hat pin.[9]

This is such a frustrating case. At this writing, it's been thirty-five years, and we're still waiting for the FBI to find the paintings and disclose the names of the crime syndicate miscreants who ordered the heist and the two thieves who carried it out, whom they say they already know. What a trying situation for the trustees and staff of the Gardner Museum.

NOTES

1. Ralph Blumenthal, "Five Years and $300 Million—A Special Report: The Maddening Mysteries of the Greatest Art Theft Ever," *New York Times*, December 1994, http://www.nytimes.com/1994/12/15/arts/five-years-300-million-special-report-maddening.

2. Thomas McShane, "The Heist of the Century," *Independent*, London, April 11, 2007, http://www.independent.co.uk/news/uk/crime/the-heist-of-the-century-444219.html.

3. "Meet the Suspects: Brian M. McDevitt," *Boston Herald*, March 16, 2008, http://www.bostonherald.com/news/regional/general./view.bg.

4. "Brian M. McDevitt," *Boston Globe*, June 2, 2004, http://.legacy.com/obituaries/bostonglobe/brian-m-mcdevitt.

5. "Meet the Suspects," March 16, 2008.

6. Ulrich Boser, *The Gardner Heist: The True Story of the World's Largest Unsolved Art Theft* (New York: Harper Collins, 2009), 98.

7. Thomas McShane, with Dary Matera. *Loot: Inside the World of Stolen Art Theft* (Meath, Ireland: Maverick House, 2006), 315.

8. Stephen Kurkjian, *Master Thieves: The Boston Gangsters Who Pulled Off the World's Greatest Art Heist* (New York: Public Affairs, 2015).

9. Paul Turbo Hendry, "The Heist of the Century," *Art Held Hostage*, April 11, 2007, http://arthostage.blogspot.com.

Chapter 17

Dead or Alive?

Hi, all. was in Swampscott this afternoon and evening. got some info that could be true if people are still interested. my mom's neighbor who is in touch with someone in touch with John McDevitt ("dad") indicated that Brian died of pneumonia. Had a bout of it, seemed to recover, then relapsed and died. So, this "seems" to be fairly accurate info, though I won't promise that it is.

Speculation on someone else's part is that it is unusual that someone young die of pneumonia without other factors involved such as bad immune system, etc., so there might be something to that. That's pure speculation though.

Ok, just got back an hour ago, and sharing on the gossip vine.

ta, ta.[1]

On the internet chat room for the Swampscott High School Class of 1978, called BigBlue78, there was a great deal of speculation and gallows humor about the so-called death of one of their classmates, Brian Michael McDevitt, in May 2004. First, it was just gossip passed around by some of his classmates, and then finally, his death was published on June 2 in the *Boston Globe*:

Brian M. McDevitt
Formerly of Swampscott, MA. Died May 27, Age 43. Loving son of John H. McDevitt of Millinocket, ME and Mary A. McDevitt, Swampscott, MA. Dear brother of Colleen A. Lewis of Santa Barbara, CA., Melanie A. Anasoulis of Wrentham, MA and Sean McDevitt of Boston, MA. Grandson of Mary E. McDevitt of Burlington, MA. Also survived by many other relatives and friends. Memorial Services will be private. If you wish, donations in Brian's Memory to the charity of your choice.[2]

The first thing that stands out in McDevitt's brief obituary is the word "formerly." As I noted earlier, after he left Hollywood, his movements are sketchy at best. In the various chat room exchanges, some of his classmates mentioned Missouri, Seattle, and even Colombia, South America, but their

messages were unclear and could have possibly been referring to other people. In my research, I could only find one other obituary, and that was in the Bates College magazine published on April 21, 2010, under alumni obituaries, that implies that McDevitt returned to New England following his Hollywood screenwriting adventure:

> The intriguing, intelligent, and articulate Brian McDevitt, a nongraduate of Bates, found himself implicated in an art-robbery attempt at the Hyde Museum in upstate New York in 1980, a plan that went awry when he and accomplices, dressed as delivery men, arrived at the museum after closing. Thus in 1990 he was in the media's eye after the Isabella Stewart Gardner Museum was robbed under similar albeit successful circumstances. He moved to Los Angeles to pursue screenwriting, thereafter, returning to New England in recent years. He graduated from the College of Management at UMass-Boston in 1987. His death became known to the college in September 2005.[3]

Brian, known to be pretty much a loner among his classmates when he was a student at Swampscott High School, soon fell out of favor and became a butt of many jokes and snide comments by them as word of his various crimes began to surface over the years. From the high traffic of chatter following his so-called death, one can sense how much of a con man they thought he was:

- "However, it shows this guy was a real operator. Con men have no scruples and begin to believe the con they are living. He might have conned the wrong people . . ."
- "An obit remarkably devoid of details for someone so young . . ."
- "I wonder what happened to him. It says send donations to a charity, we should all send donations to an 'Art fund' . . ."
- "Maybe Whitey Bulger caught up to him . . ."
- "So, Brian could be pulling off his biggest hoax yet. Maybe we will see some of the stolen art turn up over the next year . . ."
- "Most plausible theory yet! Death IS a career move . . ."
- "It was only in the *Globe* . . . not in the *Item* or *Salem News*, either . . . very odd . . ."
- "On the McDevitt story—there was no obit in the *Marblehead Reporter* last week—the whole thing seems strange. But then again, strange is as strange does . . ."
- "I was too broken up about the McDevitt thing to respond . . . Still trying to uncover the conspiracy theory about the 'Lightbulb Fundraiser' as the real reason for his demise . . ."

The lack of sympathy was noteworthy. Only one of his classmates cautioned the others that "let's not say bad things about him as he is dead." The bulk of the comments seemed to express doubts about whether or not he really was dead. As one of his classmates speculated, "It's all hush. Maybe he really isn't dead, and they buried his casket empty. Maybe he is going to change his identity and move to Switzerland and spend his money"

The fog surrounding McDevitt's activities after he fled Hollywood, as well as his supposed death, cleared somewhat when, in 2018, the WBUR/*Boston Globe* podcast *Last Seen* introduced a new character to the McDevitt saga, Nat Segaloff. Nat is a writer-producer-journalist who befriended McDevitt when they were both living in Boston and Los Angeles. Two years after McDevitt vanished from LA, Segaloff got a call out of the blue from him. "In October of 1994, I got a phone call from him. He said he was in Rio de Janeiro waiting for the statute of limitations to run out. At that point I kind of got the idea that somebody was after him. He said he was in Brazil because there was no extradition treaty with the United States. And he also said that he had got wind from the grand jury that there might be an indictment handed down, so he fled the country."[4]

Segaloff said that he lost contact again with McDevitt, and it wasn't until December 2002 that he received an email from him reigniting their friendship. "We just started writing back and forth. We had a voluminous correspondence. Mostly he would send me articles about art heists all over the world and we would talk about movies, and we'd talk about politics, especially the difference in politics between America and Central America, because at that point he was living in Medellin, Colombia."[5]

Then, on May 10, 2004, Segaloff had his last telephone conversation with McDevitt from Colombia, and he recorded the call: "Look, Nate, I have to go back to the hospital tomorrow. You know, I didn't want you to hear about it late or anything else. You know I consider you one of the few friends that I have left. So, everybody else has pretty much abandoned me, including my family, and I just felt that you should know and, I hate to kinda call you like this, but I realize that I haven't really been as prolific as I used to be on the internet, really since I got back from the hospital in January. So let me just tell you what's going on. Doesn't look like I'm going to be living to your ripe old age, that's for sure. When I got out of the hospital, they asked me to come back, and they told me I was HIV positive. Needless to say, that came as quite a shock. The fact is, Nat, that I've slept with dozens of women down here. But anyway, the point, Nat, is that I am just running out of time."[6] He told Segaloff that he had pneumonia and that it was difficult for him to breathe. And then, seventeen days later, Nat received a phone call from McDevitt's sister informing him that he had died.

As one of McDevitt's high school classmates wrote about him on the alumni internet chat room: "Most plausible theory yet! Death IS a career move . . ." Did our talented con man engineer his demise with his family and the FBI in order to go underground, figuratively, in order to escape his lawless past? However, Anthony Amore, the Gardner Museum's director of security, claims that McDevitt is not one of the heist perpetrators and that he has seen his hospital bills as well as his Colombian death certificate. Which is confusing because he and the FBI claim the two heist perpetrators are dead. An obvious clue about McDevitt's guilt is the fact that he fled from LA to Brazil to avoid extradition, under the assumption that he thought a grand jury was about to issue an indictment for his arrest. Without doubt, Amore has had to coordinate with the FBI in maintaining a wall of secrecy, which only opens the door for all manner of speculation. One of the possible alternatives is that McDevitt was in the witness protection program after spilling his guts about whom he was shopping for at the Gardner. That likelihood cannot be dismissed given that FBI officials claim they know who the thieves are and that they are dead. They could have flipped him to give them evidence about who hired him to commit the heist, and faking his death would protect him from the retribution of a criminal mob boss. Why else would they keep the perpetrators' identities hidden? In all my communications with the FBI, Gardner Museum representatives, and even McDevitt's dad, during the research for this book, I've been blown off as though I were a pesky blowfly. If I were a betting man, I think I'd place my money on the fact that he's in the witness protection program.

As former FBI agent Thomas McShane told the *Last Seen* podcast narrator, Kelly Horan: "We could dig him up and make sure that there is a body beneath the ground because I don't believe there is."

The uncertainty remains, and only time will tell if McDevitt—dead or alive—will ever be officially linked with the Gardner heist. Kelly Horan proclaimed, on the last episode of her podcast series: "I have taken no end of ridicule for my theory . . . [which is] . . . that a man named Paul Stirling Vanderbilt, alias Paul Stirling Vanderbilt, who tried to rob a museum in upstate New York in 1980, returned to Boston to do it right a decade later. His name is Brian McDevitt from Swampscott, Massachusetts."[7]

NOTES

1. Big Blue 78, Swampscott High School Class of 1978, "Brace Yourselves," June 5, 2004, 4:09 a.m., http://groups.yahoo.com/group/BigBlue78/message/5070.

2. "Brian M. McDevitt," *Boston Globe*, June 2, 2004, http://www.legact.com/obituaries/bostonglobe/brian-m-mcdevitt.

3. "Obituaries," *Bates Magazine*, April 21, 2010, https://wwwbates.edu2010/04/21.
4. *"Flimflammer" Last Seen*, produced by Kelly Horan, WBUR, Boston, September 17, 2018, https://www.wbur.org>podcasts.
5. Ibid.
6. Ibid.
7. Ibid.

Chapter 18

Where Do We Go from Here?

At this writing, it's been over thirty-five years since the dreadful Gardner heist. Speculation about the reprehensible incident has been all over the map. It has spawned a small cottage industry of individuals, including myself, attempting to solve or find some new perspective on the crime. All facets of the misdeed—the robbers, the fence, and the works of art—are encircled in a haze of speculation. I have not written this book to make any new absolute claims about the case, but I offer this book to provide one more perspective to the growing list of speculations. The FBI and Gardner officials rightly are keeping the investigation held tightly to their chests. One can only conjecture what their current leads might be. Brian Michael McDevitt was/is a robber suspect but seemingly is played down by them as a suspect. Because of his 1980 attempted heist in upstate New York, his constant brush with the law, his suspicious antics, and the amazing stories from his former girlfriend, he can't be totally ignored, either. And what is unique about my experience with him at The Hyde is that I actually became acquainted with the person who would eventually attempt to rob my museum. It's an occurrence that, to my knowledge, has never happened before. Granted, McDevitt was pretty naïve at the time, and he gave himself away almost immediately, but he created a tremendous amount of angst in my life during the lead-up to his botched endeavor. While he and his accomplice, Michael Morey, were thankfully unsuccessful, I have spent many hours wondering just what it would have been like had their timing been better. They had obviously invested quite an effort in planning their heist—handcuffs, tape, ether, pellet guns, stopwatches, tools, boxes, and a stashed getaway car—it could have been as dreadful a situation as occurred ten years later at the Gardner. And when I learned of this alarming incident in Boston, I somewhat experienced a "PTSD" moment. I was back at The Hyde, and my gut was wrenching; I was reliving that episode again. As I noted earlier in this writing, I can only imagine the terror and anguish that Anne Hawley was going through on that March 18th Sunday morning, when she walked into her museum galleries to see frames thrown

on the floor among scattered chips of paint from the paintings that were cut out of them. She had no warning as I had experienced, and therefore, it must have been absolutely horrendous.

It's particularly difficult for those of us who work in the museum field, who dedicate our lives to the care and protection of delicate works of art (pieces of the world's cultural heritage), to have them considered by others as only commodity objects. But those in the underworld, who witness continuing skyrocketing values of works of art in the marketplace, have no concern for them as universal cultural icons. They're just simply indifferent possessions that merely represent monetary value, on par with gold, diamonds, and other valuable objects. The fragile works of art that we strive to maintain in optimal environmental conditions, where temperature, humidity, and illumination are carefully controlled, are suddenly ripped from their hallowed surroundings like helpless, naked infants and hoarded in God only knows what kind of circumstances. They are transformed in the minds of mafia-types to commoditized objects, no longer glowing with the reverence of cultural heritage, simply objects of high value to be used as bargaining chips for gangland transactions.

Without doubt, stealing important objects from a museum is, in reality, a theft from all mankind. On July 28, 2017, there was a theft at the Armstrong Air & Space Museum in Wapakoneta, Ohio, of a solid-gold replica of the first vehicle to land on the moon, which was given to Neil Armstrong. There were three such replicas commissioned from Cartier by the French newspaper *Le Figaro*, funded by the newspaper's readers. They were given to Buzz Aldrin, Michael Collins, and Armstrong, astronauts aboard the *Apollo 11*. It was a great shock to the museum staff, as well as to the small Ohio community, and on the museum's Facebook page was this succinct sentiment: "The truth is that you can't steal from a museum. Museums care for and exhibit items on behalf of you, the public. Theft from a museum is a theft from all of us."[1]

The frightening reality of stolen valuable museum objects is that they immediately become vulnerable, subjected to all kinds of physical threats. Transported back and forth like rocks in a sack by gangland goons, the more likely they are to deteriorate! This must be top of mind to the Gardner Museum officials as the years tick by. For them now, it's not about the two criminals who robbed the place, or about the gang who paid them to do it, it's about where the paintings are now and what condition they are in. So concerned were Gardner officials about retrieving them that immediately following the heist, they were able to, with the generous financial assistance of two major art auction houses, Sotheby's and Christie's, offer a one-million-dollar reward. Over the intervening years, the reward was elevated to five million dollars, and more recently, ten million dollars, in hopes that someone would

come forward, someone perhaps who saw one of the paintings by chance and would alert officials to its whereabouts. But to no avail at this writing.

Also exasperating is the fact that the statute of limitations relating to the crime has expired. Prior to the Gardner theft, there wasn't a statute of limitations for the theft of art. It's hard to believe, but it wasn't even considered a federal crime. In 1994, following the Gardner incident, Massachusetts senator Edward Kennedy (who, when he was contemplating running for president in 1979, had young Brian Michael McDevitt as one of his enthusiastic volunteers) was successful in including new language in a crime bill that made art theft a federal offense.

Periodically there have been moments of hope, when the FBI or Gardner officials have signaled a possible break in the case, only to have it later publicly denounced or swallowed in oblivion. One of the more recent signals of hope occurred on March 18, 2013, the twenty-third anniversary of the heist, when FBI officials hosted a big press conference, no doubt somewhat to assuage their guilt, to announce they had new, pertinent information about the case. On their official Boston Division website, they posted a press release entitled "FBI Provides New Information Regarding the 1990 Isabella Stewart Gardner Museum Art Heist." In addition, the agency created a separate web page with images of the stolen art works. The pertinent so-called new information was relayed in the release's second paragraph:

> The FBI believes it has determined where the stolen art was transported in the years after the theft and that it knows the identity of the thieves, Richard DesLauriers, special agent in charge of the FBI's Boston office, revealed for the first time in the 23-year investigation. "The FBI believes with a high degree of confidence that in the years after the theft, the art was transported to Connecticut and the Philadelphia region, and some of the art was taken to Philadelphia, where it was offered for sale by those responsible for the theft." DesLauriers added, "With that same confidence, we have identified the thieves, who are members of a criminal organization with a base in the Mid-Atlantic states and New England." After the attempted sale, which took place approximately a decade ago, the FBI's knowledge of the art's whereabouts is limited.[2]

In a March 18, 2013, article in the *New York Times*, the same day of the FBI announcement, Katharine Seelye noted, "The announcement . . . appeared timed to coincide with the anniversary of the 1990 theft rather than because of any recently unearthed information. But Mr. DesLauriers said the investigation was nearing its 'final chapter.' And Carmen Ortiz, a United States attorney . . . said: 'I think we're all optimistic that one day soon the paintings would be returned to their rightful place.'"[3] Three days later, the *Times* printed an op-ed written by Ulrich Boser, entitled "Learning from the

Gardner Art Theft." He is the author of the 2009 book *The Gardner Heist*. In the article, he noted, "Twenty-three years may seem like an inordinate amount of time to solve a burglary, but the Gardner case has actually come a long way from the days when it sometimes seemed to sit on the FBI's investigative back burner—and the robbery has done a lot to change the way that museums protect their art."[4] Boser reminded his readers that the FBI somewhat can hide behind the fact that following 9/11, they have been taken up with the more serious issues of terrorism, as well as a plethora of violent crimes. But as he notes, "The idea that art theft is not quite a serious crime has a strange hold in some quarters." And to the general arts–interested public, I might add, these ongoing revelations running hot then turning cold—particularly around every anniversary of the heist—seem to be more theatrical than serious. In Seelye's *New York Times* article, she concludes with the observation of a visitor to the Gardner on the day of the latest FBI announcement: "March 18, 1990, it's unbelievable—23 years to the day,' she mused, half joking, half skeptical. 'Did the FBI sit on this until the 18th of March? One wonders."

Boser's other observation is that an important spin-off of the Gardner heist is that many museums, especially the Gardner, have taken the security of their collections more seriously. In a January 3, 2012, article for the *Boston Magazine*, Paige Williams writes, "the Gardner's security has never been tighter. Guards undergo extensive background checks and training. Cameras 'of every size and capability' are hidden throughout the museum, equipped with night vision, low light, covert, pan, tilt, zoom—all the latest technology." And for a major policy shift, she notes, "The museum has theft insurance now, too. Big lesson brutally learned."[5]

The FBI continues to stumble into embarrassing disclosures that illustrate its lack of sophistication and/or its ongoing territorial infighting when it comes to solving art crimes. On August 6, 2015, they released to the media a six-minute video tape from the Gardner Museum's surveillance cameras with some unbelievable evidence. It was taken on March 17, 1990, the night before the heinous crime, and it shows an automobile outside the Gardner and a man being let into the museum by the night guard, Richard Abath. The elderly gentleman visitor appears to have been delivering some kind of document and reviewing it with Abath, then shortly afterward, exiting the museum. It blows a huge hole in Abath's previous testimony, in which he only alluded to the incident on the following night when he let into the museum the two police-costumed thieves. The FBI's apparent strategy is that hopefully someone will recognize the elderly individual on this twenty-seven-year-old tape and that may lead to solving the crime. And they have obviously had further interviews with Richard Abath, who moved to Brattleboro, Vermont, but unfortunately he died on February 24, 2024. Why did it take twenty-five years to release the tape? Apparently, the tape was either never reviewed or

thought to have been of little importance and stashed away with the mountain of Gardner Museum heist evidence. *New York Times* reporter Tom Mashberg noted in an article on August 6, 2015: "The tape was collected just after the theft, but it is unclear whether it had ever been reviewed before 2013. United States Attorney Carmen M. Ortiz said in a telephone interview that the prosecutor, who took over the case about two years ago, Robert Fisher, pulled it from the stacks of Gardner evidence at the F.B.I. and viewed it during a 'complete reexamination of the case.' Since then, she said, Mr. Fisher and F.B.I. investigators have tried to identify the visitor and the make and model of the car. The street images of the car remain dark, and the visitor's face is only slightly discernible two minutes and 18 seconds into the video. 'Now we are calling on the public for help,' she said."[6] Thank God the federal agency has an occasional turnover of staff. Then, in June 2017, the Boston press was once again quivering with yet a new Gardner heist tidbit. The FBI had finally admitted that the handcuffs and duct tape used to restrain the two museum guards during the heist have been missing for some time. One wonders what else might have been lost or unobserved regarding this case over the last thirty-three years.

The fascinating aspect of both The Hyde's failed heist and the Gardner tragedy is that both museums made significant and nearly parallel institutional strides following these episodes. It became unmistakably evident that the fragility of these two "arts time-capsules" could not remain viable in their current configurations as innocent, fragile little containers of world-class art. Both directors, Anne Hawley and I, were quite cognizant of our institutions' limitations well before the occurrence of these two serious incidents, but it was the shock that our collections and facilities were so extremely vulnerable that gave us the drive to push boundaries. In both museums, our security was lacking, and our institutions' public visibility was negligible. We were hampered by the constraints of our unique facilities, and in the Gardner's case, an additional restraint by Isabella's idiosyncratic trust. Following these theft incidents, our boards, staffs, and communities likewise rallied when our institution's vulnerabilities were so obviously confirmed. What's interesting about the facility enhancements of both is that they happened independently of each other. The Hyde's expansion occurred in the late 1980s, and the Gardner opened its beautiful new wing in 2012. From a brief telephone conversation I had with Anne Hawley in 2010, I could discern that she was not aware of what was accomplished at The Hyde Collection, nor should she have been, given the tremendous pressure she has been under since March 18, 1990. In both instances, the institutional growth has been amazingly beneficial in generating fresh energy and visibility in their communities. Granted, for the Gardner, the horrid loss—hopefully, temporary—of their prized Old Masters still remains a serious blow, and their facility growth doesn't offset

that fact. But had it not occurred, the museum might still be the susceptible static institution it was. In Paige Williams's *Boston Magazine* article, she ended her story of the museum's fate following the heist thusly: "It's been suggested that as the Gardner becomes a museum for the next generation it installs an exhibit dedicated to the heist. But to memorialize that 'barbaric act,' as Hawley once called it, would be opportunistic, sensationalistic—throwing dirt on the coffin. Better to let the empty frames hang, the calendar turn, and the schoolchildren make sense of mounted saints [frames] until the art finds its way home."

NOTES

1. James Doubek, "Thieves Take Neil Armstrong's Solid Gold Lunar Module Replica," *The Two-Way* (blog), National Public Radio, July 30, 2017, http://www.npr.org/sections/thetwo-way.

2. Greg Comcowich, Boston FBI, "FBI Provides New Information Regarding the 1990 Isabella Stewart Gardner Museum Art Heist," The Federal Bureau of Investigation, Boston Division, March 18, 2013, http://www.gov/boston/press-release/2013.

3. Katharine Q. Seeley, "A New Effort in Boston to Catch 1990 Art Thieves," *New York Times*, March 13, 2013, htpp://nytimes.com/2013/03/19/usfbi-says-it-has-clues-in-1990-isagardner-museum-art-heist.html.

4. Ulrich Boser, "Learning from the Gardner Art Theft," *New York Times*, March 21, 2013, http:///nytimes.com/2013/03/22/opinion/the-lessons-of-the-1990-gardner-art-theft.html.

5. Paige Williams, "The Gardner Heist: 20 Years Later: Twenty Years Ago the Isabella Stewart Gardner Museum Suffered the Largest Art Heist in History. The Crime Remains Unsolved," *Boston Magazine*, January 3, 2012, http://www.bostonmagazine.com/scripts/print/aeticle.php.

6. Tom Mashberg, "25 Years After Gardner Heist Video Raises Questions," *New York Times*, August 6, 2015, http://.nytimes.com/2015/08/07/arts/desigh/25-years-after-gardner-museum-heist-video-raises-questions.html.

Epilogue

Lastly, just a few words about me: In July 2010, I retired from my museum career, having spent the last twenty years as executive director of the Hillwood Estate, Museum & Gardens in Washington, DC. It was again an exhilarating experience applying much of what I learned at The Hyde Collection, by being able to nudge the institution along a path toward professionalism. It required an incremental process of helping the board understand its responsibilities, growing a professional staff, holding strategic planning sessions, achieving accreditation, undertaking facilities restoration and enhancements, initiating an ambitious publications program, and the opportunity to exhibit a large segment of the collection at numerous museums around the country during the two years Hillwood was closed to the public for restoration. It was an incredible ride. And as she has done throughout my career, my wife, Becky, was my source of stability and encouragement as I forged through the numerous challenges at Hillwood. Living on a twenty-five-acre museum estate, which was fenced and gated—with twenty-four-hour guard staff—was a benefit for their parents, but a challenge for our two kids, especially once they became teenagers.

I consider myself to have been extremely fortunate to have had the opportunity to shepherd these two wonderful, small art collectors' personal museums into more vital institutions. They are both rich in cultural and historical artifacts and greatly warranted an opportunity for growth, not only for the individuals who guided them, but also for the communities in which they reside. And, indeed, it was not a singular endeavor by any means. It took, in both cases, the dedicated efforts of boards and staffs to believe in the efficacy of their museums and to work tirelessly toward achieving ever higher standards in making them the exceptional institutions they have become.

Sources

CHAPTER ONE: AFFIRMATION

The memories of that blistering cold morning have been forever etched in my mind. An interesting sidebar of that day is that I was never able to determine who the character was that was parked outside of our house. My sense is, he was probably associated with the police or BCI. Given the uncertainty of the situation as it was unfolding, they may have assumed I was in cahoots with McDevitt. Who knows?

CHAPTER TWO: THE HYDES AND MRS. GARDNER

A thorough telling of the historical development of American art museums is *Palaces for the People: A Social History of the American Art Museum*, by Nathaniel Burt, published by Little, Brown and Company in 1977. Because of the incredible reserve of Louis and Charlotte Hyde and a paucity of archival material, little has been published about them and their collecting avocation. The first brief accounting was the introduction I wrote for *The Hyde Collection Catalogue*, published by The Hyde Collection, in 1981. Further, a small booklet, *A Shared Life: The History of The Hyde Collection's Founding Family*, by Erin B. Coe, former director of The Hyde Collection, was published by the museum in 2011. On the other hand, much has been written about the incredible life of Isabella Stewart Gardner. One of the major accountings of her life is titled *The Art of Scandal: The Life and Times of Isabella Gardner*, by Douglass Shand-Tucci, published by Harper Collins in 1997.

CHAPTER THREE: ACQUIRING ART ON A BUDGET

A general overview of "art collectors' private museums," as I have titled this unique genre of museums, is *A Museum of One's Own*, by Anne Higonnet, published by Periscope Publishing, Ltd. in 2009. I derived the information about Frick from the in-depth telling of her great-grandfather's turbulent story in her book, *Henry Clay Frick: An Intimate Portrait*, by Martha Frick Symington Sanger, published by Abbeville Press in 1998. My telling of the chronological story of the Hydes' acquiring their wonderful small art collection was surmised from *The Hyde Collection Catalogue*. Regarding their purchase of Rembrandt's painting *Christ with Arms Folded*, I have relied on information from the publication *Rembrandt's Christ, in Thirteen paintings and one Etching*, by James Kettlewell, published by The Hyde Collection in 1968. For information pertaining to Mrs. Hyde's fake Vermeer painting, see the book *The Man Who Made Vermeers: Unvarnishing the Legend of Master Forger Han van Meegeren*, by Jonathan Lopez, published by Harcourt Books, 2008, pages 61–64 and 239–40. The source for the purchase of Raphael's *Portrait of a Young Man* was obtained from the catalog *Raphael and America*, by David Alan Brown, published by the National Gallery of Art, Washington, DC, 1983, pages 55 and 56. I have relied on the publication *Passion & Clarity: The Art of Joseph Jeffers Dodge*, by Debra Murphy-Livingston, published in 2002, by the Cummer Museum of Art & Gardens. It is a lively telling of Dodge's colorful life. Dodge's quote about how Mrs. Hyde responded to art was taken from one of the first serious periodical articles about The Hyde Collection published in the September/October 1982 issue of *Museum Magazine*, titled "The Surprising Hyde Collection," by Noel Suter, pages 23–26. The information about Mrs. Hyde's attempt to retrieve her fifty thousand dollars from the Schaffer Gallery was taken from Lopez's book on van Meegeren, page 240.

CHAPTER FOUR: THE TRANSITION

Again, I was able to garner details of Jerry Dodge's transition from The Hyde to the Cummer from Murphy-Livingston's book, *The Art of Joseph Jeffers Dodge*. Much of my telling of the transition of Mrs. Hyde's home into a public museum came from stories gathered over the years when I directed the museum. The sad loss of the Picasso and Braque paintings cast a pall over the museum for many years following the sale. It was not a favorite subject of the trustees when I arrived. One of the many quirky memories I have of my Hyde experience happened one morning in the mid-1980s, before the museum's opening hours: when I answered the front doorbell, standing there was a

distinguished gentleman who introduced himself as Sherman Lee, director of the Cleveland Museum of Art, who jokingly said, "I'm here for the other Picasso!" He was the director at Cleveland when the purchase was made and boasted about its great historical importance, but he also acknowledged that it was a tremendous loss for The Hyde. I did have a chance to fill him in on the backstory of our loss much of which he had been unaware of.

CHAPTER SIX: YOUNG MR. VANDERBILT

Much of the day-by-day operational activities described in this and other chapters were garnered from my pocket calendars, which were a business necessity before the days of smartphones. Thankfully, I saved them. Vanderbilt's request for a portfolio of photographs of the museum's paintings would have been unnecessary had a catalog of the collection been available. Some may wonder why I was so obsessed with publishing one given McDevitt's request for photos to be used for a heist sales pitch. As noted in the chapter, having a scholarly publication broadly distributed to research libraries and auction houses was considered by me to be valuable insurance should, God forbid, The Hyde ever again be the victim of a heist. Further, at that time, The Hyde's art collection was not very well known by scholars, and this was a way to broaden its awareness.

CHAPTER NINE: PLANNING THE HEIST

For this chapter and the following one, I'm indebted to Ronald Kermani for providing me with the sworn statements of Brian McDevitt, Michael Morey, and Mary Winglosky, which were conducted by the South Glens Falls Police Department. He also gave me the original notes of his first interview with me, conducted on December 30, 1980, which were helpful in constructing various chronological details provided herein. Finally, I had a lengthy telephone interview with Michael Morey, who was very generous in sharing with me his memories of the attempted heist, as well as of his life's journey.

CHAPTER THIRTEEN: DÉJÀ VU

My acquaintance with Stephanie Rabinowitz, Brian McDevitt's girlfriend, was made through the help and advice of Jim Arnold. He had befriended McDevitt in Hollywood and wrote about him in an entry of his internet blog titled Jimbolaya, which is quoted in chapter 15. Stephanie was tremendously

helpful in providing me with passages from her diary relating to her relationship with McDevitt, which are quoted in this and other chapters. I also interviewed her, which was most helpful in discerning more details of their relationship and insights into McDevitt's behavior.

CHAPTER FIFTEEN: HOLLYWOOD REINVENTION

There are quotes in this chapter, as well as in later chapters, from the popular podcast *Last Seen*, a ten-episode production about the Gardner heist produced by Boston's public radio station WBUR and the *Boston Globe*. It was aired in 2018 and received national acclaim. Episode eight, titled "Flimflammer," was entirely devoted to Brian McDevitt. My experiences with McDevitt at The Hyde Collection were included. I was interviewed by WBUR's producer, Kelly Horan. As an aside, I was also interviewed for the Netflix four-part miniseries entitled *This Is a Robbery: The World's Biggest Art Heist*, produced by the Barnicle Brothers Video Production Service and which aired on Netflix in the spring of 2021. However, the final editing of the miniseries eliminated McDevitt's connection to the heist, apparently considered too inconsequential to be taken seriously. Former FBI agent Thomas McShane informed me about Los Angeles' talk show host Doug McIntyre's brush with McDevitt. My interview with Doug was very informative.

Index

60 Minutes:
 "The IBM Caper," 65, 66, 71, 111;
 "To Catch a Thief," 167–70, 171,
 173, 177, 178, 189
AAM. *See* American Alliance of
 Museums
Abath, Richard "Ray," 183–84, 185, 202
accreditation (AAM), 136–37, 146, 205
adoption of children (Bill and Beth),
 134
American Alliance of Museums (AAM),
 41, 45, 143, 159
Amon, Dan, 92, 93
Amore, Anthony, 159, 196
Armstrong Air & Space Museum
 (Wapakoneta, OH), 200
Armstrong, Neil, 200
Armstrong, Tom, 56–57, 58
Arnold, Jim, 176–77, 209
Art Institute of Chicago (Chicago, IL),
 16, 54
Association of Museum Directors, 31
Astor, Brooke, 58, 110
AVISO (American Alliance of Museums
 newsletter), 38, 39

Babcock, James, 61, 67, 69–72
Baldwin, Eliza Jane, 7

Barnes, Albert, 9
Barnes, Edward Larrabee, 138, 139,
 140, 151
Bates College (Lewiston, ME), 97, 98,
 194
BCI (New York Bureau of Criminal
 Investigation), 60, 61, 65, 67, 69,
 75, 207. *See also* Babcock, James
Beatrice, Thomas, 164–65, 168, 170,
 171, 174, 175, 181, 189
Beeman, Polly, 47, 140
Berenson, Bernard, 7, 8, 10, 17, 22
BigBlue 78 (Swampscott High School
 Class of 1978), 193
Bigelow, Henry Forbes, 10–11, 13
Bliss, Robert and Mildred, 9
Bloodgood, Morgan, 125
Blow, David, 108
Blumenthal, Ralph, 181
Bolan, Barbara, 107
Boser, Ulric, 182–83, 201–2
Boston Globe (Boston, MA), 27, 171,
 173, 174, 175, 182, 188, 193, 194,
 195, 210
Boston Herald (Boston, MA), 164, 182
Boston Magazine (Boston, MA), 202,
 204
Brooke Astor Foundation, 55, 57
Brown, Jerry, 98, 190

Brown, Loren N., 128, 129
Bydalek, Jeff, 172, 173

Cady Hill (Saratoga Springs, NY), 50, 105, 109
Canale, William, 121
Carter, Jimmy (President), 96
Catalogue, The Hyde Collection, 44, 59, 68, 132–33, 207, 208, 209
Chapman Historical Museum (Glens Falls, NY), 51, 59, 84. *See also* Cutshall-King, Joseph
Chapman, Joseph M., 151–52, 153, 159, 160
Charles, Ellen MacNeille, 146–47, 148, 150, 151
Christian Science Monitor (Washington, DC), 155
Christie's, 155, 200
Christison, Muriel B., 38–39, 40
Cleveland Museum of Art (Cleveland, OH), 16, 24, 209
CNN, 165
Coe, Erin, 141, 207
Crandall Library (Glens Falls, NY), 22, 25, 31, 51
Crockwell, Douglas, 25, 31, 32
Crystal Bridges Museum of American Art (Bentonville, AR), 16, 34. *See also* Walton, Alice
Cummer Museum (Jacksonville, FL), 29, 30
Cunningham, Eliza Jane, 6, 11, 37
Cunningham House, 37, 52, 53–54, 56, 62, 64, 69, 74, 92, 110, 111, 137, 140
Cunningham, John, 31
Cuomo, Mario (Governor), 140
Cutshall-King, Joseph, 59, 84, 134. *See also* Chapman Historical Museum

Davies, Joe, 147
Day, Richard, 38, 40, 58, 64–65, 67, 74, 84, 111
De Montebello, Philippe, 62

DesLauriers, Richard, 201
Dodge, Joseph, Jeffers "Jerry," 23–29, 208
Donohue's Meat Market (Glens Falls, NY), 115, 118
Doran, Robert, 127
Duggan, James, 58, 60, 61, 65, 67, 84
Dukakis, Michael (Governor), 96

Earp, Jeffrey, 182
Eden Park Nursing Home (Glens Falls, NY), 119
Eichler, Fran, 42–43, 66, 72, 76, 81, 90
Eichler, Muriel, 42, 54, 67, 70, 72, 81, 84
Esposito, Cecilia "Ceil," 45, 50, 51, 54, 55, 57, 59, 60, 62, 63, 66, 68, 69, 72, 74, 77, 78, 79, 80–81, 84, 90, 147, 165, 167

Faiella, Ida, 77–79
Falzon, Dan, 181, 183
FBI (Federal Bureau of Investigation), 3, 151, 153, 155, 156, 157, 159, 160, 164, 165, 166, 168, 169, 170, 172, 173, 174, 178, 181, 182, 183, 184, 189, 190, 191, 196, 199, 201, 202, 203
Febbo, Carmen, 98
Federal Express, 84, 87, 95, 115, 116–21, 126, 128, 129, 152, 183, 184, 185, 186, 187, 189
Finch Pruyn & Company (Glens Falls, NY), 6–7, 81
First National Bank of Boston (Boston, MA), 100
Fisher, Becky, 1, 39, 40–41, 50, 56, 60, 65, 73, 76, 79, 80, 81, 83, 85, 86, 88, 89, 90, 93, 134, 144, 146, 147, 152, 165, 167, 205
Fisher, Robert, 203
Frick, Henry Clay, 9, 15, 27, 208

Gallery Association of New York State, 61, 144–45

Garbo, Greta's Dusenberg, 138–39
Gardner, Isabella Stewart, 7–10, 11, 17, 22, 26, 33, 34, 207. *See also* Isabella Stewart Gardner Museum
Glens Falls, NY, 3, 6–7, 11, 16, 17–18, 22, 23, 24, 25–26, 30, 31, 33, 37, 39, 40, 41, 47, 48, 57, 58, 61, 64, 77, 80, 84, 89, 92, 93, 103, 104, 105, 106, 107, 108, 109, 110, 117, 131, 134, 137, 139, 141, 147, 157, 164, 165, 166, 167, 171, 173, 188, 189, 190
Great Escape Amusement Park (Queensbury, NY), 47, 138–39
Griffin, Mr., 112, 114
Grindle, Lyle, 159
Grist Mill Restaurant (Queensbury, NY), 112
Gupte, Pranay, 104

Hague, Roger, 145
Harrington, Michael J., 96
Hawkins, Kami, 105, 107, 109, 110, 113, 123, 126
Hawley, Anne, 156–57, 158–59, 199–200, 203, 204
Hendry, Paul "Turbo," 190
Hestand, Randy, 185, 188
Hill-Stead Museum (Farmington, CT), 5
Hillwood Estate, Museum & Gardens (Washington, DC), 143–44, 146, 147, 149, 152, 155, 165, 205
Homsy, Dimitri, 99–100
Honan, William, 160–62, 163, 164
Hoopes, Mary Pruyn, 6, 10
Hoopes, Maurice, 10
Hoopes, Sam, 43, 146
Horan, Kelly, 188, 196, 210
Howard Johnson's Motor Inn (Queensbury, NY), 88, 114, 116, 117, 119–20
Howat, John, K., 29–31
Huntington, Henry and Arabella, 9
Huntington T. Block, 155–56

Hyde, Charlotte Pruyn, 5, 6, 9, 10, 34, 37, 133;
death, 30;
education and courtship, 7, 9;
established The Hyde Collection Trust, 25;
hired curator John K. Howat, 29;
hired curator Joseph Jeffers Dodge, 23–29;
hired curator Otto Wittman Jr., 21–23;
initiated art collecting avocation, 16–20;
purchased forged Vermeer, 21, 26
Hyde Collection, The (Glens Falls, NY), 3, 5, 6, 26, 27, 194, 199, 203, 205, 207, 208;
juxtaposition of Hyde attempted heist and Gardner heist, 183–91;
professionalizing the museum, 131–14, 143–47, 168, 171;
transition to museum, 30–38, 40, 47, 68, 95–104, 106, 109, 126, 128
Hyde House, 11–13
Hyde, Louis Fiske, 7, 10, 137;
initiated art collecting avocation, 16–20, 22;
status as art collector, 33.
See also Charlotte Pruyn Hyde
Hyde, Mary Van Ness, 7

IBM Corporation, 140
IBM Selectric typewriters, 59, 63, 66, 67, 70, 71, 110–11
Independent, The (UK), 181
Inkwell Productions, 173
Isabella Stewart Gardner Museum (Boston, MA), 3, 160, 171, 172, 173, 175, 177, 178, 181–83, 194, 196, 199, 200, 201, 202, 203, 204;
60 Minutes segment, 167–70;
construction and collection, 7–10, 13, 39, 137;
heist aftermath, 155–59

heist, 3, 152, 153;
juxtaposition of Hyde attempted heist and Gardner heist, 183–91;
McDevitt becomes heist suspect, 161–62, 164–65

Jackson, Harry, 145–46

KABC's *McIntyre in the Morning*, 177
Kennedy, Hellen, 164–65
Kennedy, Ted (Senator), 98, 200
Kermani, Ronald, 86, 87, 88, 92–93, 95, 97, 98, 122, 126, 127, 128, 129, 209
Kettlewell, James K., 31, 32, 37, 42, 44, 45, 50–52, 55, 68, 69, 71, 79, 80, 85, 132
Krannert Art Museum (Champaign, IL), 38–39, 40, 41
Kruse, Dean, 139
Kurkjian, Stephen, 190

Lake George (New York), 32, 41, 47, 52, 107, 117, 120, 135
Lake George Village (New York), 47, 48, 107, 110, 117
Lake, Peter A., 173–74
Last Seen (podcast), 173, 174, 188, 194, 196, 210
LeBrun, Fred, 86, 89, 90
L'Ensemble, 68, 77–79, 80, 113
Lillard, Jim, 165–66
Los Angeles Times (Los Angeles, CA), 151, 173, 174, 175, 178

Mahoney Notifier, 42, 111, 116
Mahoney, Virginia, 112, 114, 116
Marcellus, Earl, 42
Markey, Edward (Senator), 97, 100
MaryHill Museum (Goldendale, WA), 5
Mashberg, Tom, 203
Matthai, Robert, 137
McDevitt, Brian Michael (alias Paul Sterling Vanderbilt), 1, 2, 3, 5, 199, 207, 209, 210;

60 Minutes "To Catch a Thief," 167–70;
appearance at concert, 78–79;
attendance at exhibit opening, 51–52;
delivery of typewriters, 62–64;
early life, 95–101;
fallout from attempted heist, 83–89;
first formal meeting, 52–54;
first troubling phone call, 54, 55;
flight from Los Angles, 181–83;
Hollywood screenwriter deception, 171–78;
initial encounter, 48–50;
juxtaposition of Hyde attempted and Gardner heist, 183–91;
last meeting, 69–72;
legal fallout, 125–30;
planning the attempted heist, 103–23;
second phone call, 56;
supposed death, 193–96;
suspect of Gardner heist, 160–66;
third phone call, 58–59
McDevitt, Mary A., 95, 126, 193
McDevitt, John H., 95, 126, 127–28, 193, 196
McElroy, Frank, 190
McIntyre, Doug, 177, 210
McShane, Thomas, 181–82, 188, 196, 210
Mellon, Andrew, 15
Mendel, Mesick, Cohen, 140
Metivier, Don, 91–92, 131
Metropolitan Museum of Art (New York, NY), 5, 16, 31, 49, 61, 136
Morey, Michael, 85, 87, 86–88, 92, 95, 106–7, 108–23, 126, 129–30, 161, 164, 165–66, 168, 169, 183, 184, 185, 186, 187, 188, 189, 199, 209
Morgan, J. P., 15
Museum's Collaborative, 135, 136
Museum of Fine Arts (Boston, MA), 16
Musser, Henry, 39–40

National Gallery of Art (Washington, DC), 5, 15, 26, 151

Native Textiles, 118, 119
New England Merchants National Bank, 93, 98–100, 104, 128, 190
New York Times (New York, NY), 52, 104, 139, 146, 155, 160, 164, 165, 174, 181, 201, 202, 203
Noonan, Richard, 87, 121, 122

O'Keefe, Francis, 108
Ortiz, Carmen, 201, 203

Phillips Collection (Washington, DC), 5
Picasso, *Fan, Salt Box, Mellon*, 24, 31, 38
Pollock, Ben, 169, 172, 173
Post, Marjorie Merriweather, 9, 143, 146, 148–49, 150. *See also* Hillwood Estate, Museum & Gardens
Post-Star (Glens Falls, NY), 2, 3, 80, 91, 92, 93, 108, 131
Potters Diner (Warrensburg, NY), 111
Pratt, Edward, 121, 126
Prestin, Terry, 175
Prout, Roy, 93, 100–101, 161, 169, 178
Pruyn, Eliza Jane Baldwin, 6, 25
Pruyn, Samuel, 6–7, 10, 25

Queensbury Hotel (Glens Falls, NY), 41, 48–49, 54, 56, 58, 85, 105–7, 108, 109, 110, 111, 126, 129, 147

Rabinowitz, Stephanie, 162–64, 166, 168, 171, 172, 174, 176, 177–78, 183, 184, 190, 199, 209–10
Raych, A. Morton, 32, 38
Rembrandt van Rijn, *Christ with Arms Folded*, 18–20, 37, 77, 89, 116, 187, 208
Riggs, Adelaide, 148
Roger, Bertrand, 96
Russell & Wait (Glens Falls, NY), 63

Safer, Morley, 167–70, 171, 173, 189
Saratoga Singers, 68, 79–80

Saratoga Springs (New York), 32, 44, 47, 48, 49, 52, 93, 105, 126, 135
Seelye, Katharine, 201, 202
Segaloff, Nat, 162, 178, 195
Shanley, Terrance, 121, 126, 127, 129
Skidmore College (Saratoga Springs, NY), 31, 42, 44, 49, 51
Smith, David, 25, 32, 62
Smith, Harold, 182–83
Sotheby's, 155, 200
Stromyer, David, 62
Sutter, Noel, 33, 208
Swampscott High School, 95–96, 194
Swampscott (Massachusetts), 84, 95, 96, 97, 103, 107, 125, 126, 127, 128, 160, 171, 189, 193, 196

Taylor, Katrina, 149
Times-Union (Albany, NY), 86, 88, 91, 92, 93, 95, 97, 98, 100, 106, 121, 122, 125, 126, 127, 128, 129
Trustees of Hillwood Estate, Museum & Gardens, 148, 149
Trustees of The Hyde Collection, 30, 31, 33, 34, 38, 39, 42–43, 45, 48, 58, 70, 74–75, 131–32, 133, 134, 137, 139, 141, 143, 147
Towsend, David, 96
Turley, Leo, 108, 129

United States Trust Corporation, 98–99, 100

Valentiner, Wilhelm Reinhold, 18–19, 22, 23, 24
Vanderbilt, Paul Sterling. *See* McDevitt, Brian Michael
Van Meegeren, Han, 21, 26
Volunteer Council of The Hyde Collection, 30, 32, 33, 38, 42, 51, 68

Wait, David, 128, 129, 168, 189
Walton, Alice, 16, 34. *See also* Crysal Bridges Museum of American Art

WBGH (Boston, MA), 156
WBUR (Boston, MA), 173, 174, 188, 195, 210
West Meadow Estate (Lake George, NY), 107, 120
Whitney, Cornelius Vanderbilt "Sonny," 105, 139
Whitney, Marylou, 47, 105, 109, 139. *See also* Cady Hill
Whitney Museum of American Art (New York City), 52
Wilhelm, Den, 60–61, 110
Williams, Page, 202, 204
Wingloskky, Mary Paula Elizabeth, 84, 88, 115, 116–22, 126, 127, 129, 183, 184, 209
Wings Tavern (Glens Falls, NY), 105, 110
Winter Hill Mob, 190
Wittmann, Otto, Jr., 21–23, 25, 149
Wood, Charles R., 139, 143, 144, 145–46
Writer's Guild of America, 169, 172, 174, 175, 176, 177

Youngken, Joan, 59
Youngken, Rich, 59–60

About the Author

Frederick J. Fisher is a retired museum professional. He received his bachelor's degree from Portland State University, Portland, Oregon, and his master's degree (art history with a museum internship at the Smithsonian Institution's National Museum of American Art) from George Washington University, Washington, DC. Among his museum positions were assistant to the director of the Krannert Art Museum, University of Illinois, Champaign-Urbana; executive director of The Hyde Collection, Glens Falls, New York; and executive director of the Hillwood Estate, Museum and Gardens, Washington, DC. Both The Hyde and Hillwood are art collector homes with collections of international significance, which, under Fisher's leadership, were upgraded professionally, including being accredited by the American Alliance of Museums, establishing research and publication programs, and physical plant restoration and enhancements. While this is his first book, he has contributed to numerous museum catalogs and publications. He and his wife live in Gettysburg, Pennsylvania.